THELISTENER

THELISTENER

Es Konnte auch anders sein. It could just as well be otherwise.

What do you think an artist is?
An imbecile who only has eyes if he is a
painter, or ears if he is a musician...
He is at the same time a political being,
constantly alive to world events that can be
heart-rending, fiery or happy, and he responds
to them with his whole being.

—PABLO PICASSO (1881-1973) ARTIST

DAVID LESTER

ARBEITER RING PUBLISHING • WINNIPEG

Arbeiter Ring Publishing
201E-121 Osborne Street
Winnipeg, Manitoba
Canada R3L 1Y4
www.arbeiterring.com

Cover design by David Lester
Copy edit by Sarah Michaelson
Printed in Canada by Kromar Printing

With assistance of the Manitoba Arts Council/Conseil des Arts du Manitoba.

We acknowledge the support of the Canada Council for our publishing program.

ARP acknowledges the financial support to our publishing activities of the Manitoba Arts Council/Conseil des Arts du Manitoba, Manitoba Culture, Heritage and Tourism, and the Government of Canada through the Canada Book Fund.

Arbeiter Ring Publishing acknowledges the support of the Province of Manitoba through the Book Publishing Tax Credit and the Book Publisher Marketing Assistance Program.

Text on page 272 by Jean Smith.

Printed on 100% recycled paper.

LIBRARY AND ARCHIVES CANADA CATALOGUING IN PUBLICATION

Lester, David, 1958-
 The listener / David Lester.

ISBN 978-1-894037-48-8

 1. Germany--History--1933-1945--Comic books, strips, etc. I. Title.

PN6733.L47L57 2011 741.5'971 C2011-900777-0

DEDICATED TO

Jean Smith

Alan Twigg

and

Wendy Atkinson

CONTENTS

EDITORIAL NOTE:

Throughout this book an asterisk is used to indicate direct quotes, which have been translated from the original German.

GLOSSARY OF GERMAN POLITICAL PARTIES / ORGANIZATIONS:

DNVP (German National People's Party):
Right-wing nationalist political party led by
Alfred Hugenberg during the 1920s and early 1930s

KPD (Communist Party of Germany):
A major political party between 1918 and 1933

NSDAP (National Socialist German Workers' Party):
Also referred to as the Nazi Party and led by Adolf Hitler

SA (Storm-Troopers):
The Nazi Party's paramilitary organization

SPD (Social Democratic Party of Germany):
Germany's oldest left-wing political party

CHAPTER 1

Europe, Cycling, Riots & the Black Madonna

Ah, but the true protest is beauty.

—PHIL OCHS (1940-1976) MUSICIAN

MANIFESTO OF MEDICINE FOR ALL!

No discrimination!

The Pharmaceutical industry must:

STOP blocking developing countries from obtaining fairly priced medications. 14 million people in the world die from infectious diseases every year. 8,000 in the world die every day from HIV and AIDS.

STOP running themselves as corporate entities whose loyalty is profits for shareholders instead of health for customers.

STOP carrying out a form of economic genocide.

STOP focusing research on cures for baldness, toe fungus, and erectile dysfunction and instead tackle global life threatening diseases.

STOP wasting energy on public relations and legal battles and instead create effective ways for those living in poverty to afford medications.

Action Speaks Louder than Words

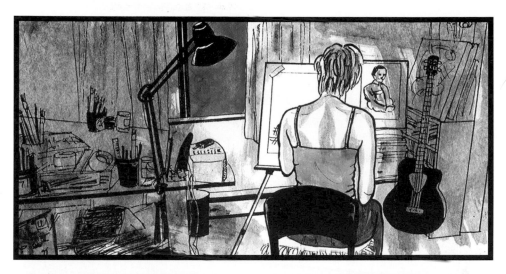

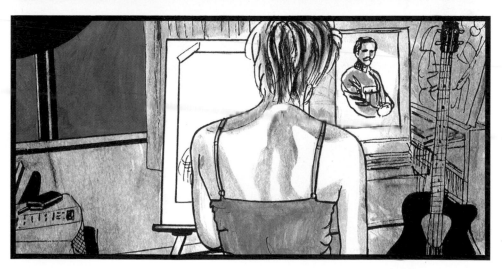

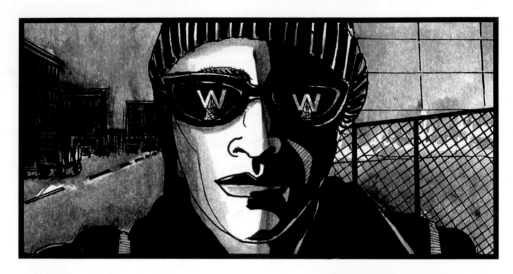

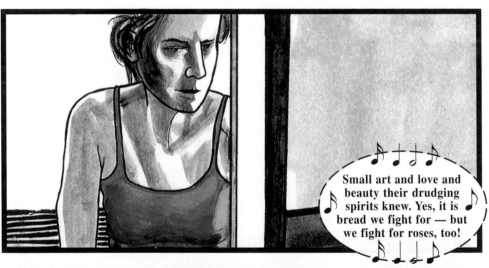

Small art and love and beauty their drudging spirits knew. Yes, it is bread we fight for — but we fight for roses, too!

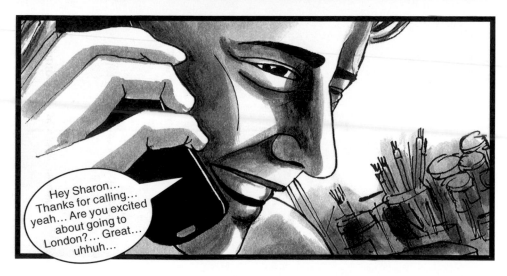

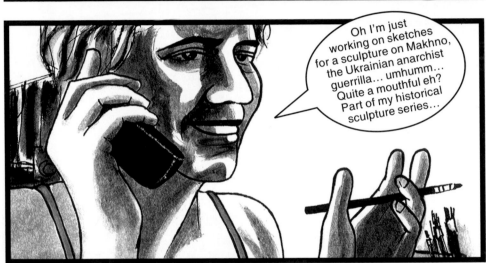

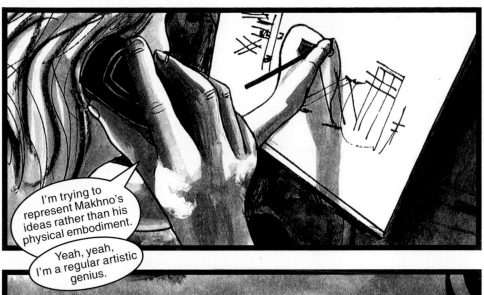

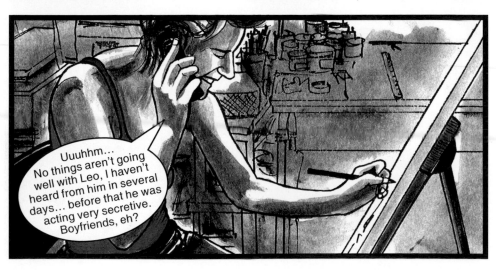

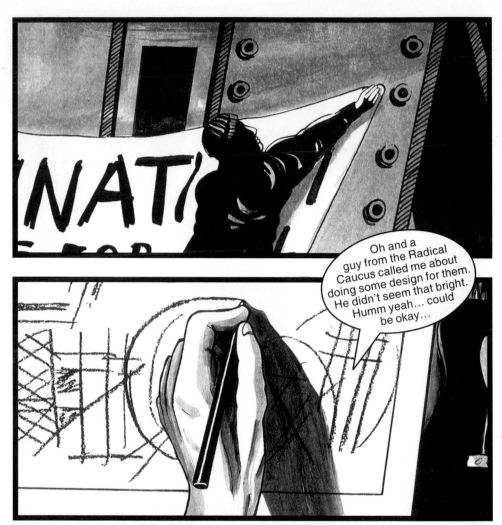

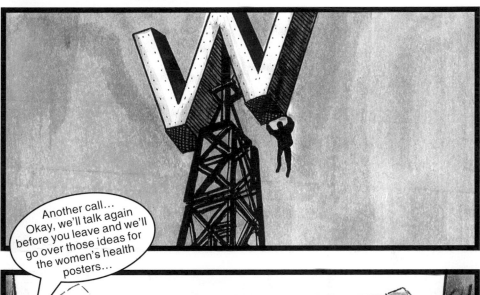

Hey I miss you Already… Cheerios…

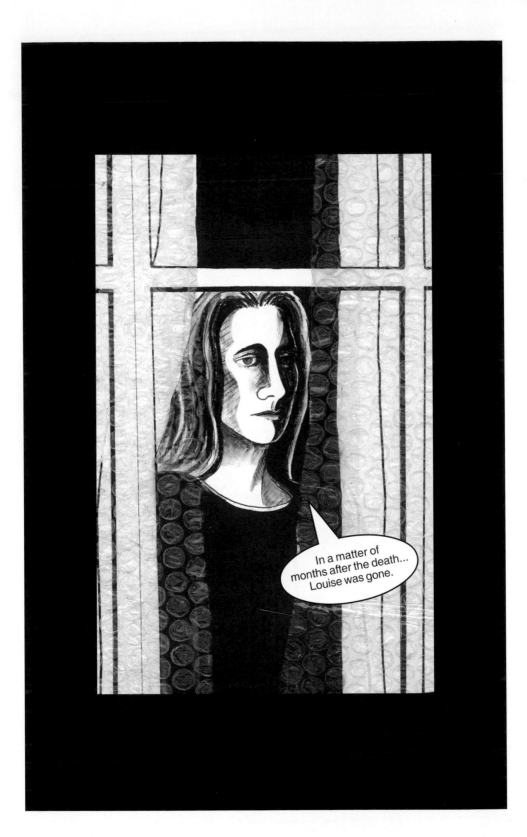

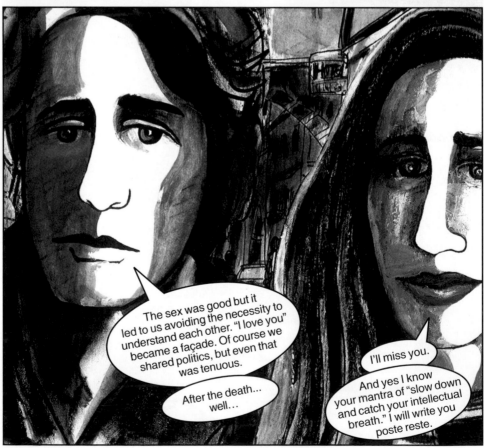

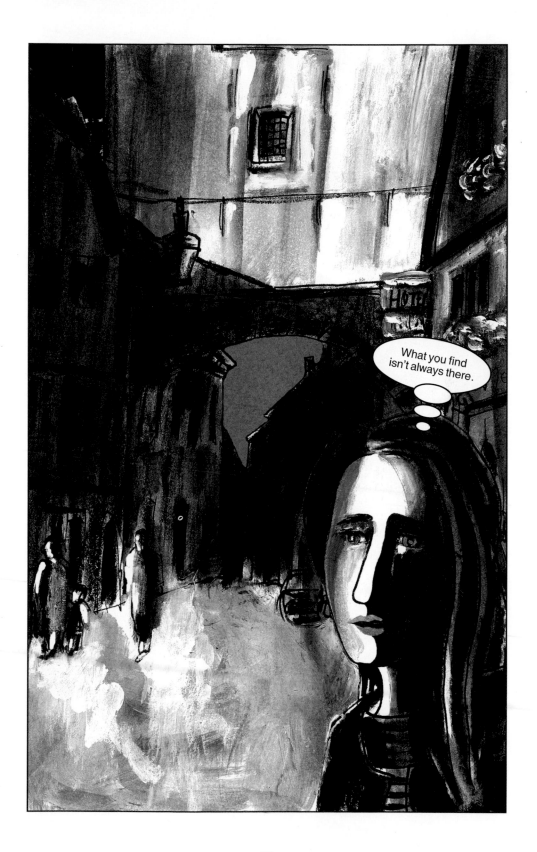

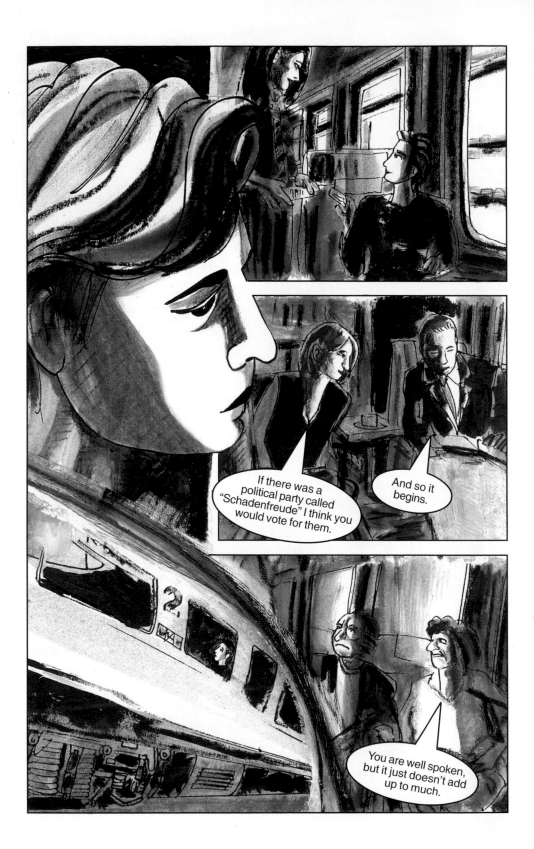

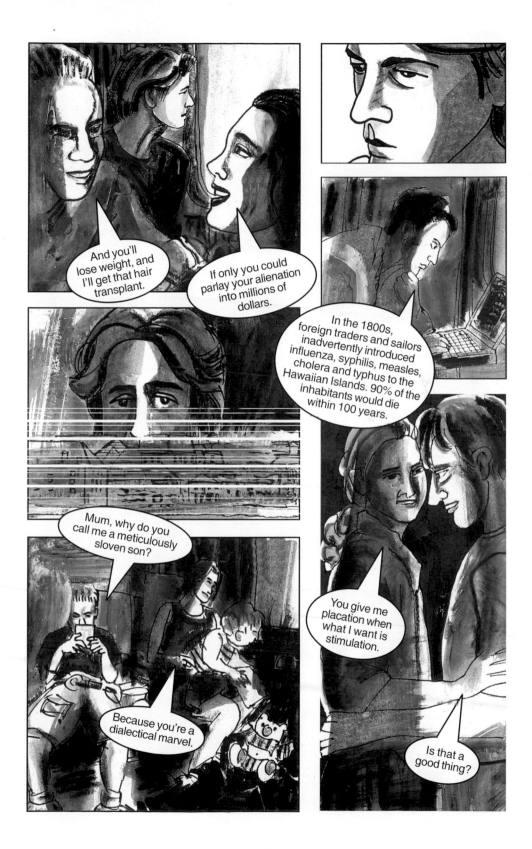

France...

Munich, Germany...

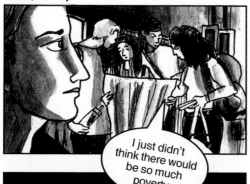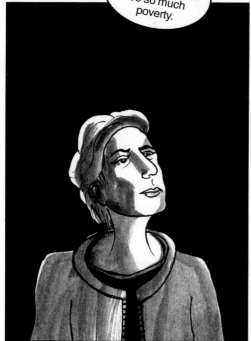

I just didn't think there would be so much poverty.

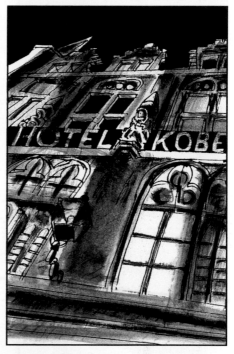

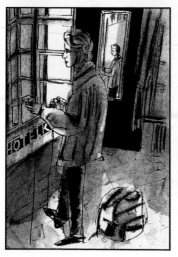

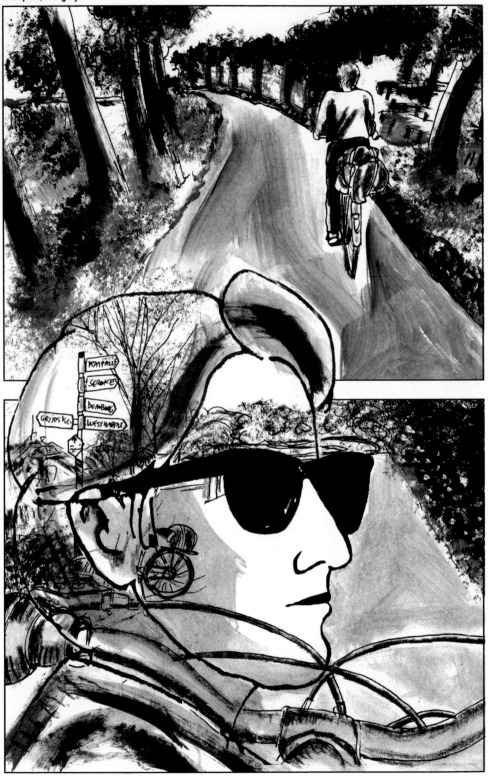

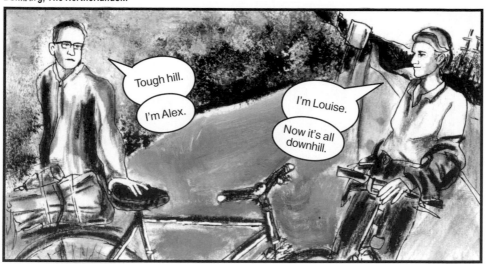

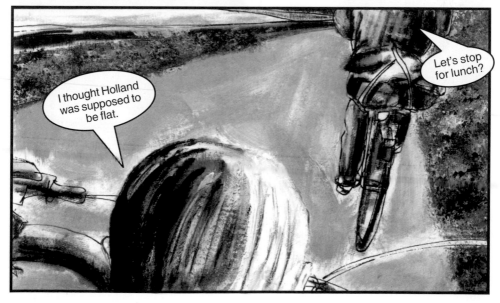

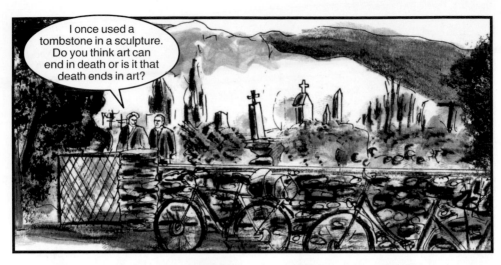

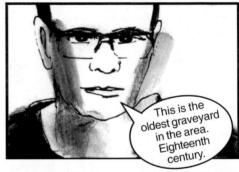

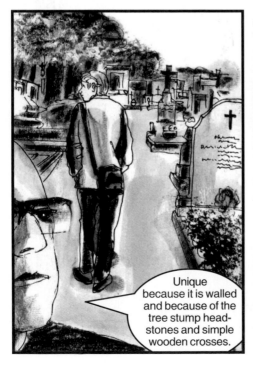

Louise, what will you do?

I don't know.

This church is 14th century. Built to enshrine a vial containing Christ's blood.

Now that sounds plausible.

I used to be plausible. I believed in a better world, a more humane society... that kind of thing. But the stupidity of the world wore me down. I aged. I got smarter. The hopelessness of it all became obvious. My patience drained. The barricades were replaced with a comfortable chair. I was left in isolation with ideals and loneliness. There is nothing more lonely than to have once felt passion and desire in your beliefs. Even though my ideals remain, they feel like a kind of nostalgia. It hurts. To see my ideas become unfashionable. That is loneliness.

Yes.

No.

Let's go over it again.

No!

Just once more.

No.

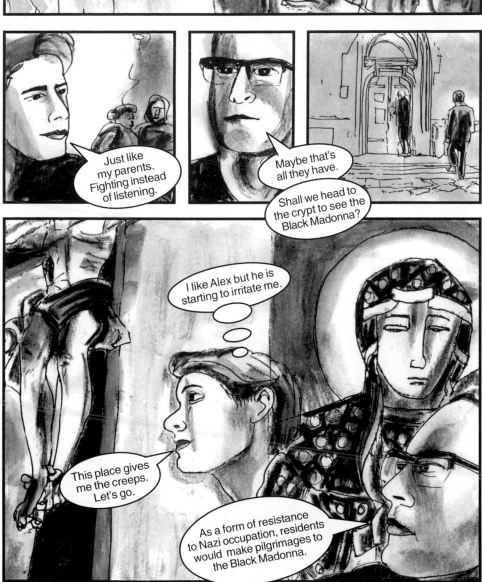

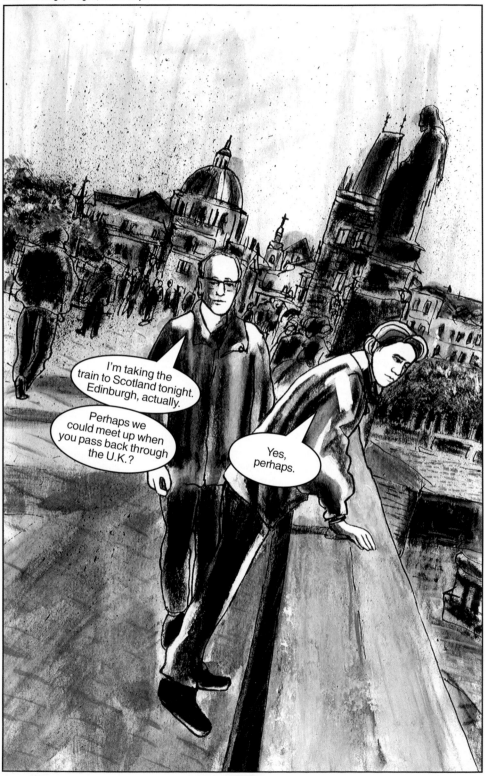

Kunst Museum (Bonn, Germany)... **Haus der Kulturen der Welt** (Berlin, Germany)...

Musée Picasso (Paris, France)... **Palais des Beaux-Arts** (Lille, France)...

Museum of Contemporary Art Kiasma (Helsinki, Finland)...

The Museo Nacional Centro de Arte Reina Sofía (Madrid, Spain)...

Ghent Museum of Fine Arts (Ghent, Belgium)... **Musée d'Orsay** (Paris, France)...

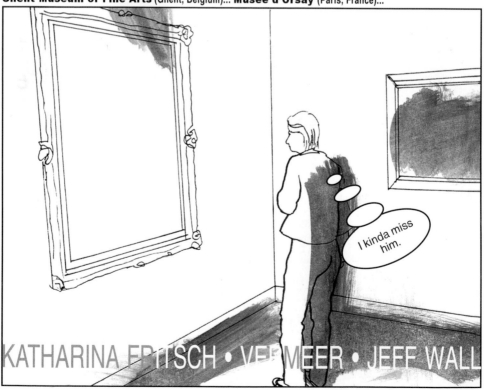

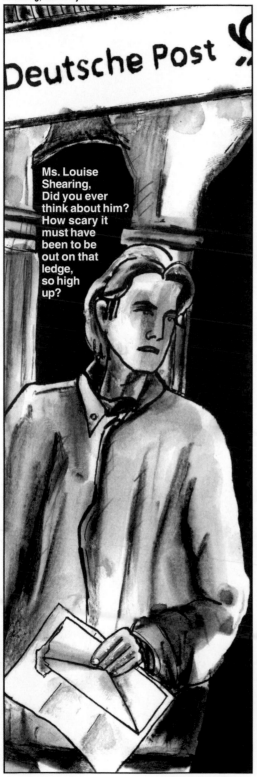

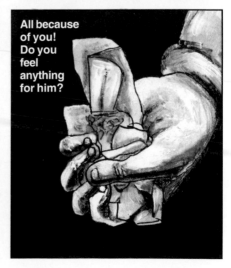

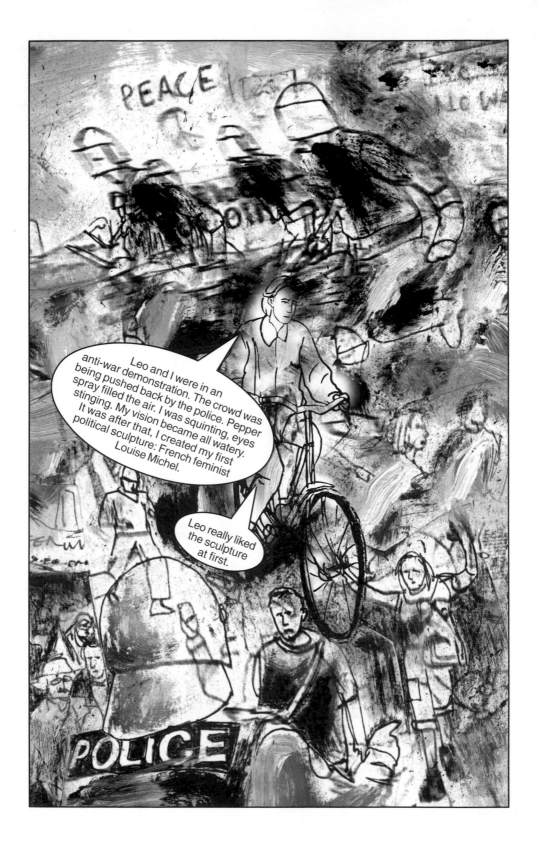

Berlin...

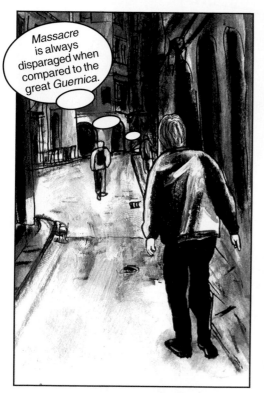

Massacre is always disparaged when compared to the great *Guernica*.

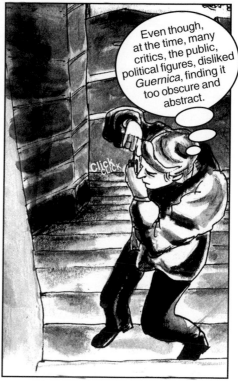

Even though, at the time, many critics, the public, political figures, disliked *Guernica*, finding it too obscure and abstract.

click click

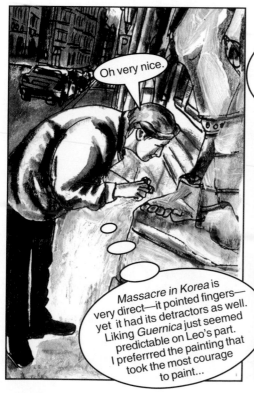

Oh very nice.

Massacre in Korea is very direct—it pointed fingers— yet it had its detractors as well. Liking *Guernica* just seemed predictable on Leo's part. I preferrred the painting that took the most courage to paint...

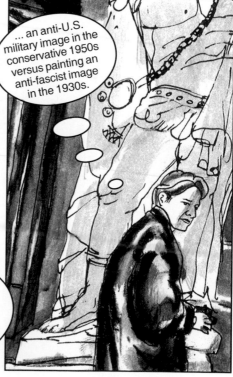

... an anti-U.S. military image in the conservative 1950s versus painting an anti-fascist image in the 1930s.

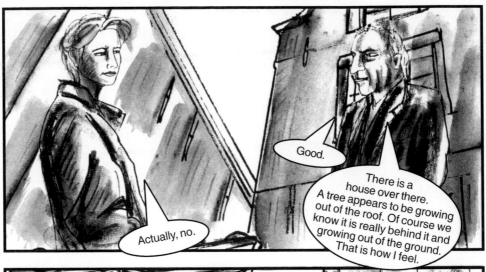

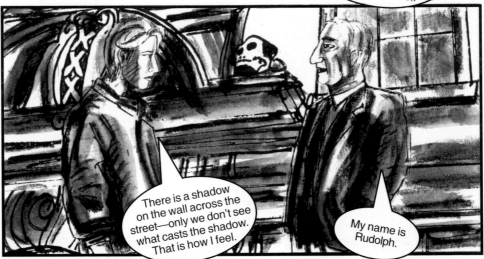

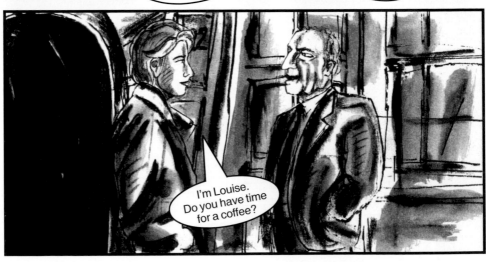

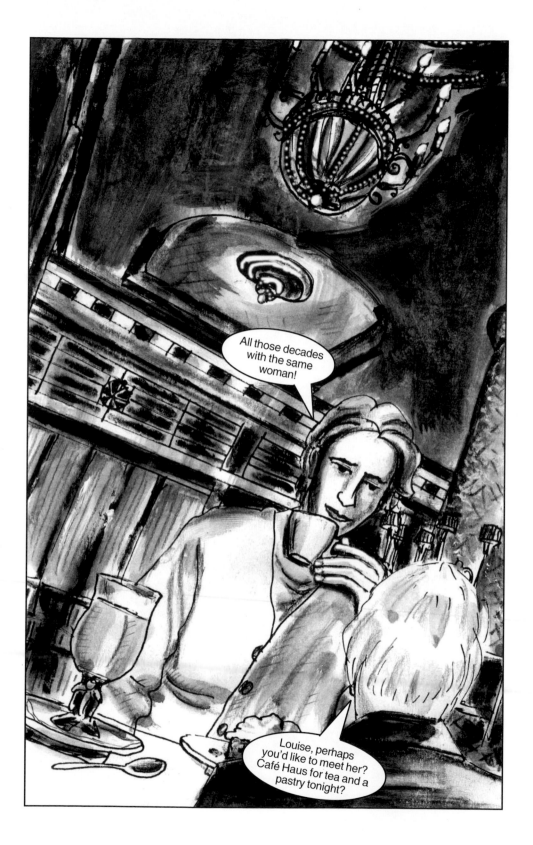

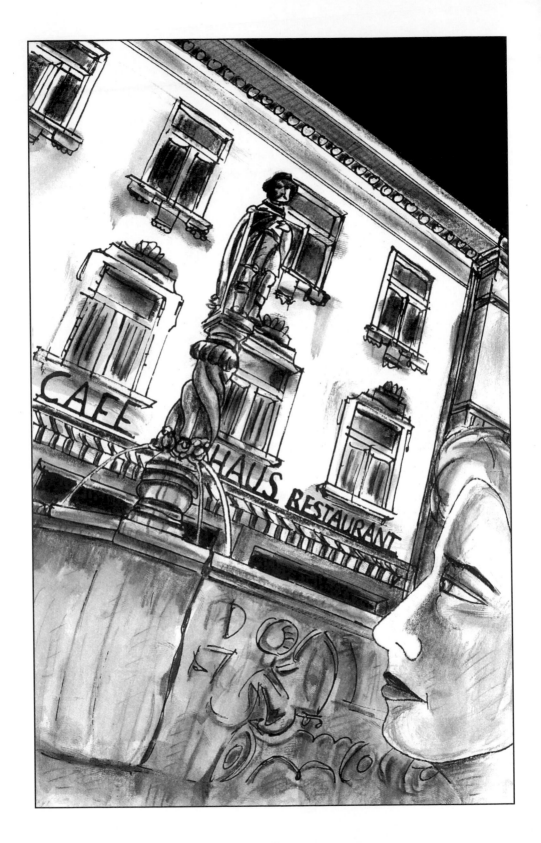

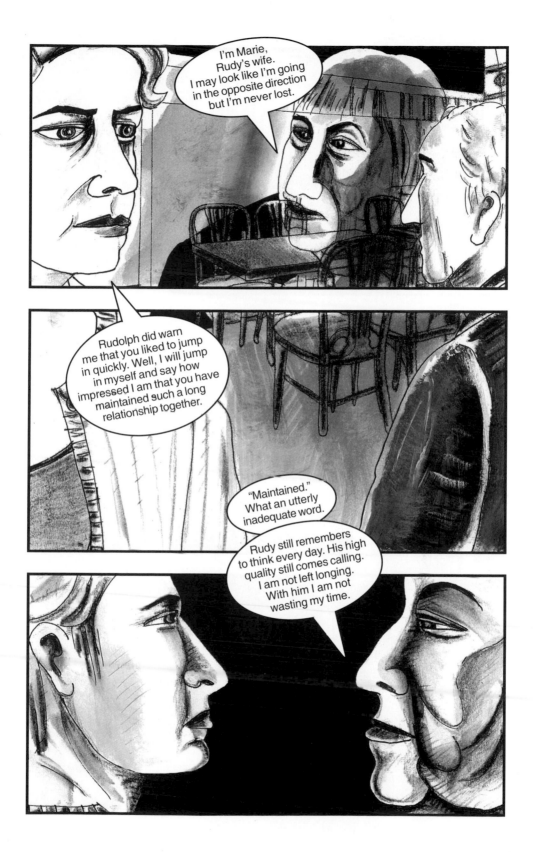

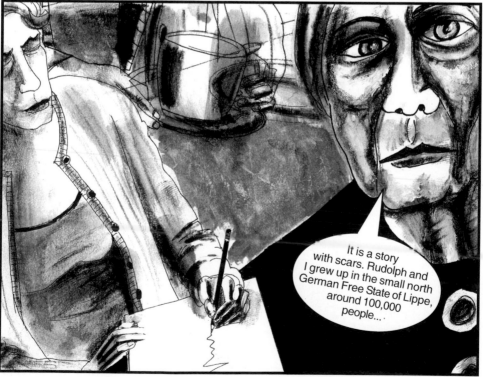

CHAPTER 2

Public Transit & Concentration Camps

Art doesn't reproduce what we can see,
it makes it visible.

—PAUL KLEE (1879-1940) ARTIST

Passau, Germany...

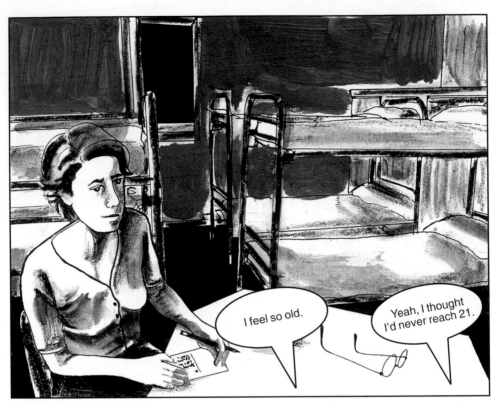

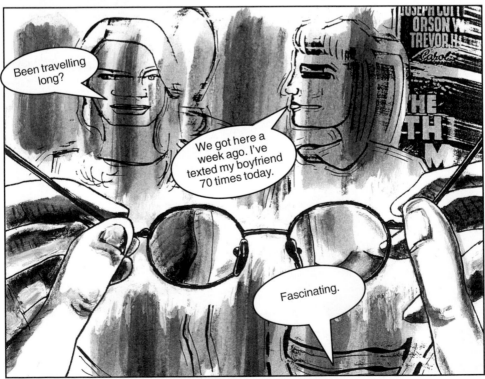

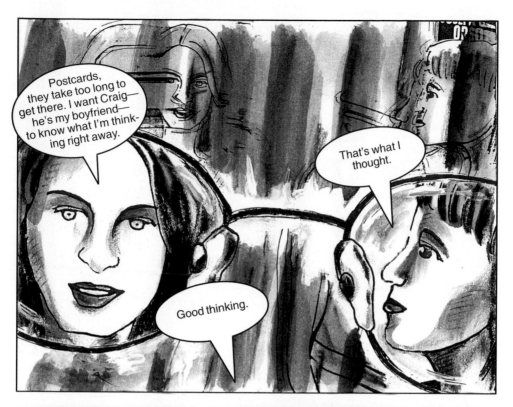

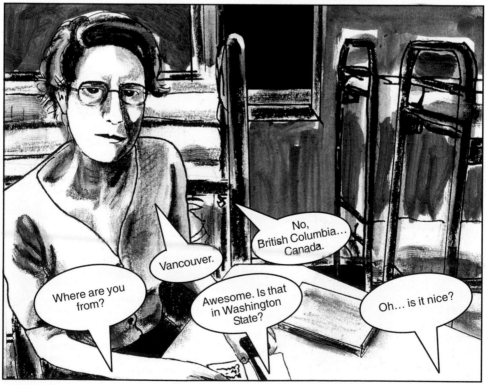

"Is it nice?"

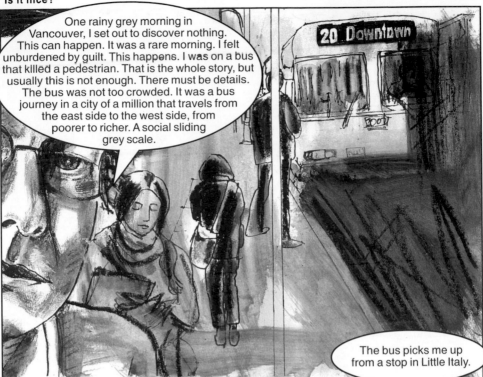

One rainy grey morning in Vancouver, I set out to discover nothing. This can happen. It was a rare morning. I felt unburdened by guilt. This happens. I was on a bus that killed a pedestrian. That is the whole story, but usually this is not enough. There must be details. The bus was not too crowded. It was a bus journey in a city of a million that travels from the east side to the west side, from poorer to richer. A social sliding grey scale.

20 Downtown

The bus picks me up from a stop in Little Italy.

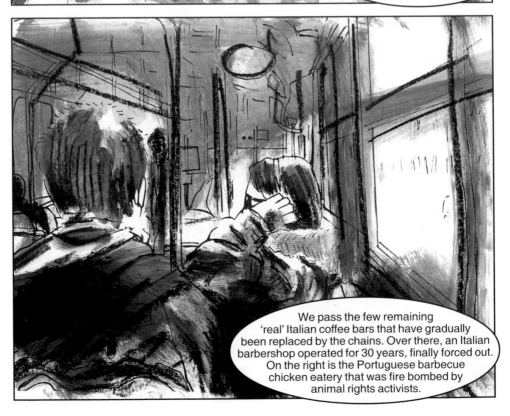

We pass the few remaining 'real' Italian coffee bars that have gradually been replaced by the chains. Over there, an Italian barbershop operated for 30 years, finally forced out. On the right is the Portuguese barbecue chicken eatery that was fire bombed by animal rights activists.

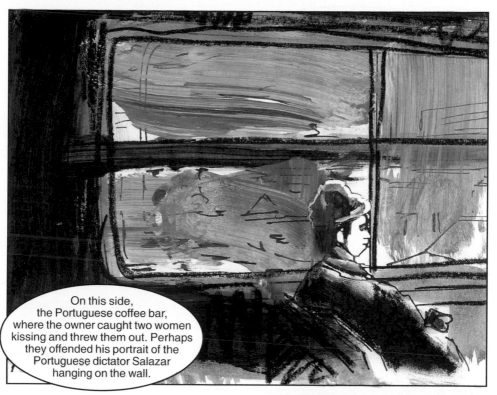

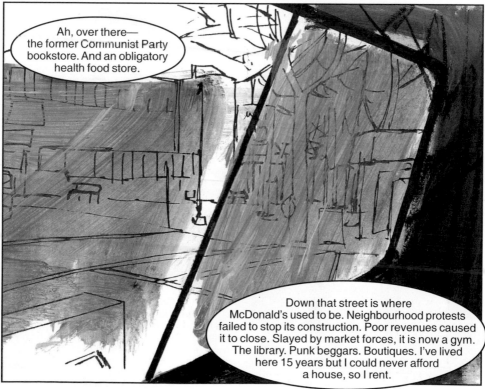

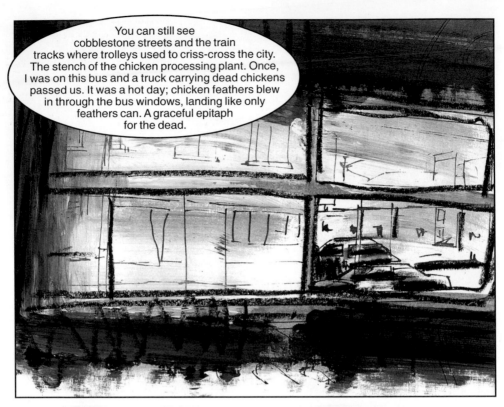

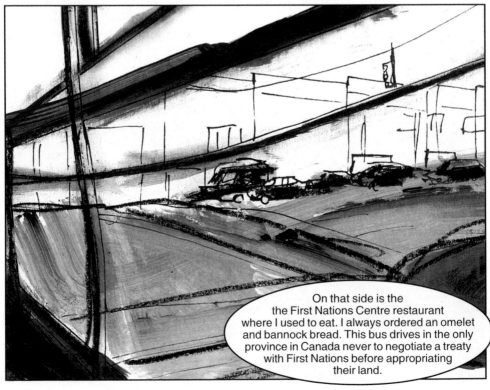

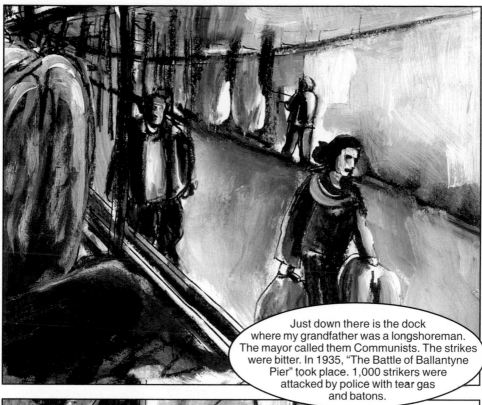

Just down there is the dock where my grandfather was a longshoreman. The mayor called them Communists. The strikes were bitter. In 1935, "The Battle of Ballantyne Pier" took place. 1,000 strikers were attacked by police with tear gas and batons.

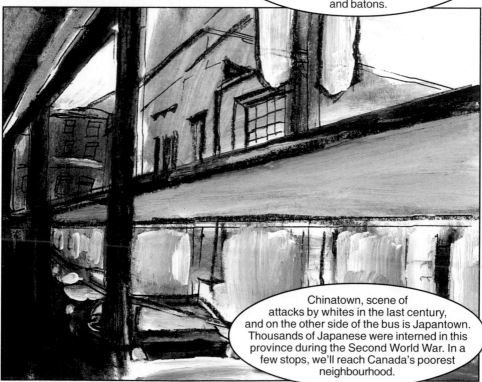

Chinatown, scene of attacks by whites in the last century, and on the other side of the bus is Japantown. Thousands of Japanese were interned in this province during the Second World War. In a few stops, we'll reach Canada's poorest neighbourhood.

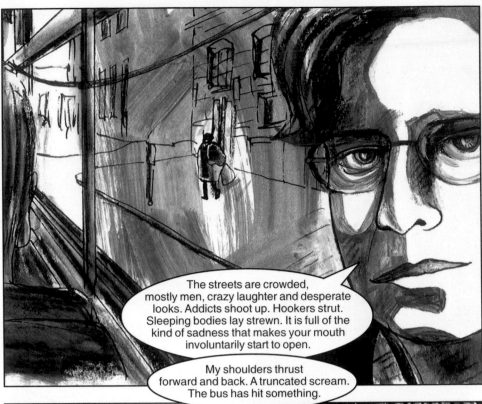

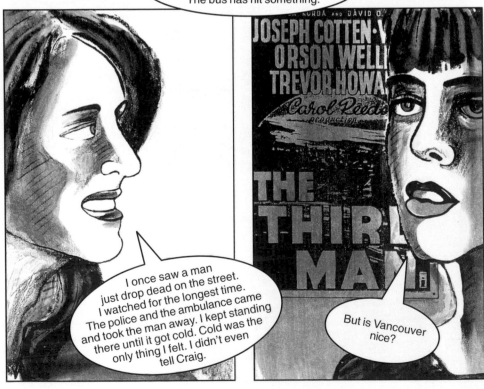

Vienna, Austria...

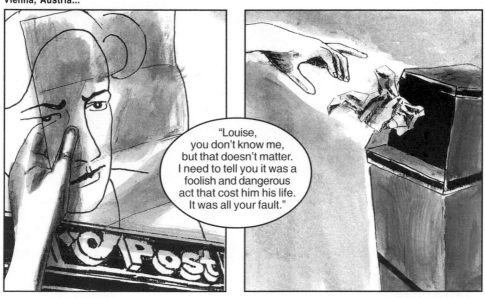

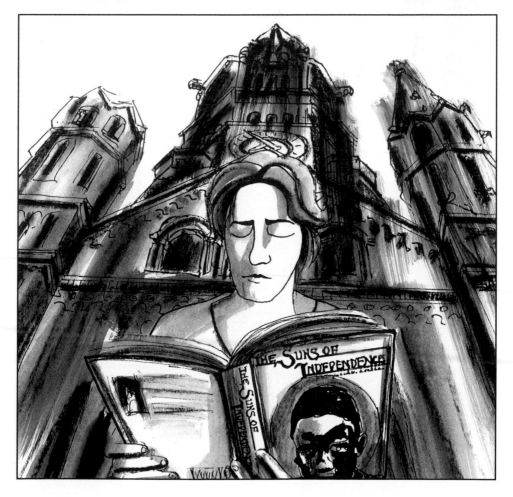

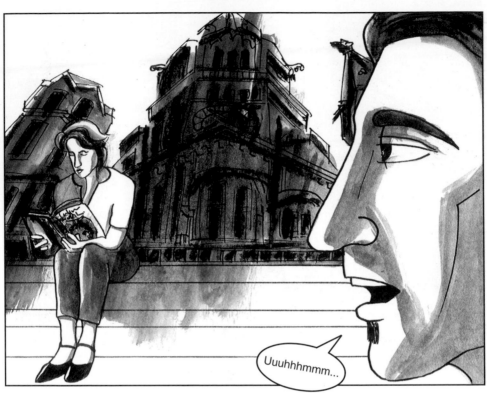

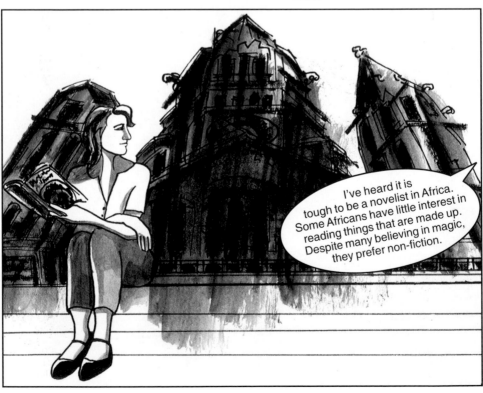

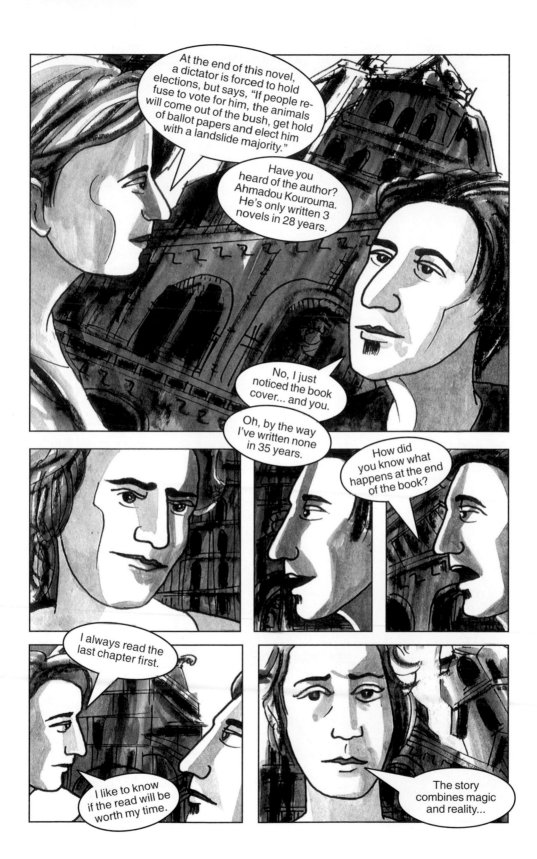

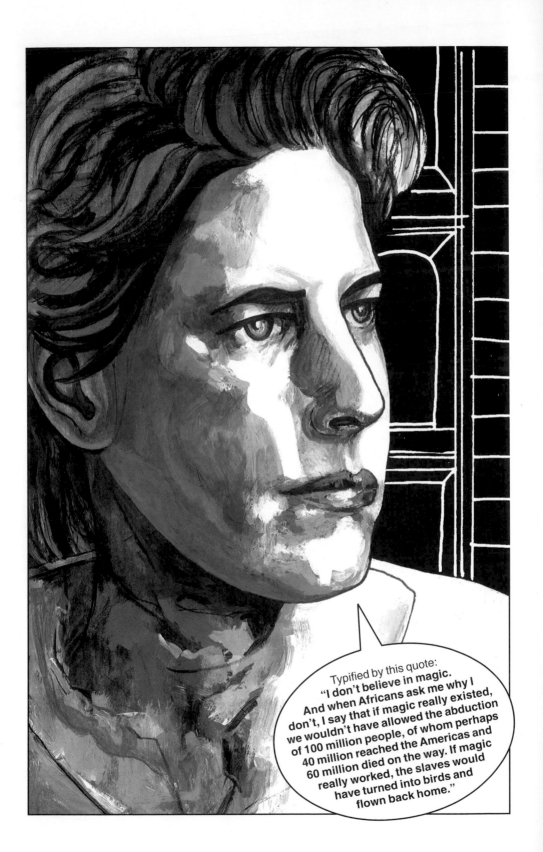

Typified by this quote:
"I don't believe in magic. And when Africans ask me why I don't, I say that if magic really existed, we wouldn't have allowed the abduction of 100 million people, of whom perhaps 40 million reached the Americas and 60 million died on the way. If magic really worked, the slaves would have turned into birds and flown back home."

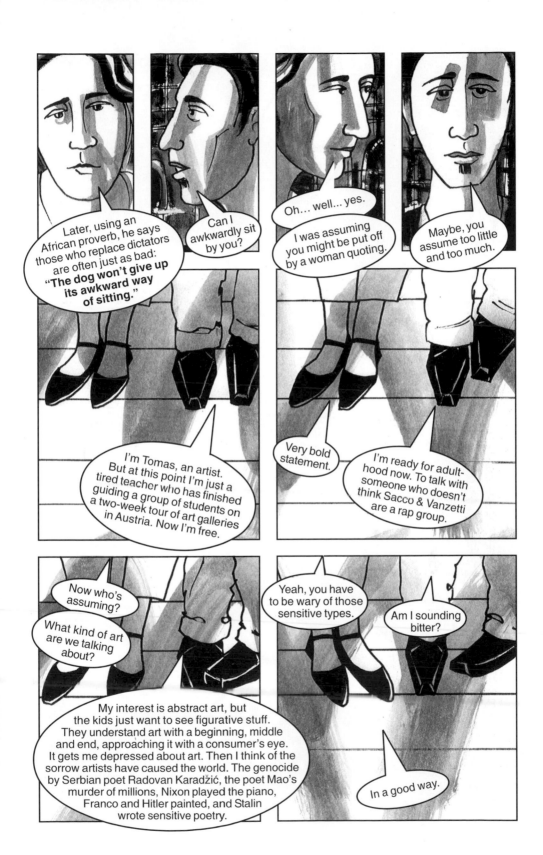

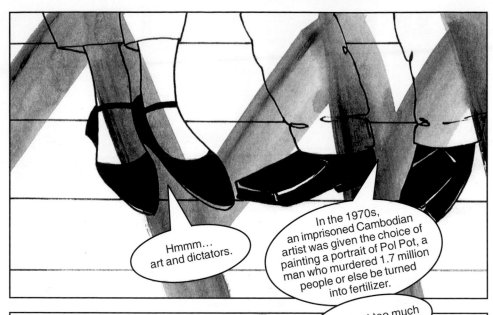

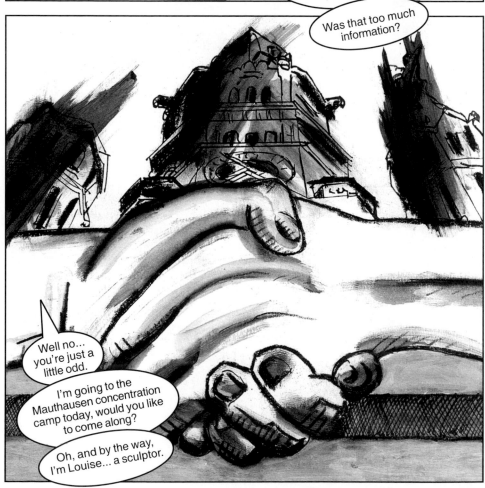

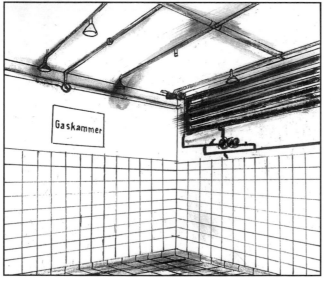

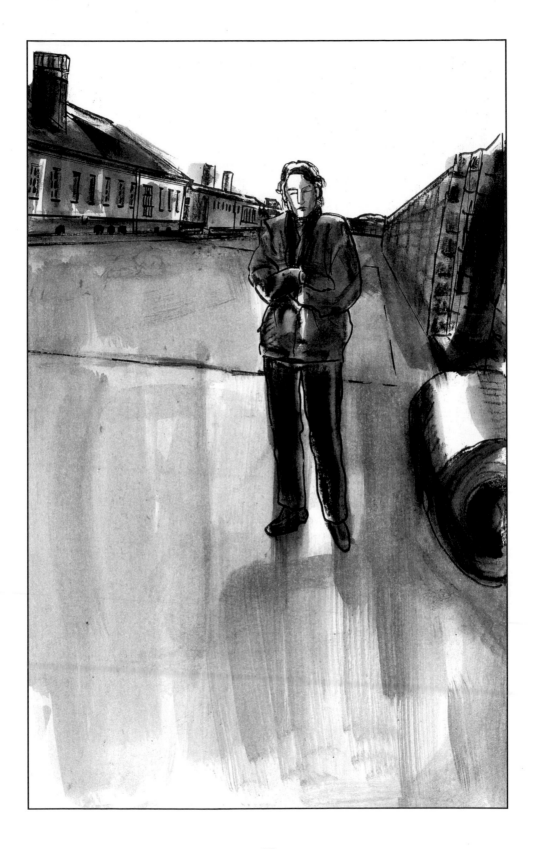

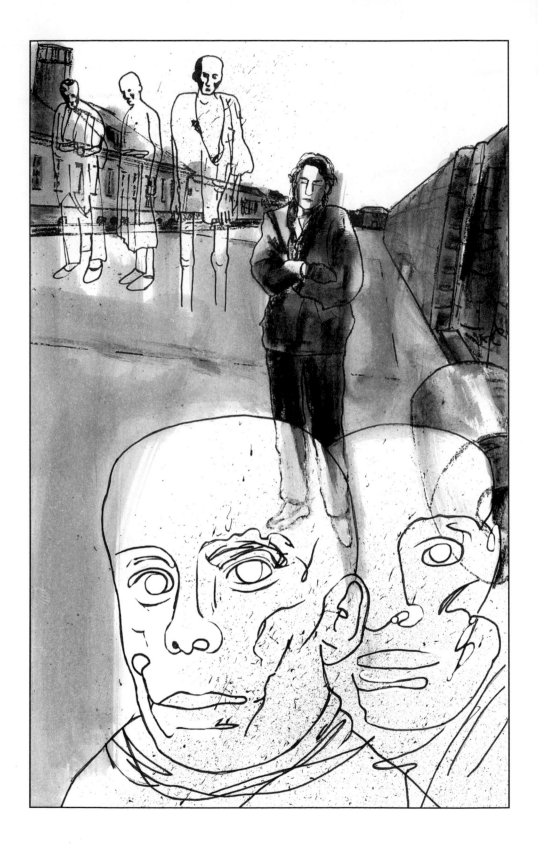

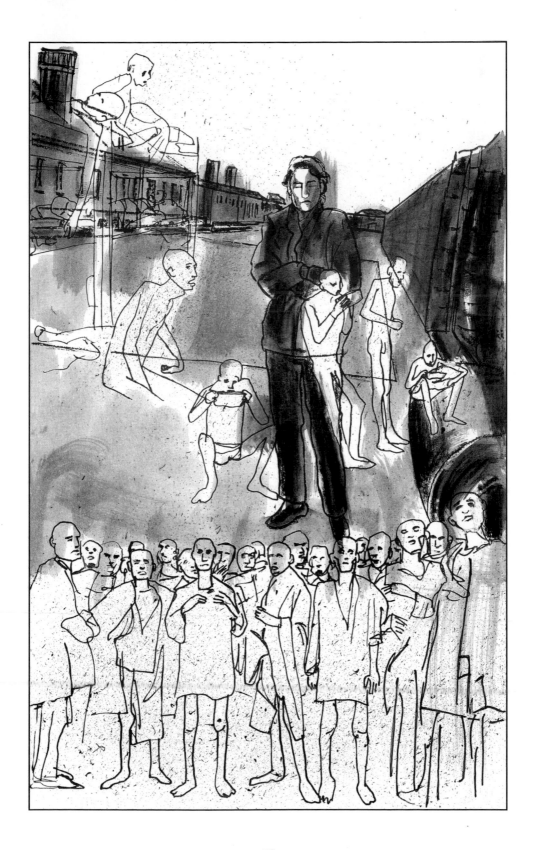

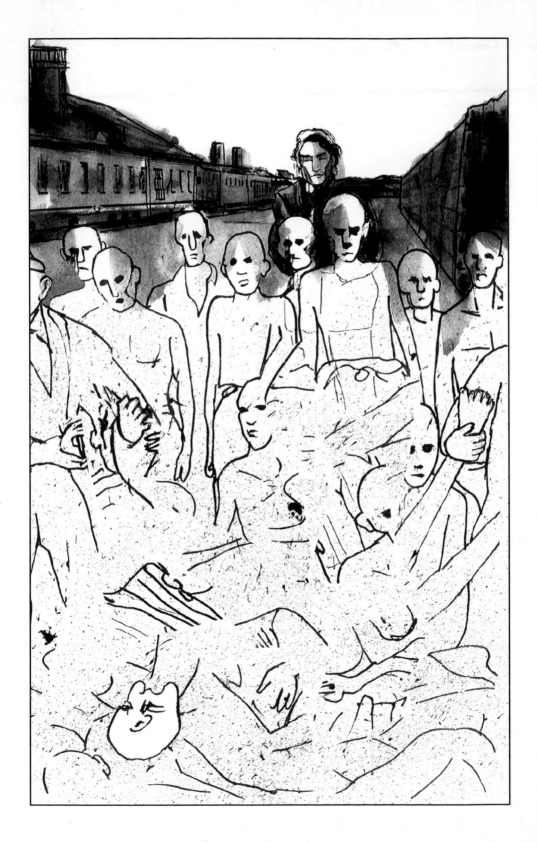

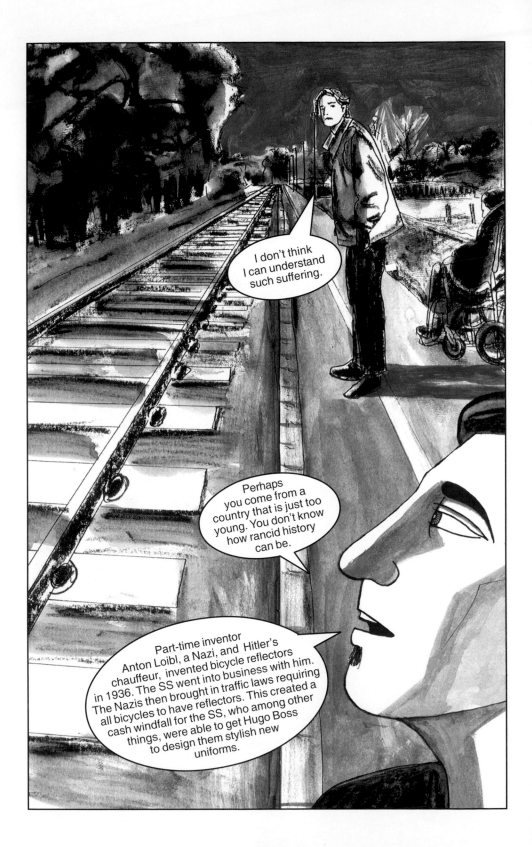

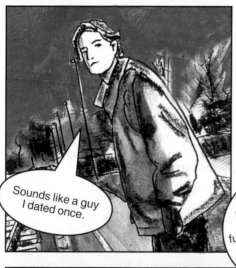

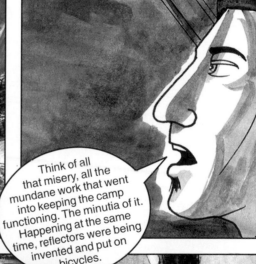

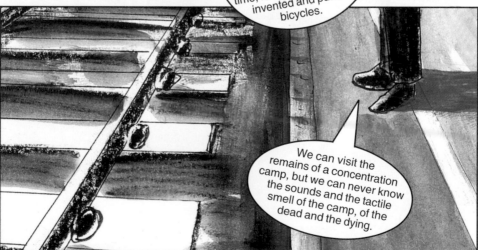

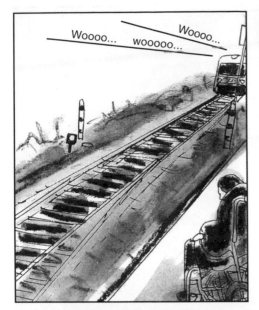

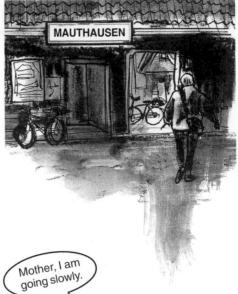

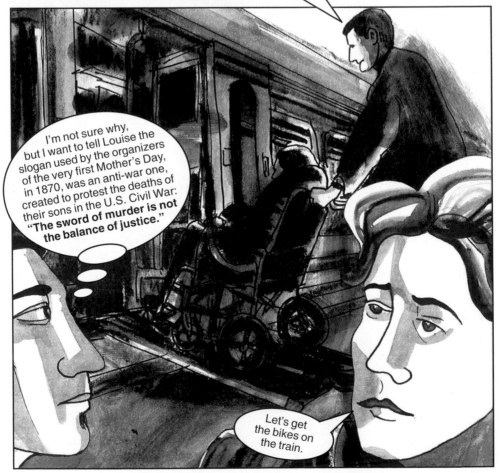

CHAPTER 3

Lippe & Martin Luther

The café...

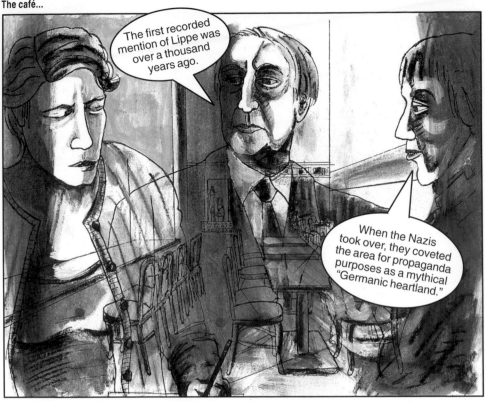

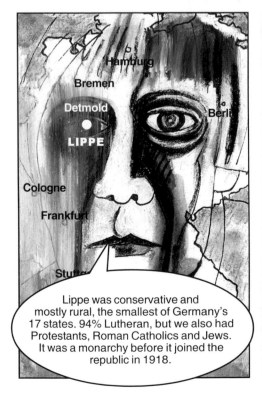

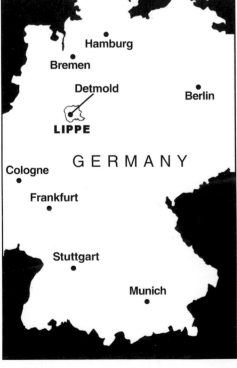

Lippe...

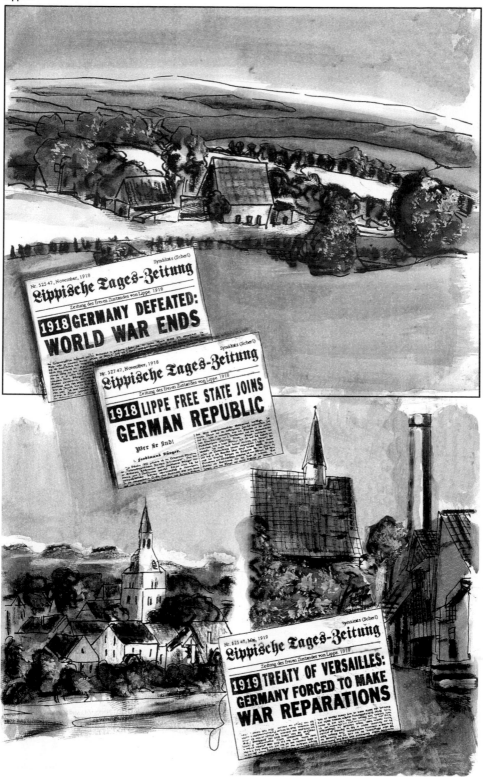

Lippische Tages-Zeitung
Nr. 525 47, November, 1918
Zeitung des freien Zustandes von Lippe 1918

1918 GERMANY DEFEATED:
WORLD WAR ENDS

Lippische Tages-Zeitung
Nr. 527 47, November, 1918
Zeitung des freien Zustandes von Lippe 1918

1918 LIPPE FREE STATE JOINS
GERMAN REPUBLIC

Lippische Tages-Zeitung
Nr. 525 47, Mai, 1919
Zeitung des freien Zustandes von Lippe 1919

1919 TREATY OF VERSAILLES:
GERMANY FORCED TO MAKE
WAR REPARATIONS

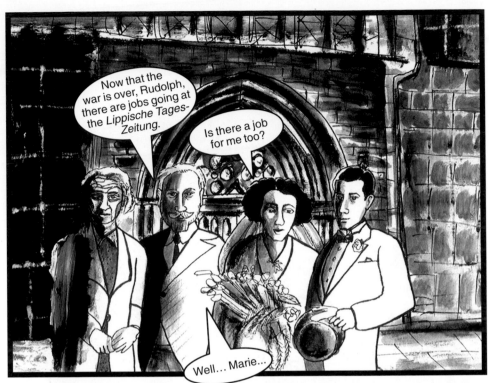

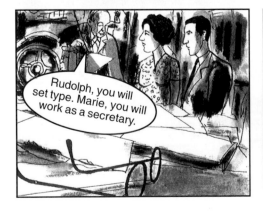

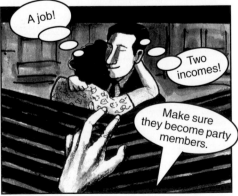

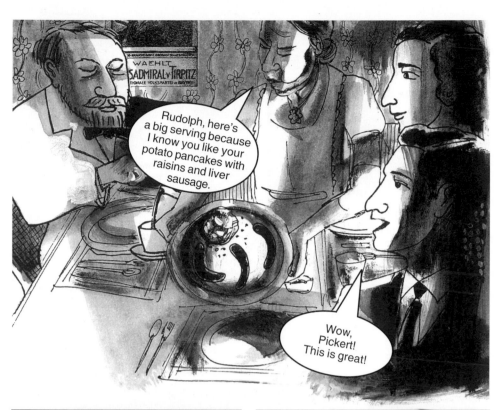

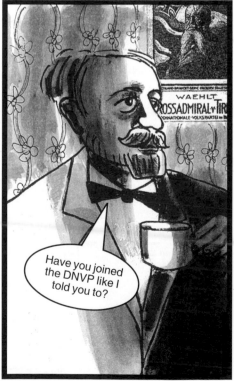

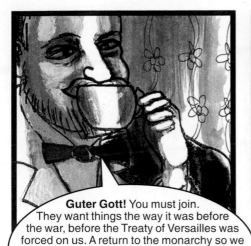

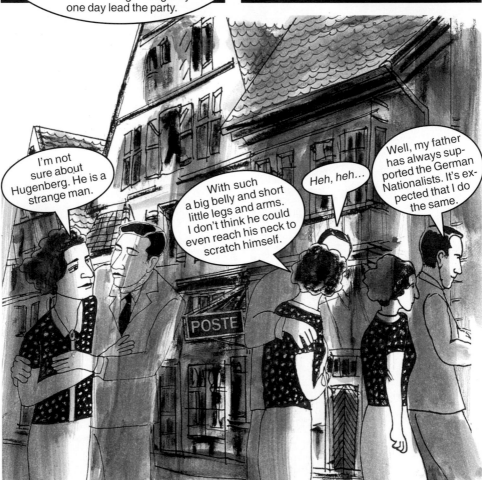

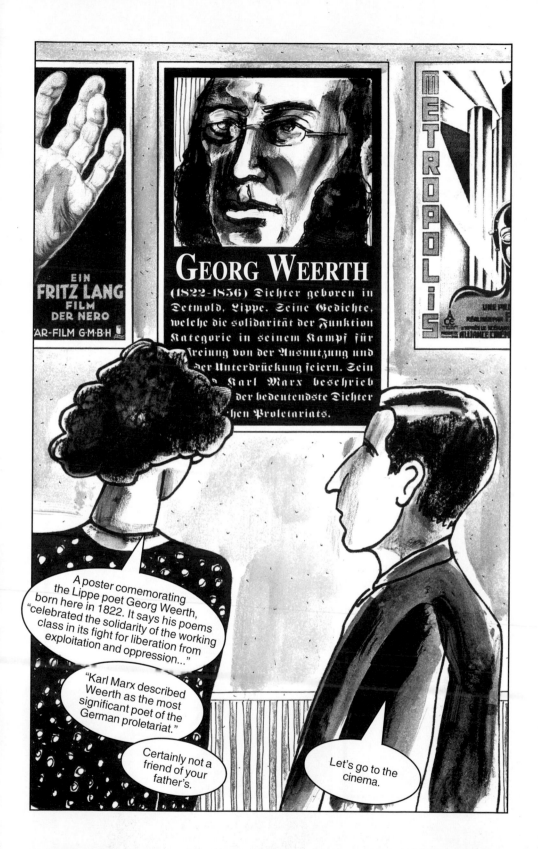

89

Nr. 527 47, November, 1928 Syndikats (Scherl)

Lippische Tages-Zeitung

Zeitung des freien Zustandes von Lippe. 1928

LIPPE'S HUGENBERG ELECTED TO PARLIAMENT

HUGENBERG TO BECOME NEW LEADER OF DNVP

ALFRED HUGENBERG, industrialist, press baron and newly elected member of parliament for Lippe, will also become the next leader of the conservative German National People's Party (DNVP). Hugenberg is an outspoken nationalist who opposes the republic because it was forced upon Germany by the Treaty of Versailles after losing the war. He is equally opposed to the Nazi Party as well as the Communist Party. Hugenberg is considered to be "one of the most powerful men" in the land. He also owns the film studio UFA, which is rumoured to be planning a film called *The Blue Angel*, starring newcomer Marlene Dietrich.

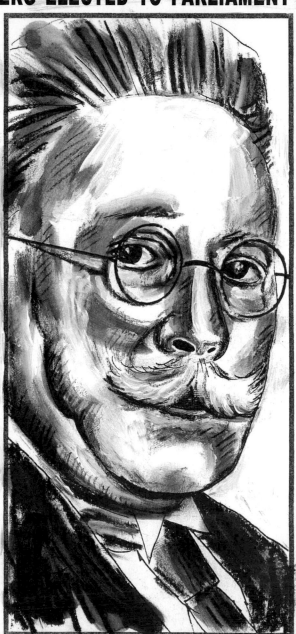

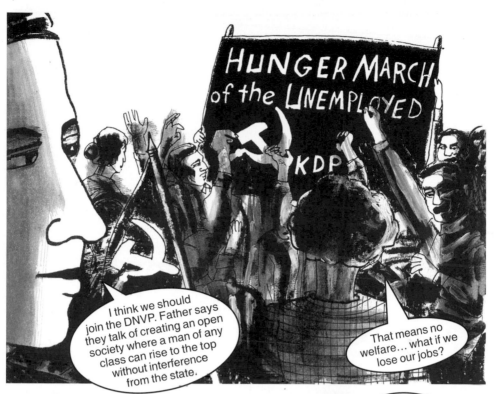

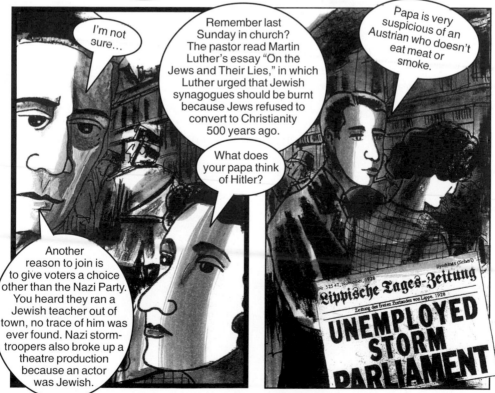

CHAPTER 4

Love, Art, Goya & Orson Welles

It is wrong to expect a reward for your struggles.
The reward is the act of struggle itself, not what you win.
Even though you can't expect to defeat the absurdity of the world,
you must make that attempt. That's morality, that's religion.
That's art. That's life.

—PHIL OCHS (1940-1976) MUSICIAN

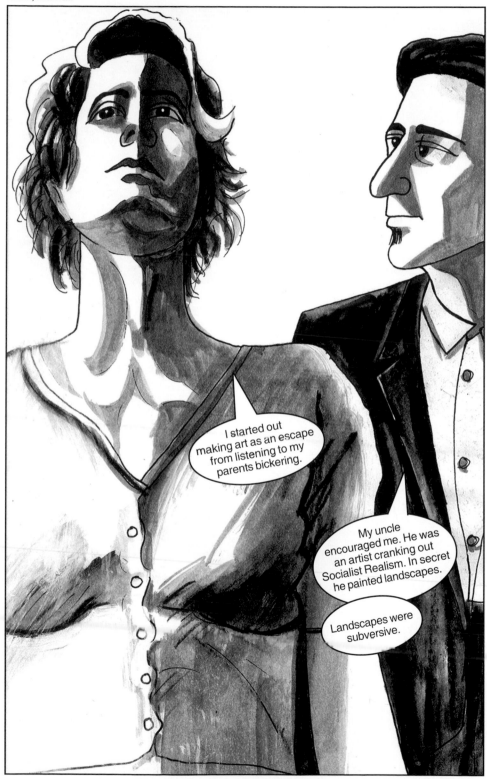

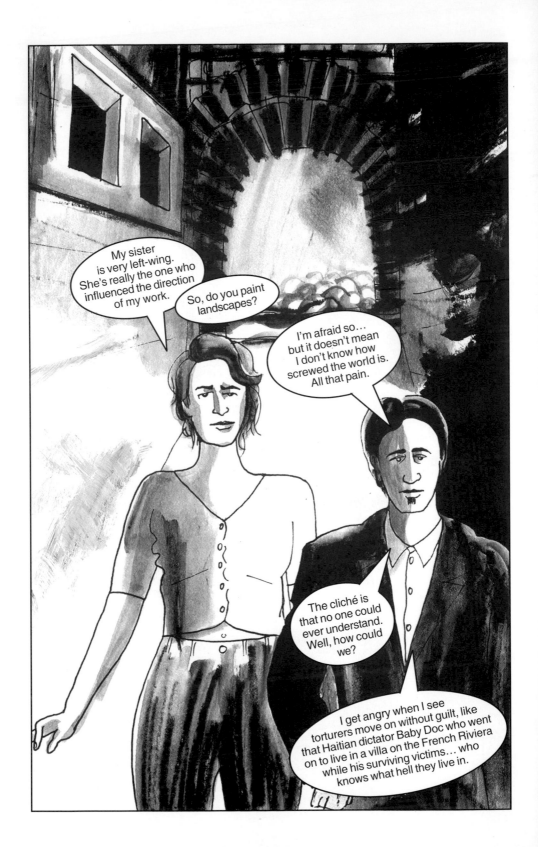

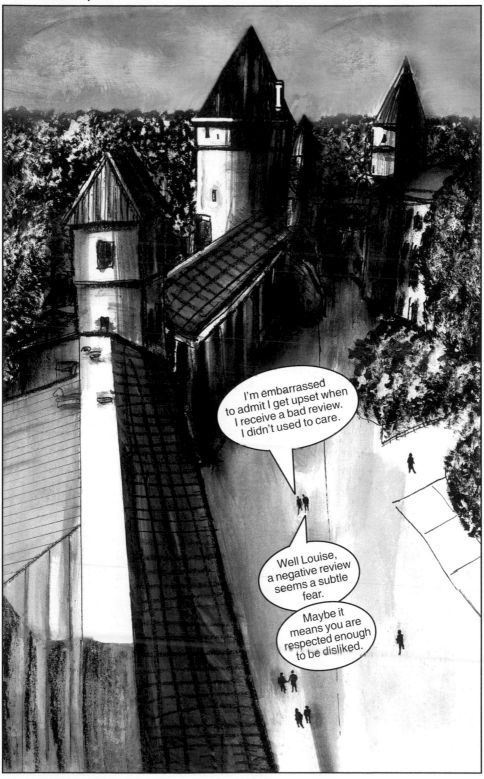

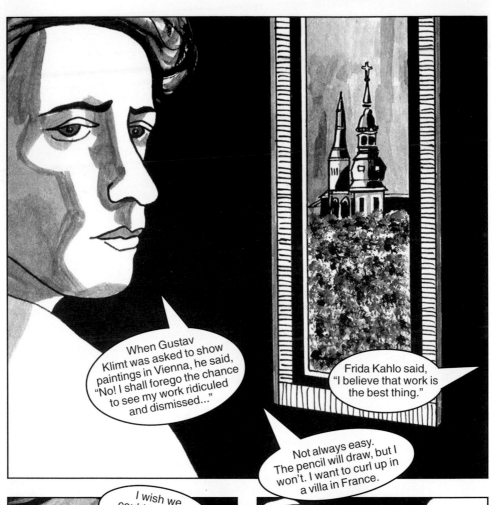

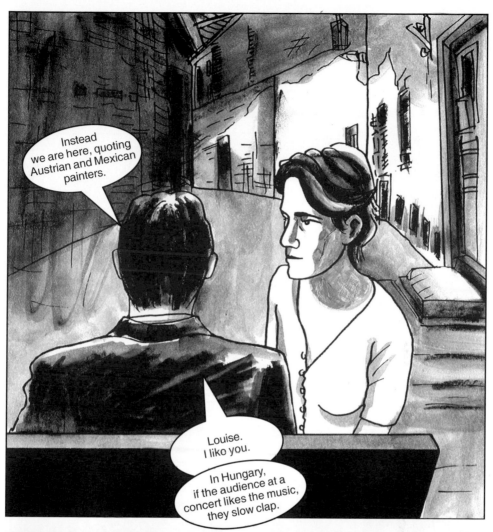

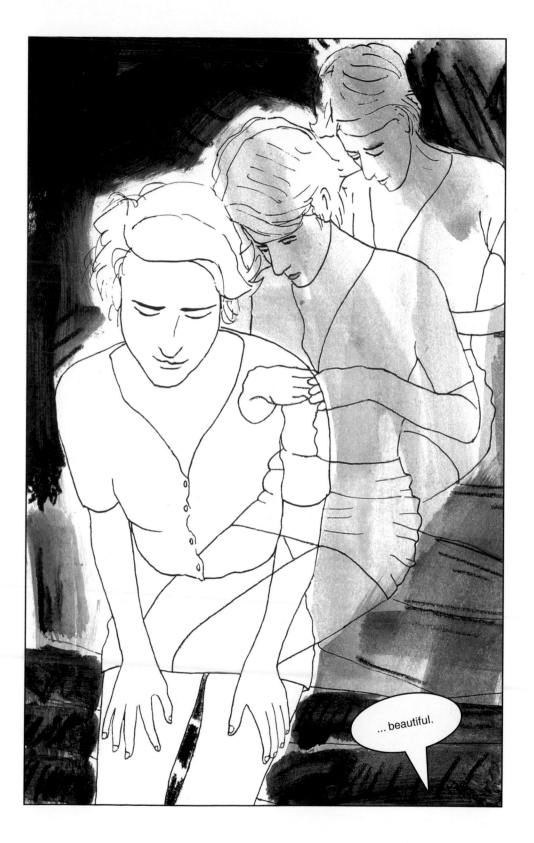

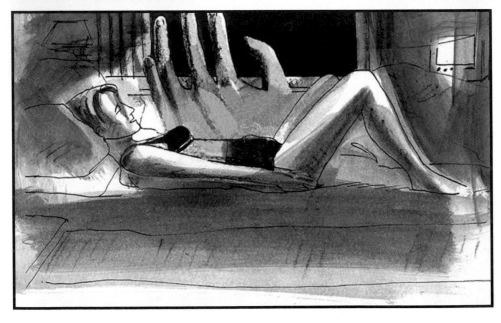

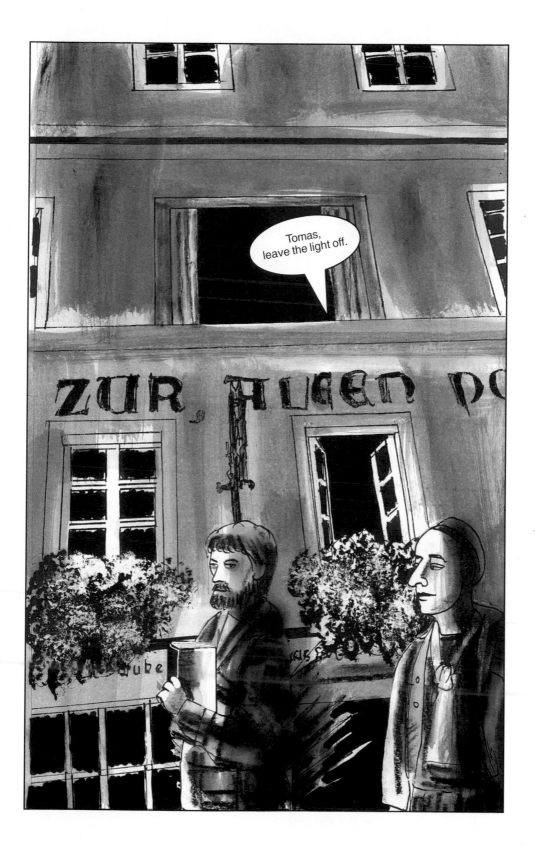

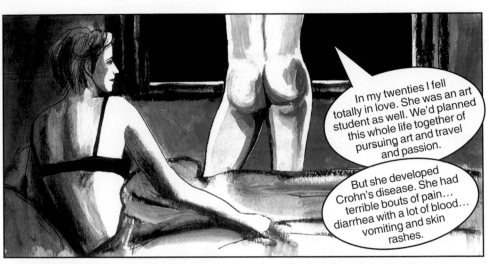

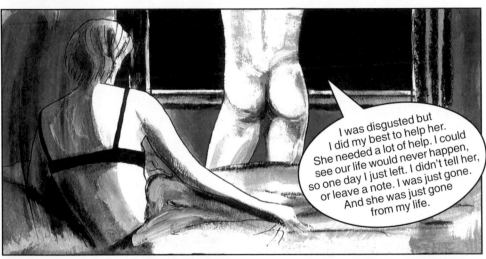

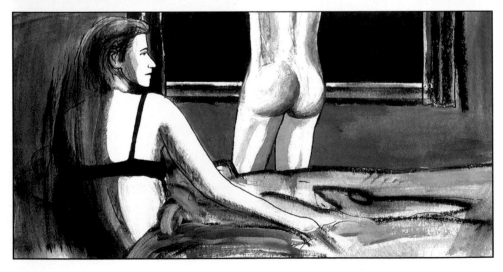

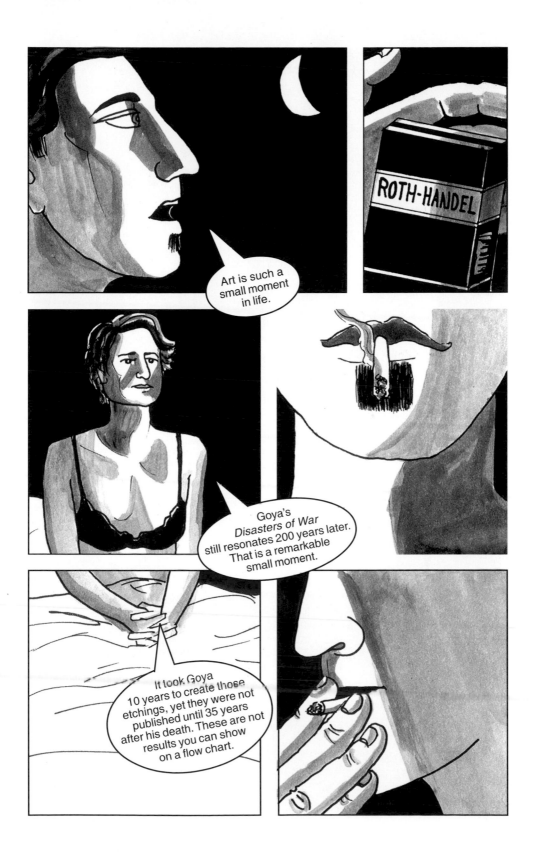

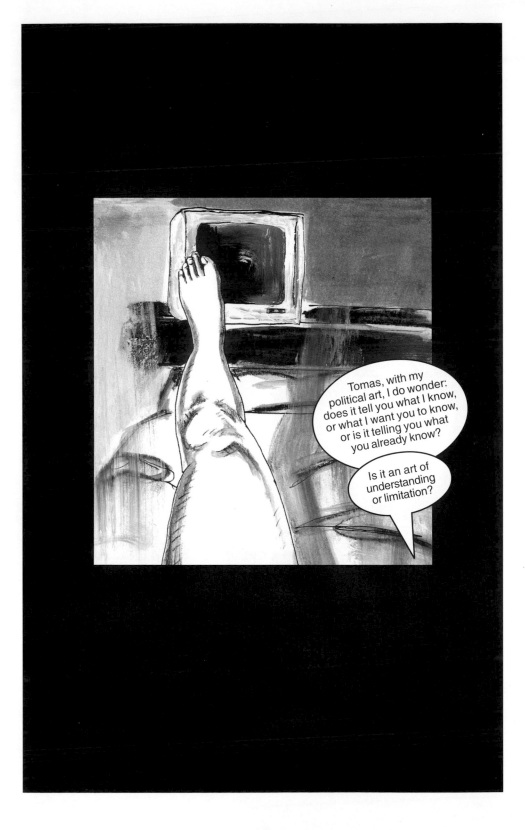

I don't know.

Thanks Señor Profundity.

Maybe your art *just is.*

Orson Welles once said something like, every artist has an obligation to criticize civilization and this should be the task of an artist of any ambition.

In 1946, years after making *Citizen Kane*, Welles was asked by the Democratic Party to run for the senate in his birth state of Wisconsin. He declined.

So?

Joseph McCarthy ended up winning it for the Republicans. Just imagine how the 1950s might have been different. No witch hunts. No climate of fear. No blacklisting and jailing of artists.

If Welles had only run, he might have prevented all of that. Welles later said his decision was "a terrible thing to have on one's conscience."

How does a Czechoslovakian know so much about Wisconsin?

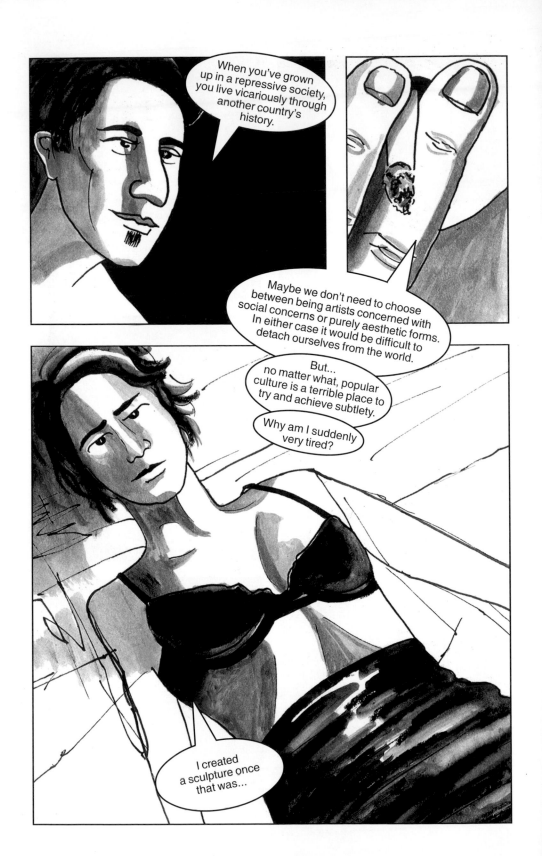

CHAPTER 5

Who Has the
Best Uniforms?

The café...

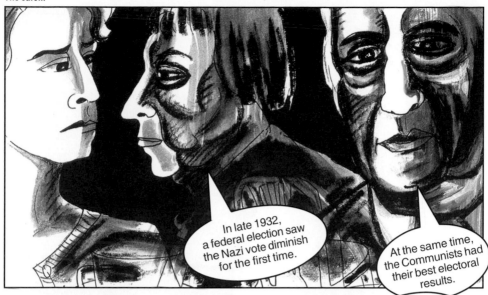

In late 1932, a federal election saw the Nazi vote diminish for the first time.

At the same time, the Communists had their best electoral results.

I chaired the first meeting of the DNVP after that 1932 election...

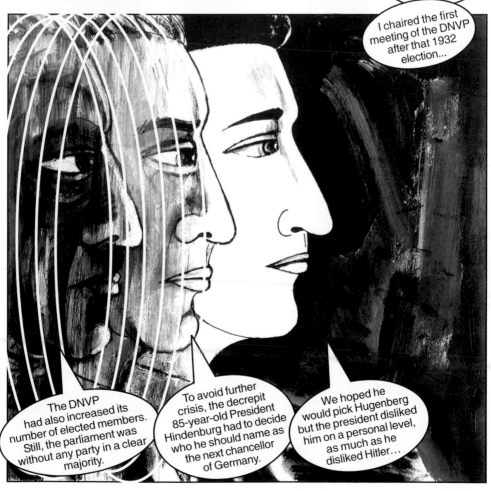

The DNVP had also increased its number of elected members. Still, the parliament was without any party in a clear majority.

To avoid further crisis, the decrepit 85-year-old President Hindenburg had to decide who he should name as the next chancellor of Germany.

We hoped he would pick Hugenberg but the president disliked him on a personal level, as much as he disliked Hitler…

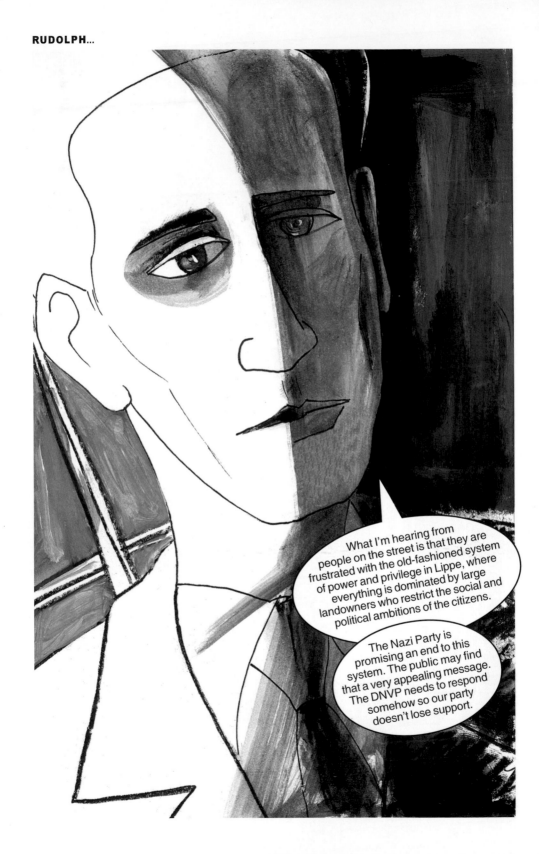

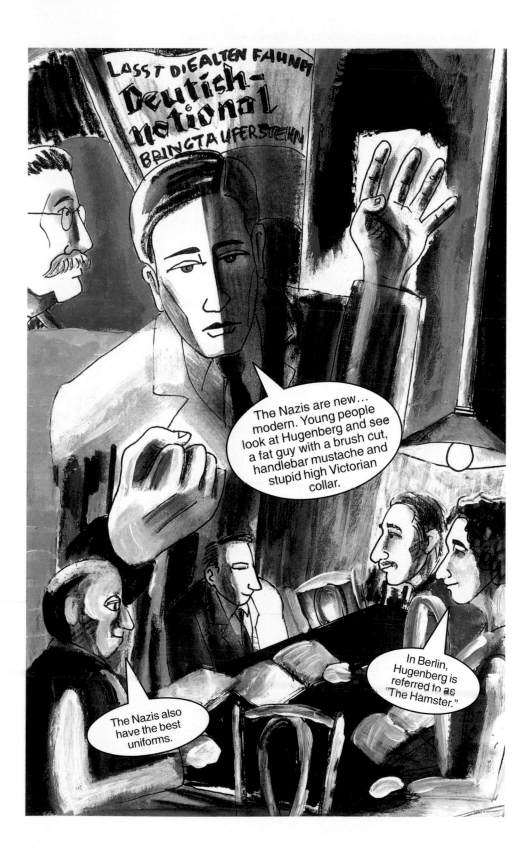

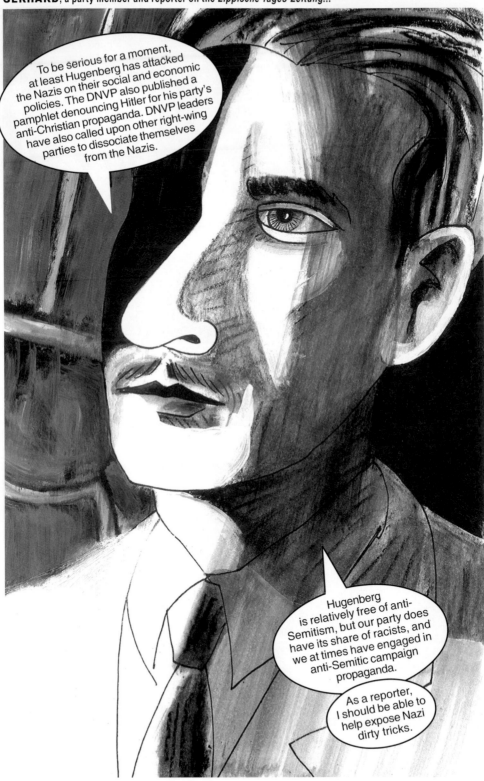

Nr. 727 37, September, 1930 Syndikats (Scherl)

Lippische Tages-Zeitung

Zeitung des freien Zustandes von Lippe. 1930

SEPT. 1930 ELECTION RESULTS:

NAZIS GAIN 95 SEATS

Nr. 835 27, June, 1932 Syndikats (Scherl)

Lippische Tages-Zeitung

Zeitung des freien Zustandes von Lippe. 1932

JUNE. 1932 PARLIAMENT DISSOLVED:

ELECTION CALLED

Nr. 842 52, November, 1932 Syndikats (Scherl)

Lippische Tages-Zeitung

Zeitung des freien Zustandes von Lippe. 1932

JULY. 1932 ELECTION RESULTS:

NAZIS INCREASE SEATS

NAZI PARTY becomes the largest in parliament, but they do not win a majority. The Communist Party has also made major gains.

Nr. 936 77, November, 1932 Syndikats (Scherl)

Lippische Tages-Zeitung

Zeitung des freien Zustandes von Lippe. 1932

SEPT. 1932 PARLIAMENT DISSOLVED:

NEW ELECTION AGAIN!

Nr. 1002 97, November, 1932 Syndikats (Scherl)

Lippische Tages-Zeitung

Zeitung des freien Zustandes von Lippe. 1932

NOV. 1932 ELECTION RESULTS:

NAZI VOTE DROPS

TODAY'S ELECTION saw the Nazi Party vote drop for the first time in four elections, getting two million less votes than last time. The party seems to have lost its momentum.

Berlin Nazi leader **JOSEF GOEBBELS** writes in his diary...

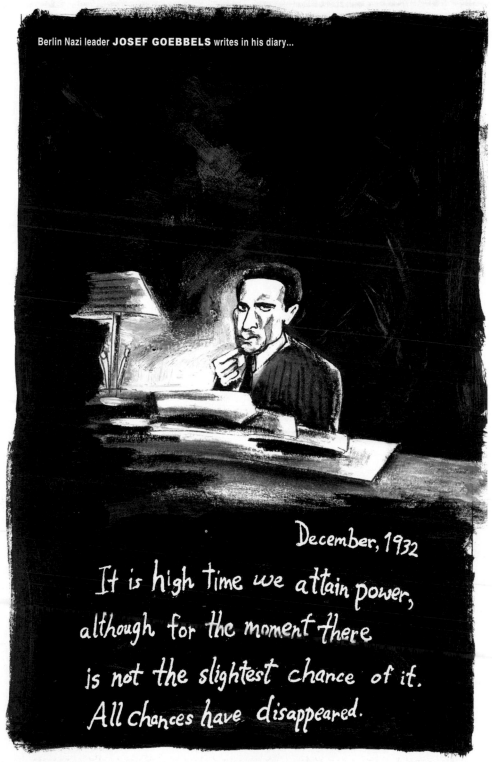

December, 1932

It is high time we attain power,
although for the moment there
is not the slightest chance of it.
All chances have disappeared.

In the federal election of 1932, the Nazi Party vote in the city of Berlin peaked at 28%,
compared to the combined Left's (Social Democrats and Communists) 55% of the vote.

HERMANN GOERING, president of the German parliament (Reichstag), and
JOSEF GOEBBELS meet with **HITLER** at his home "The Berghof" in the Bavarian Alps...

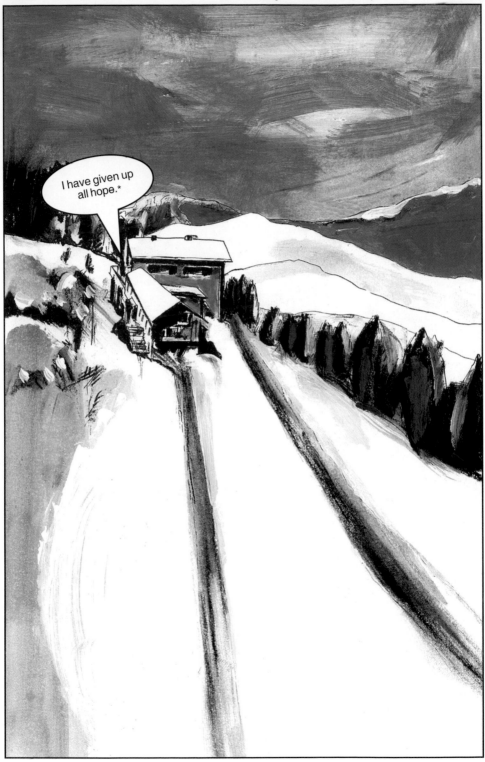

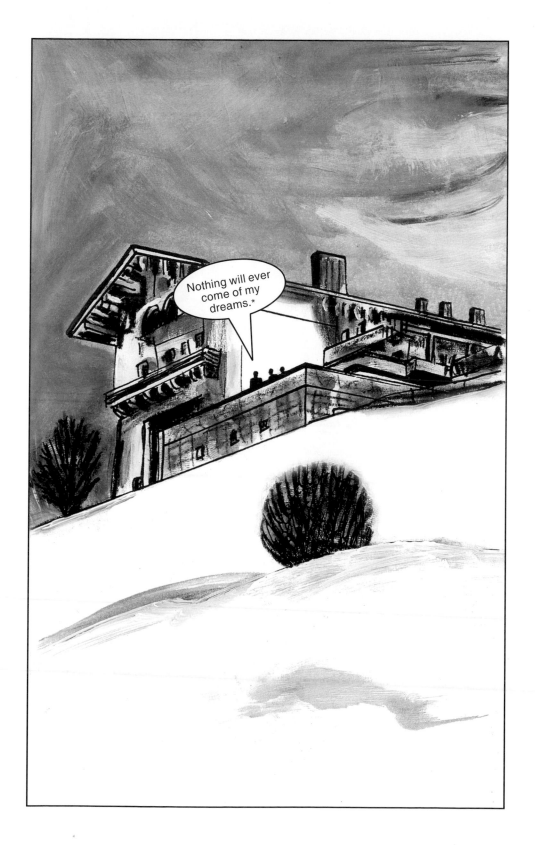

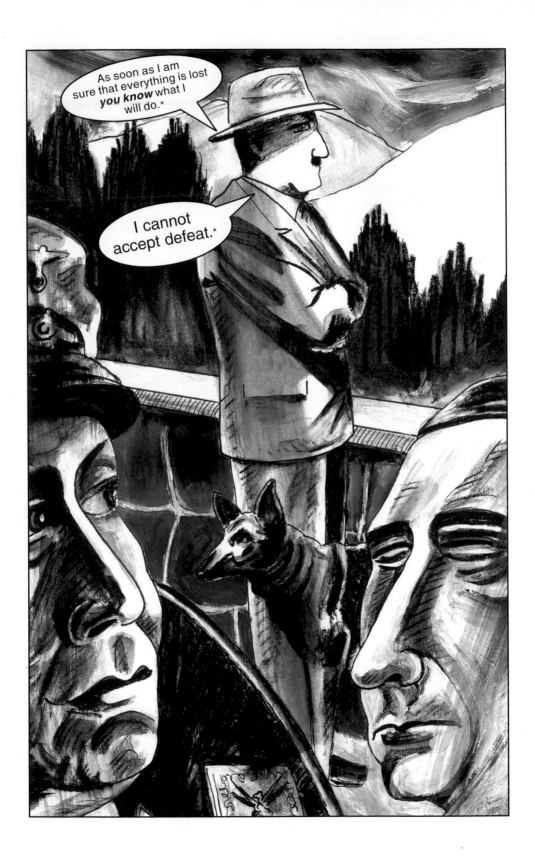

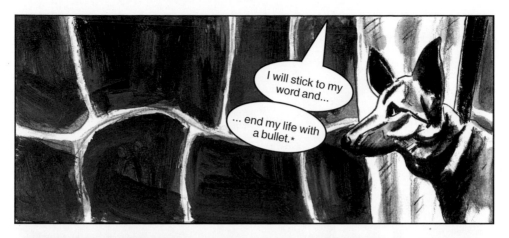

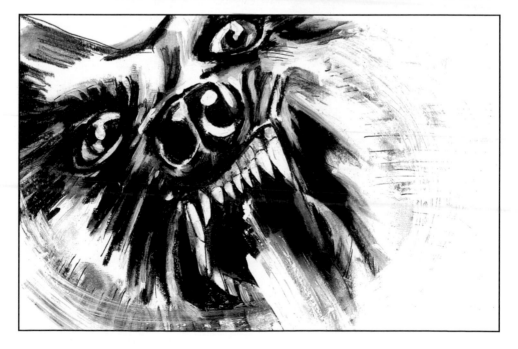

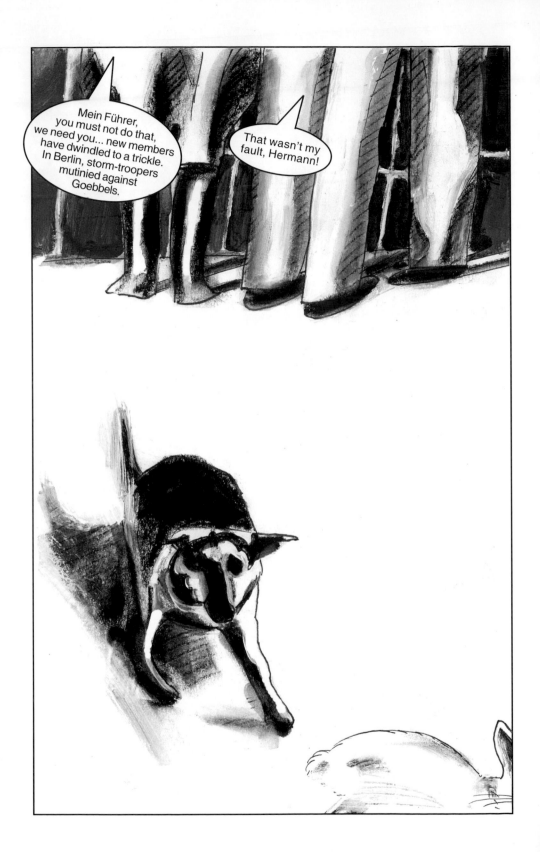

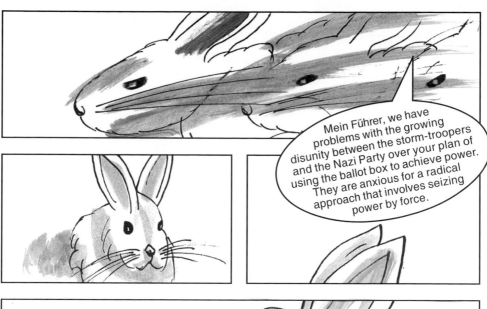

Mein Führer, we have problems with the growing disunity between the storm-troopers and the Nazi Party over your plan of using the ballot box to achieve power. They are anxious for a radical approach that involves seizing power by force.

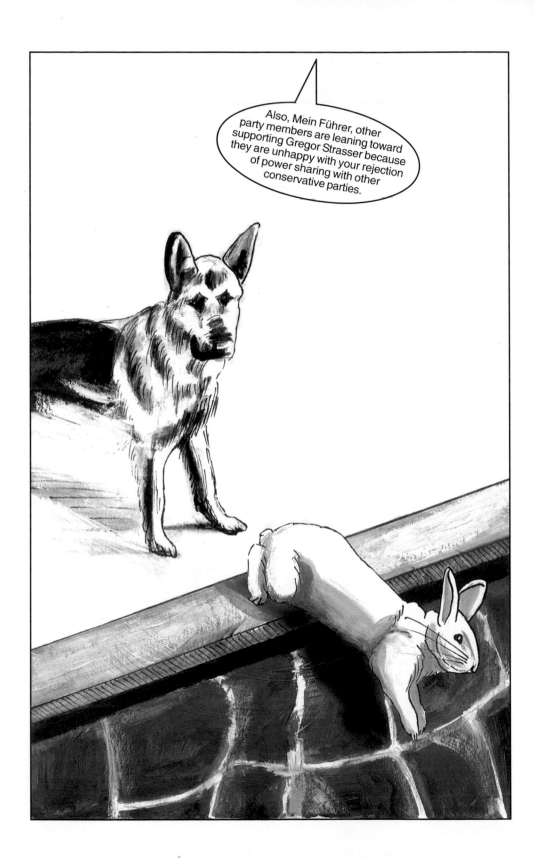

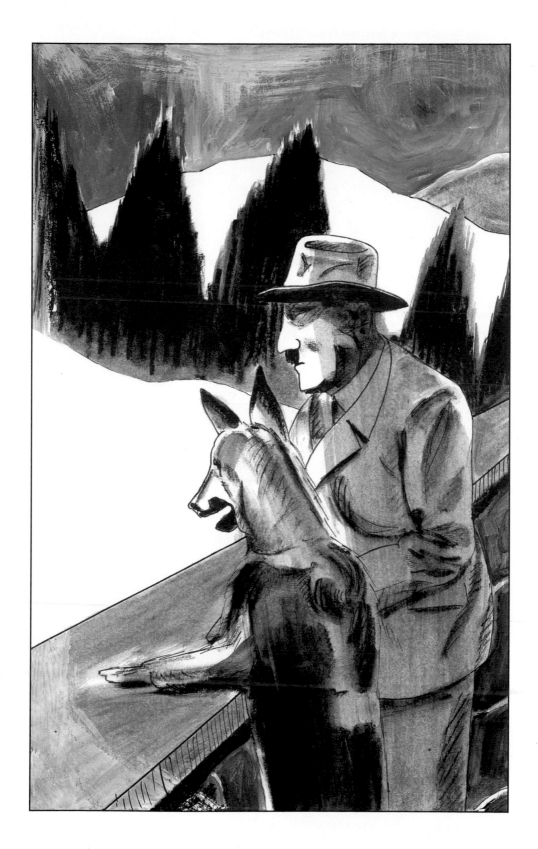

Nr. 560 59, Dec, 1932 Mbend Muegabe

Berliner Tageblatt

und Handels-Zeitung

HITLER REFUSES
TO BE JUNIOR PARTNER
IN GOVERNMENT

NAZI PARTY LEADER **ADOLF HITLER** RULED out any possibility of becoming part of the government as a junior minister.

Arguably the other three grow out of these two. Legitimate power, the power of the policeman or is very

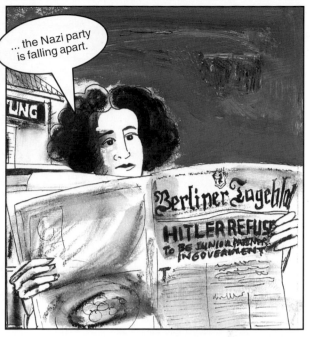

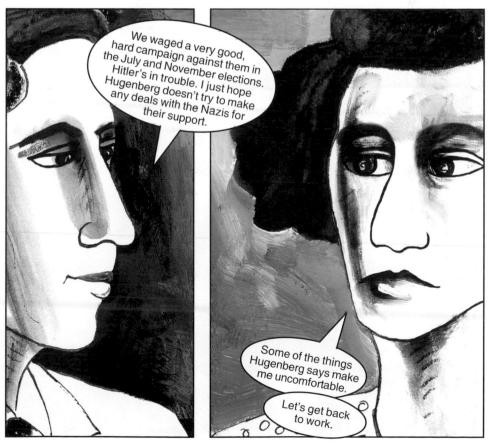

PRESIDENT HINDENBURG at his palace in Berlin meets with ex-Chancellor **FRANZ VON PAPEN**...

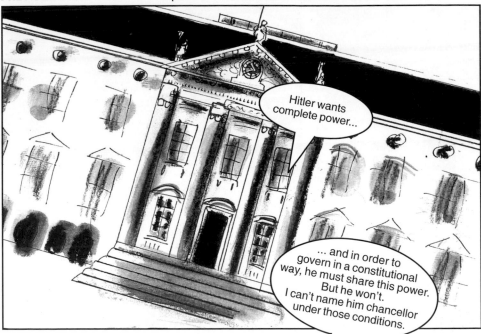

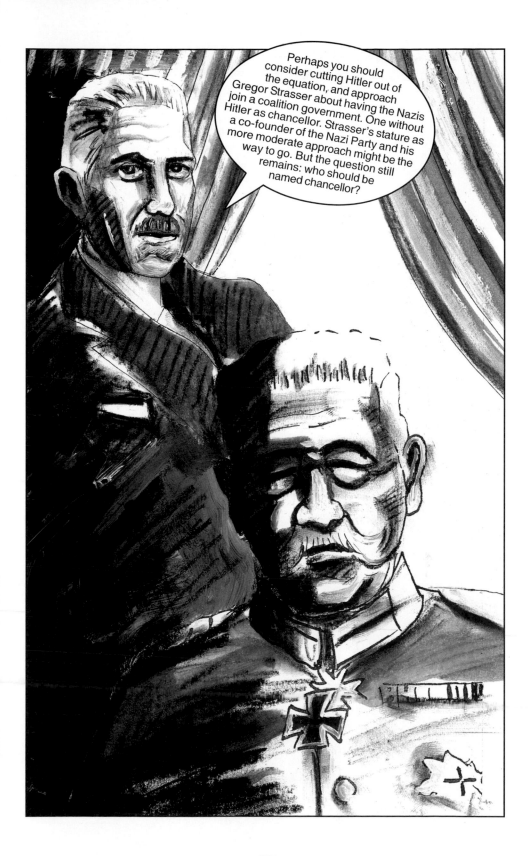

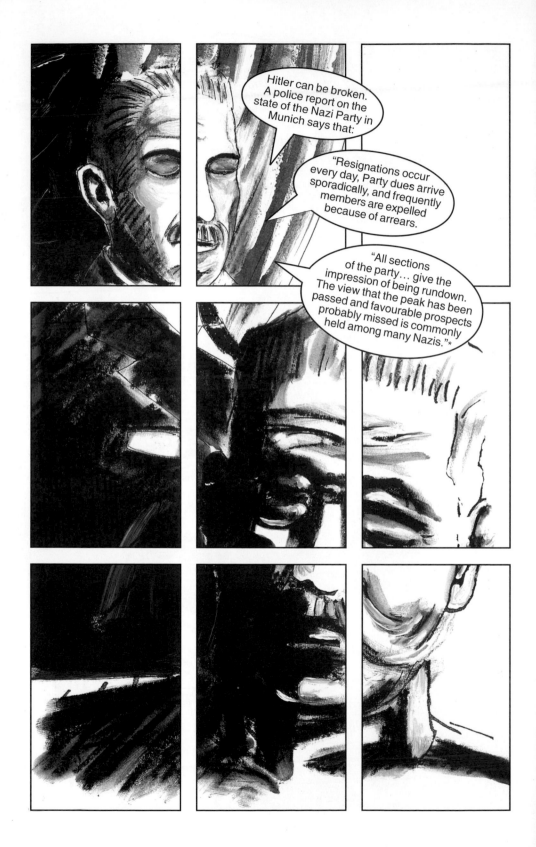

HITLER's Munich apartment with late-night visitors **GOEBBELS** and **GOERING**...

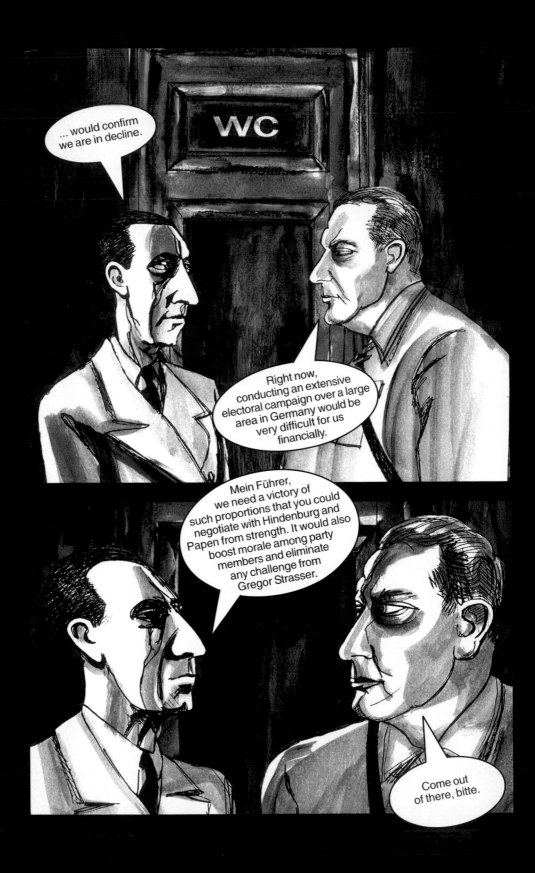

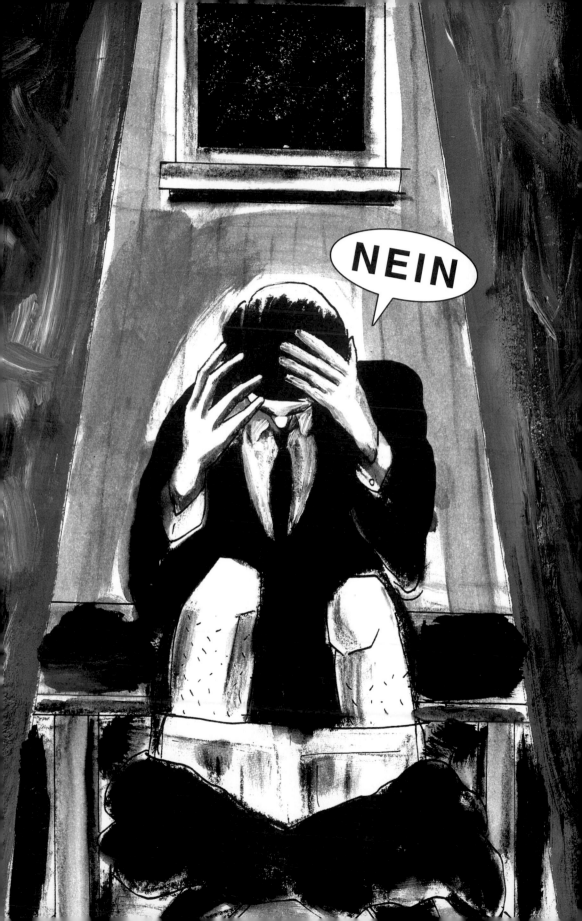

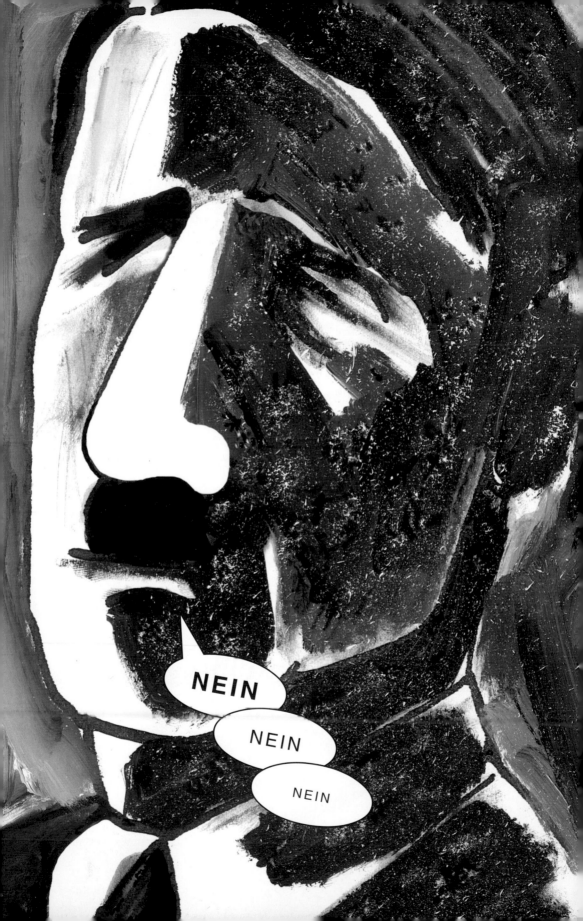

It is almost dawn. Go downstairs and see if the newspaper has arrived.

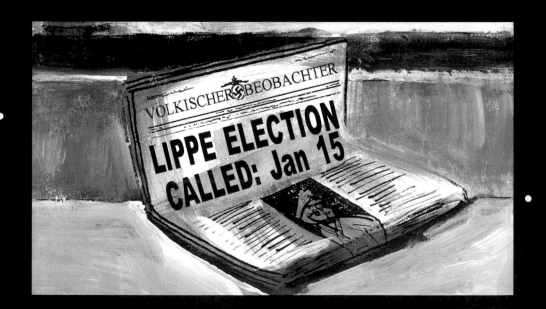

The Berkeley Barb, 100,000 Books & John Heartfield

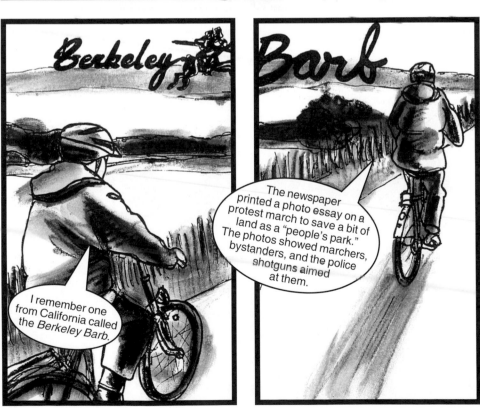

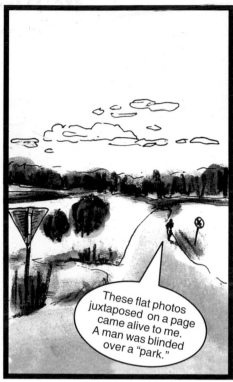

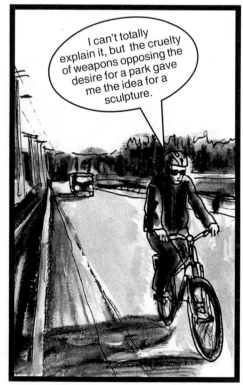

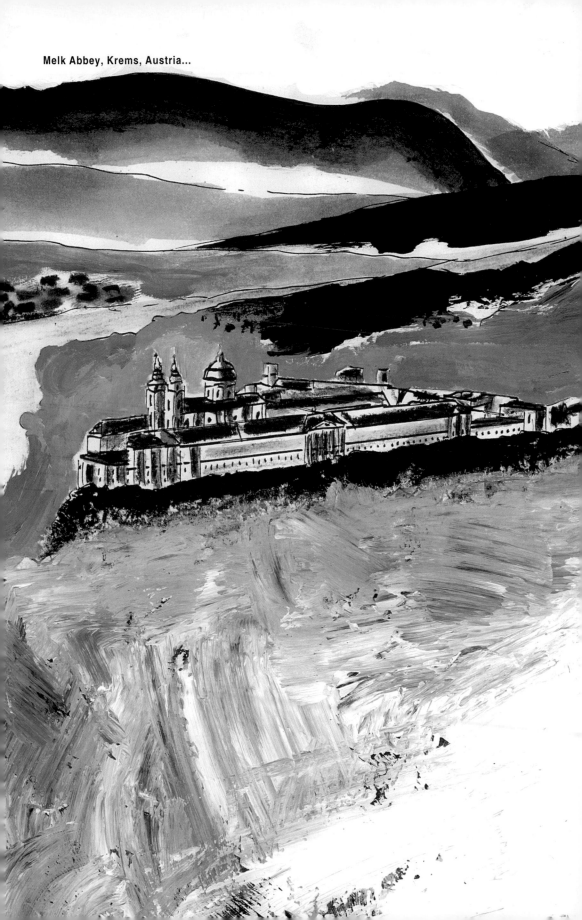

Melk Abbey, Krems, Austria...

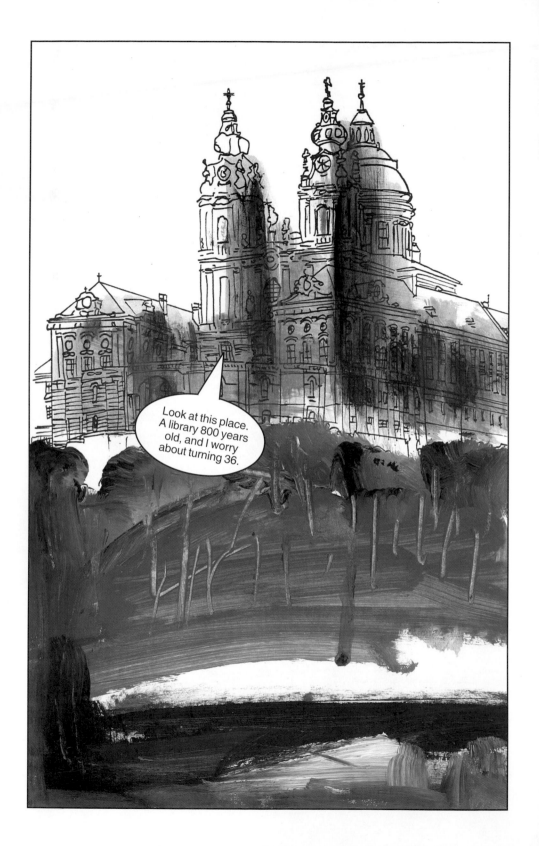

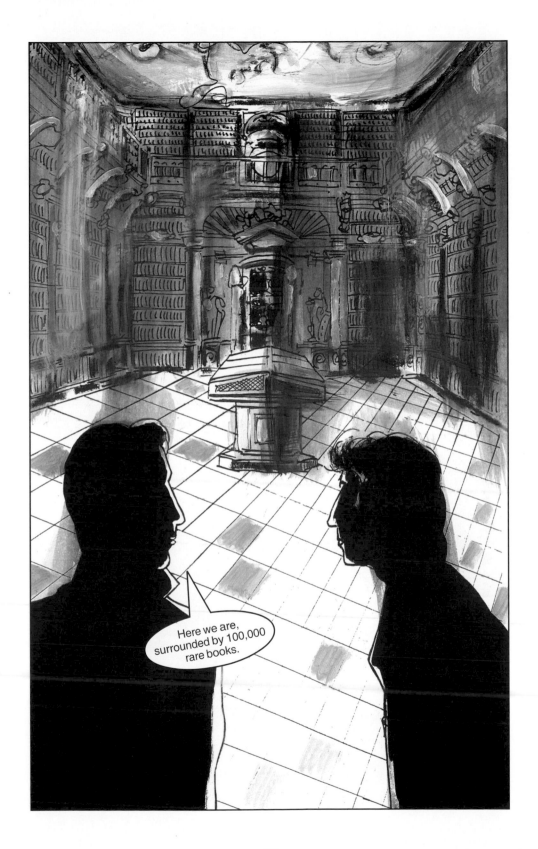

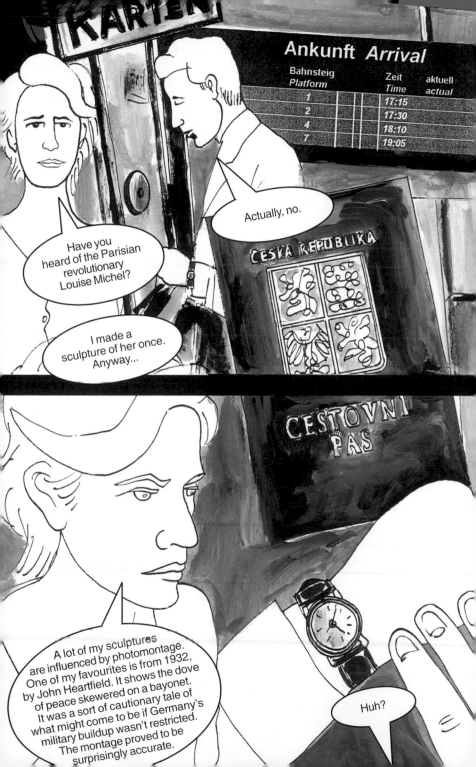

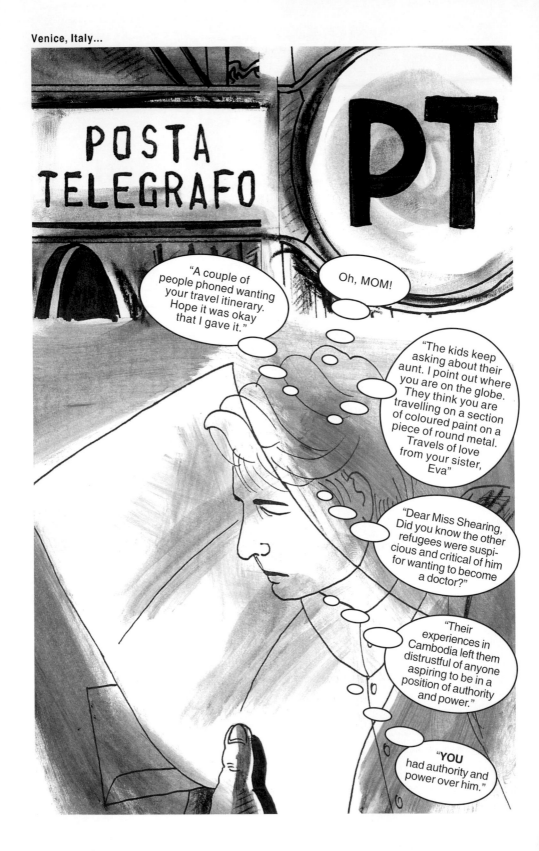

Prado Museum (Madrid, Spain)... **Uffizi** (Florence, Italy)...

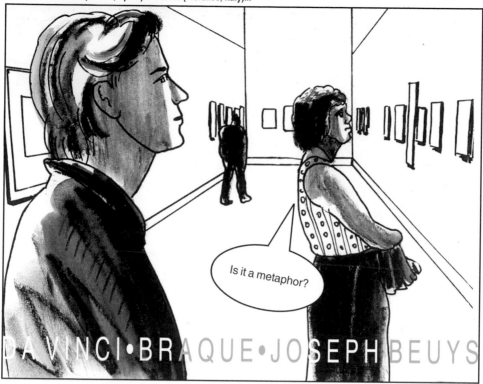

Peggy Guggenheim Collection (Venice, Italy)...

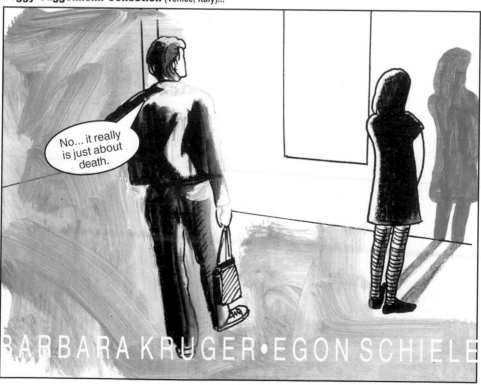

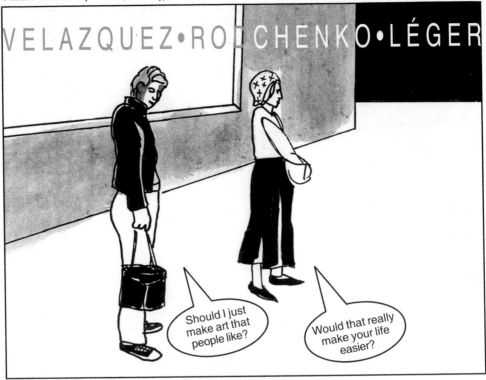

Sistine Chapel (Rome, Italy)... **Albertina** (Vienna, Austria)...

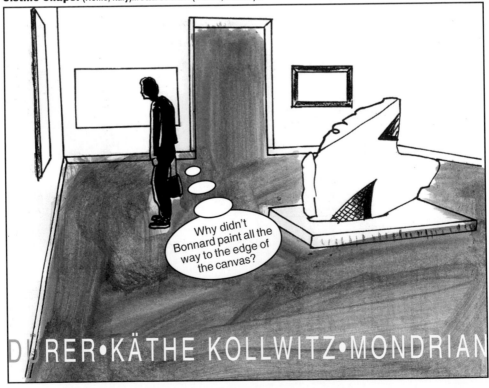

Käthe-Kollwitz-Museum (Berlin, Germany)... **Kunstverein** (Hamburg, Germany)...

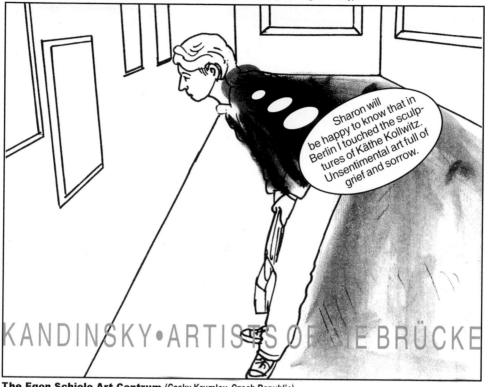

The Egon Schiele Art Centrum (Cesky Krumlov, Czech Republic)...

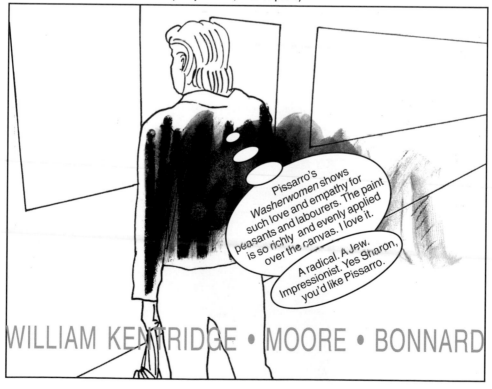

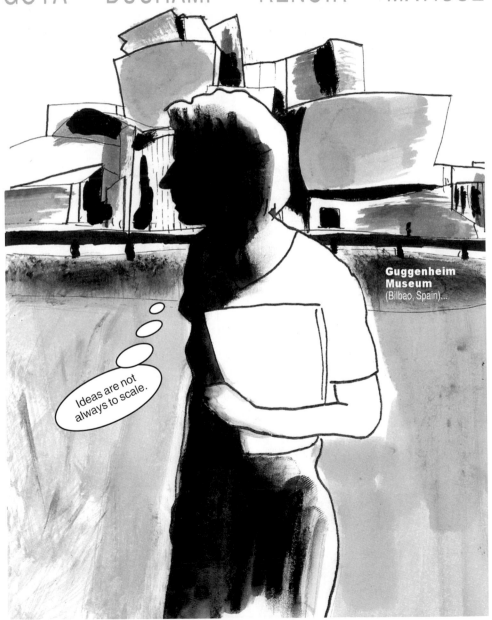

STENBERG BROTHERS • KLEE • JUDY CHICAGO ARTEMESIA GENTILESCHI • FRANS MASEREEL GEORGE GROSZ • MONET • GUERRILLA GIRLS GERHARD RICHTER • BOTTICELLI • CÉZANNE GOYA • DUCHAMP • RENOIR • MATISSE

CHAPTER 7

And So it Begins...

*For the Party to lose Lippe Detmold
would be to lose Germany.*

—HANS-OTTO MEISSNER, 1980
SON OF GERMAN REICH MINISTER OTTO MEISSNER

*I threw myself, heart and soul,
personally into the Lippe electoral campaign.*

—ADOLF HITLER, 1942
HITLER'S TABLE TALK (PHOENIX PRESS, 2000)

The café...

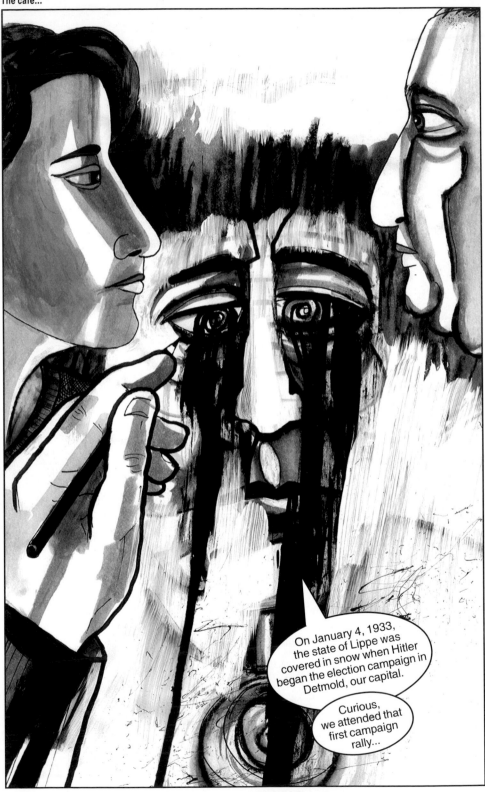

154

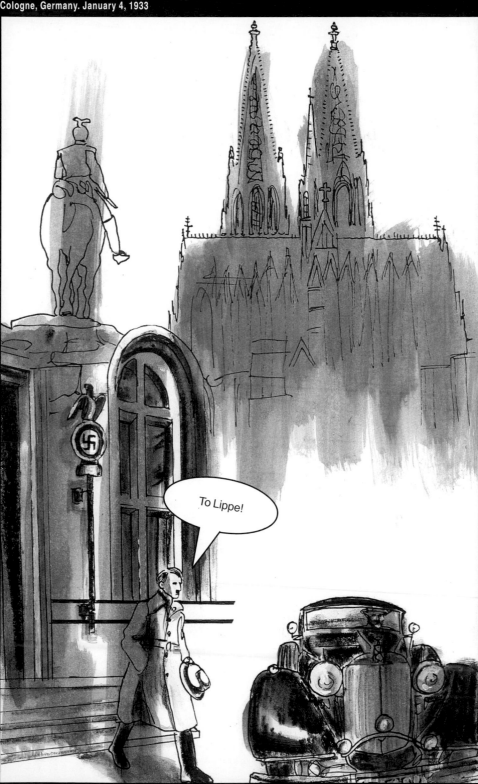

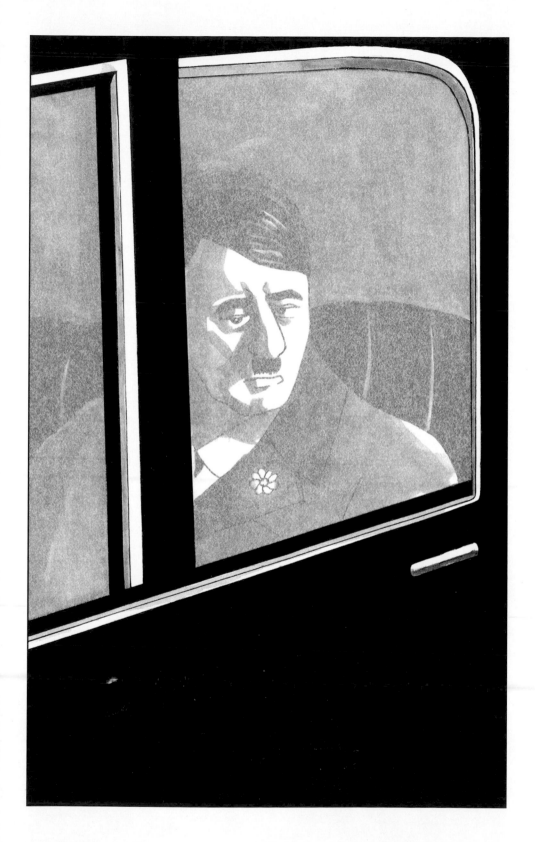

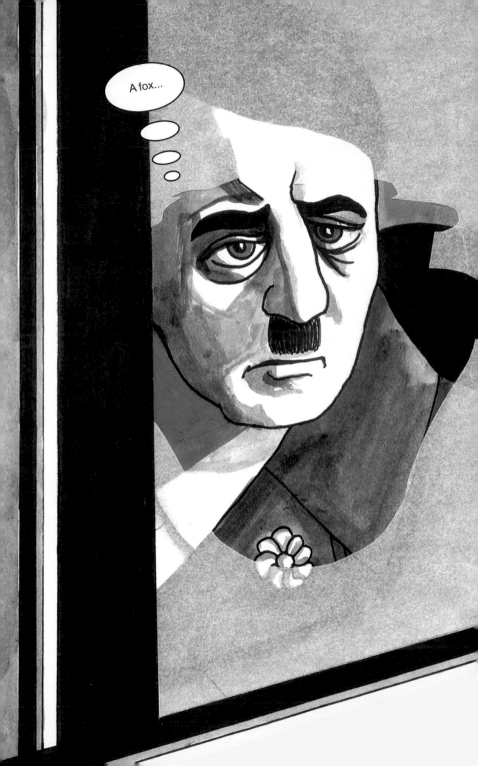

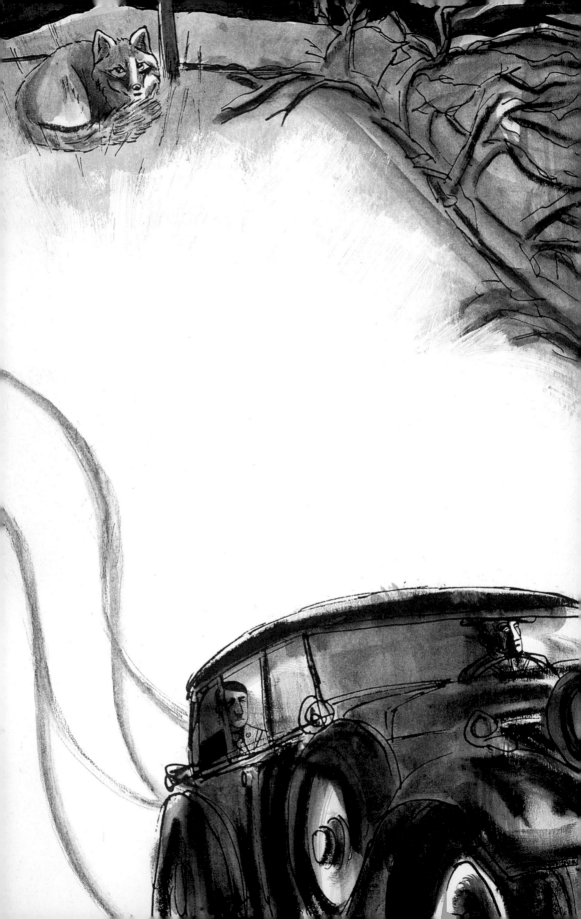

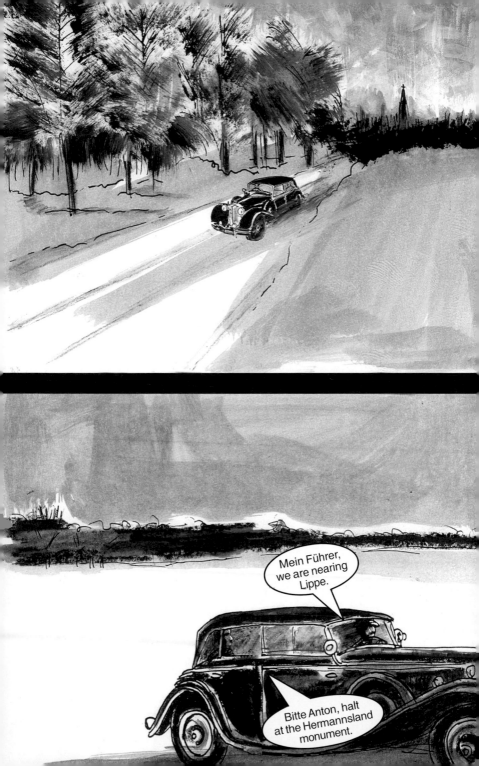

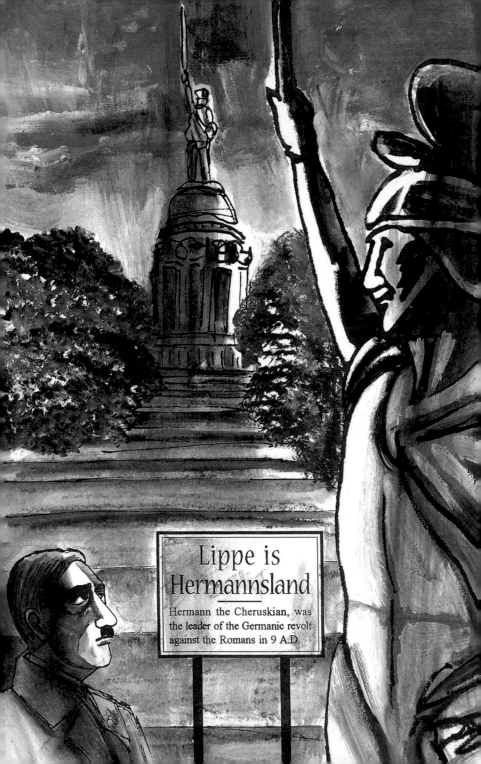

Lippe is
Hermannsland

Hermann the Cheruskian, was
the leader of the Germanic revolt
against the Romans in 9 A.D.

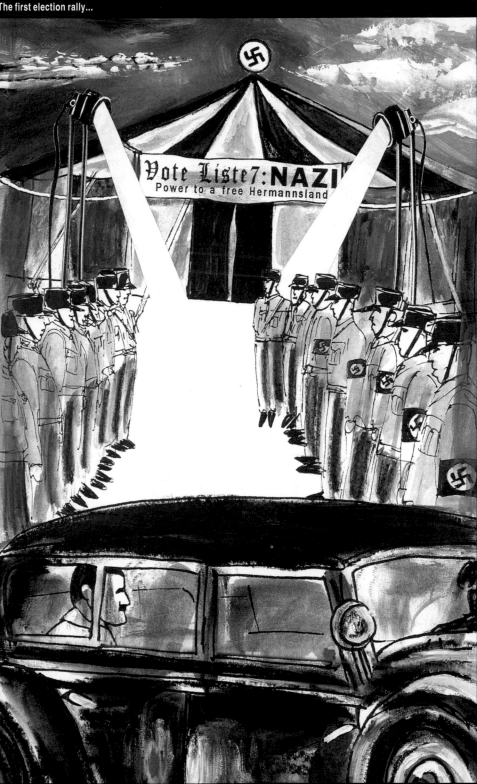

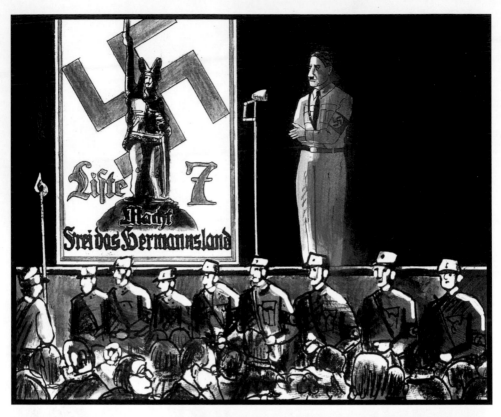

Number 7 in the above poster refers to the order in which the Nazi Party appeared on the ballot in Lippe.

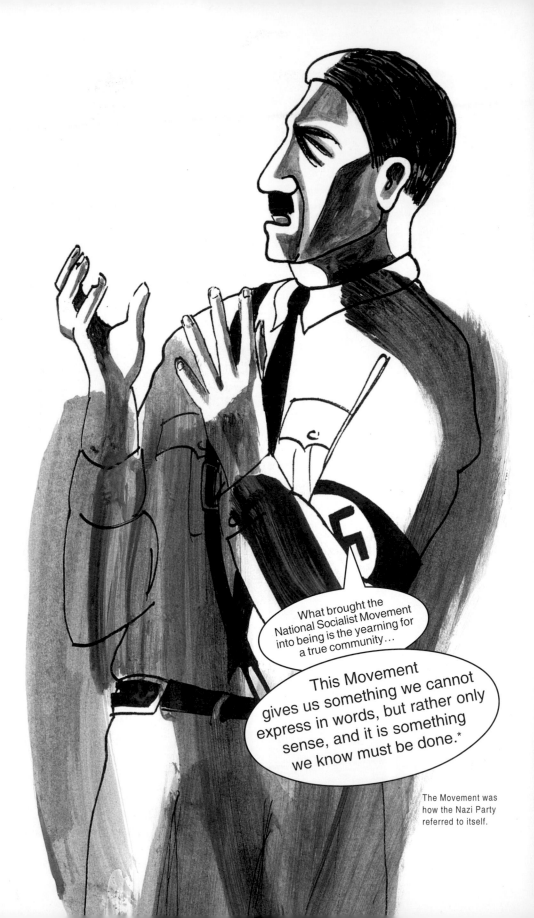

What brought the National Socialist Movement into being is the yearning for a true community...

This Movement gives us something we cannot express in words, but rather only sense, and it is something we know must be done.*

The Movement was how the Nazi Party referred to itself.

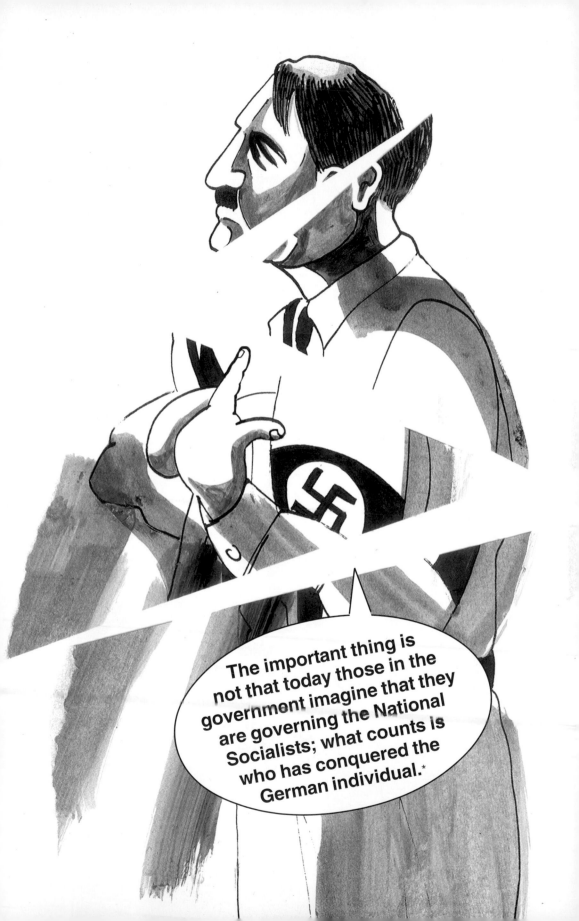

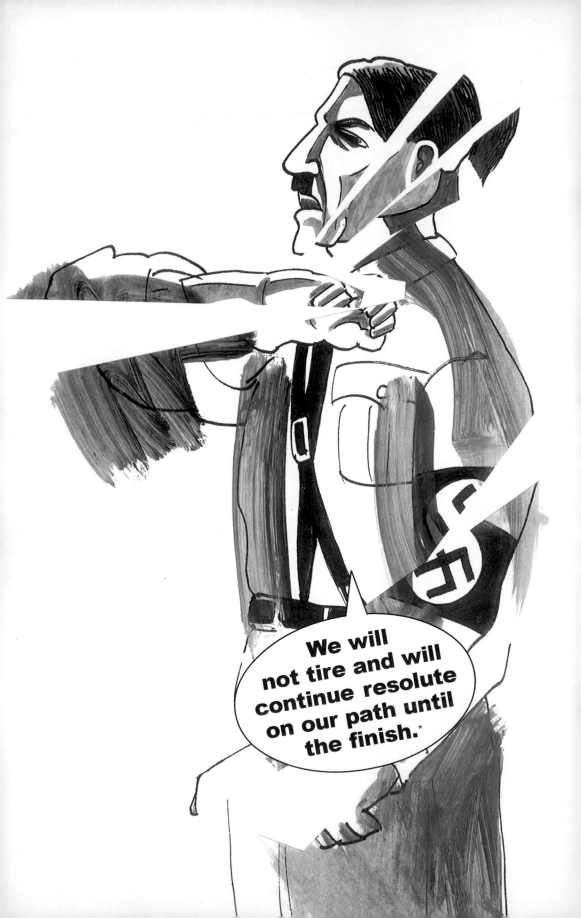

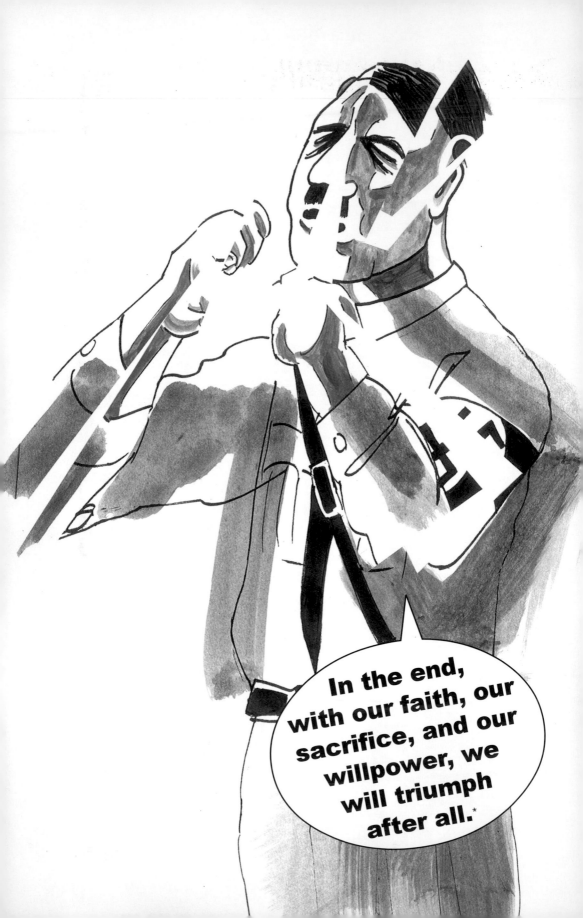

And thus this election will also take us one step further on the road...*

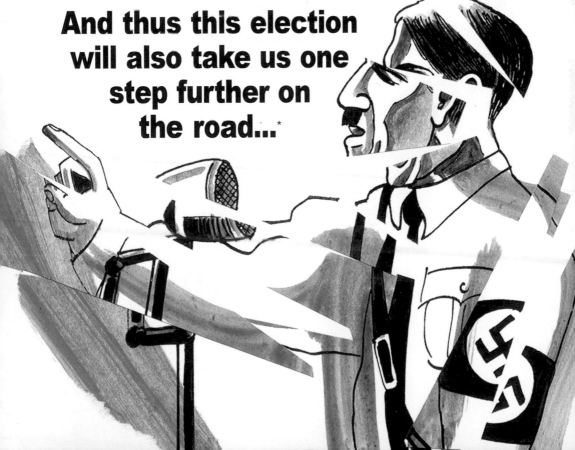

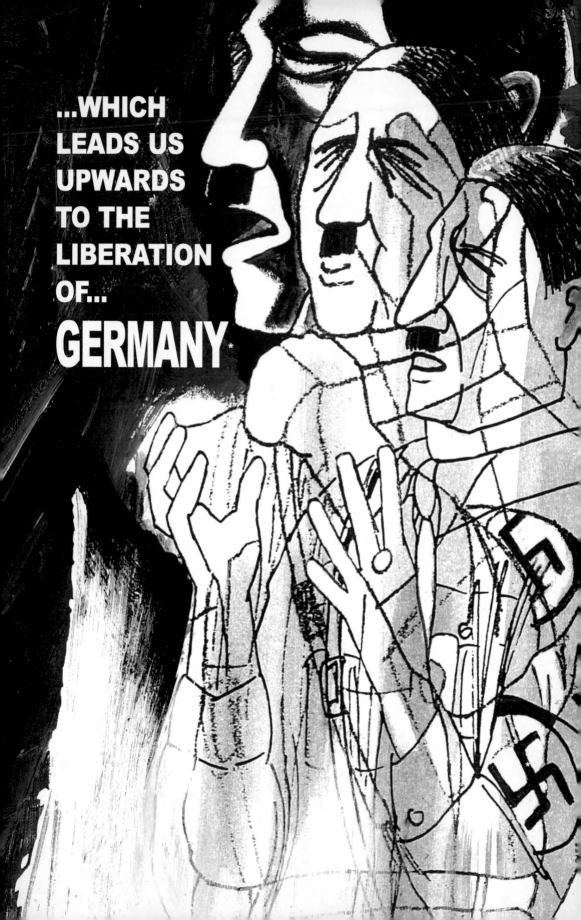

...WHICH LEADS US UPWARDS TO THE LIBERATION OF... GERMANY*

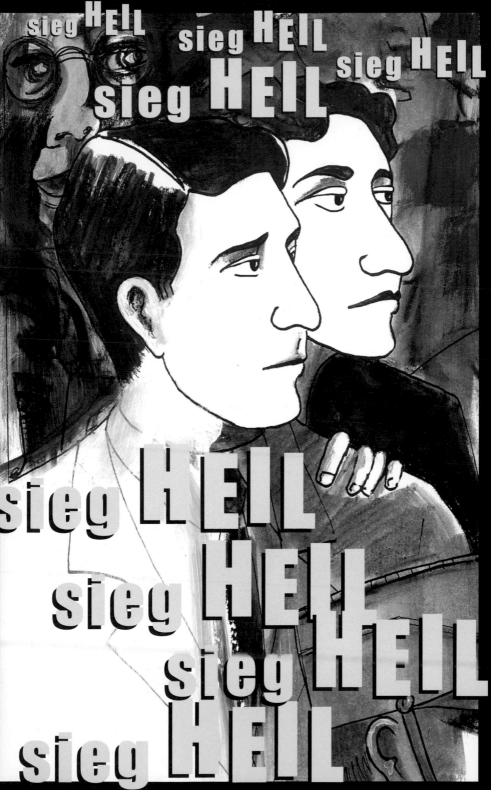

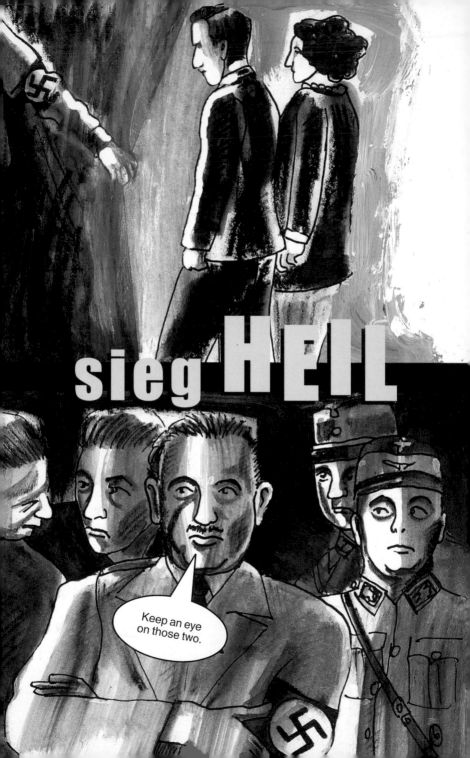

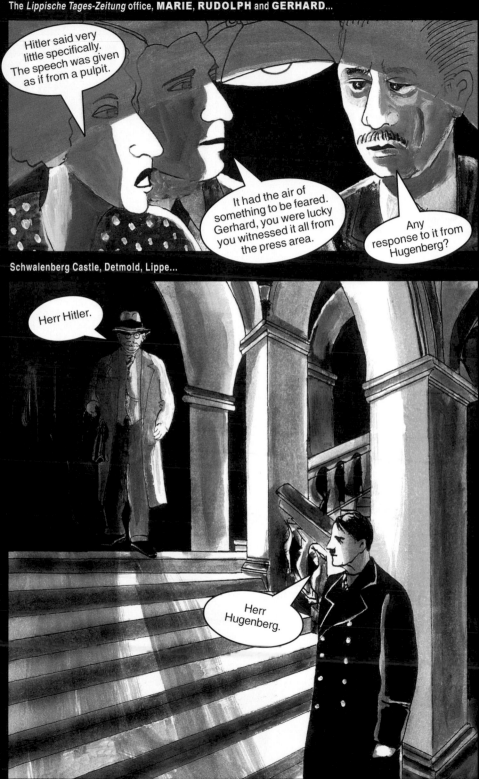

Hitler said very little specifically. The speech was given as if from a pulpit.

It had the air of something to be feared. Gerhard, you were lucky you witnessed it all from the press area.

Any response to it from Hugenberg?

Schwalenberg Castle, Detmold, Lippe...

Herr Hitler.

Herr Hugenberg.

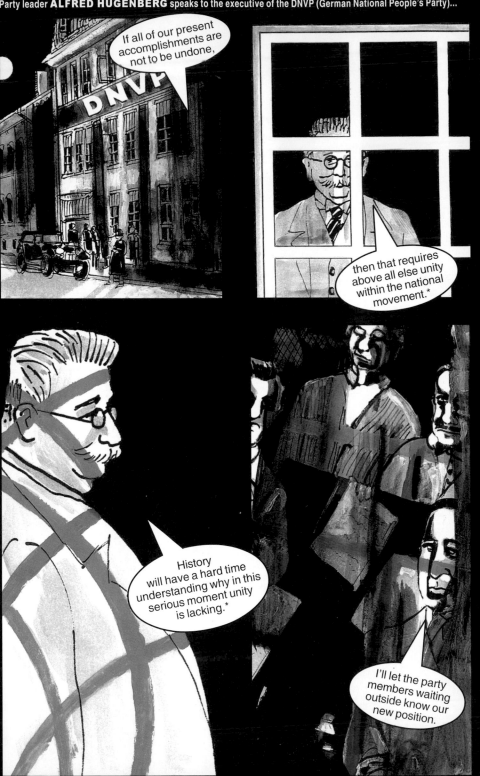

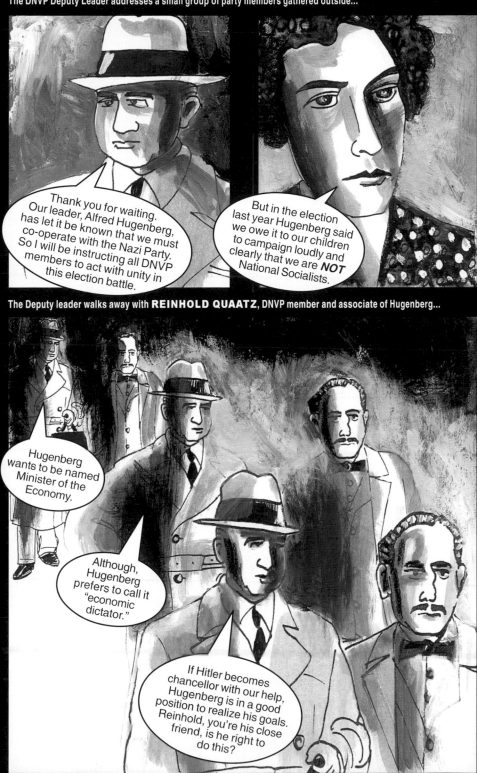

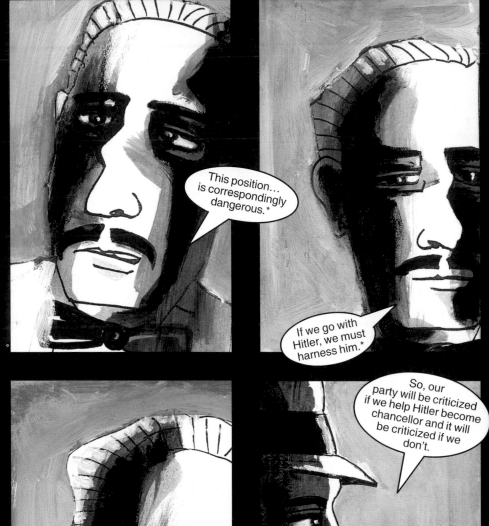
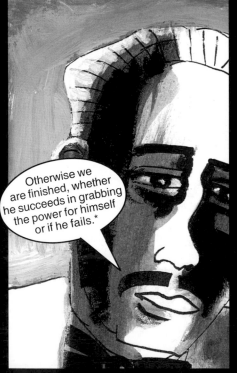
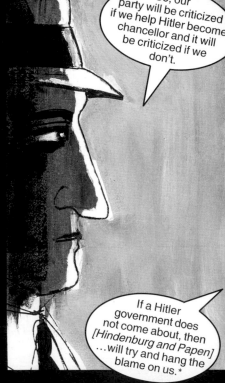

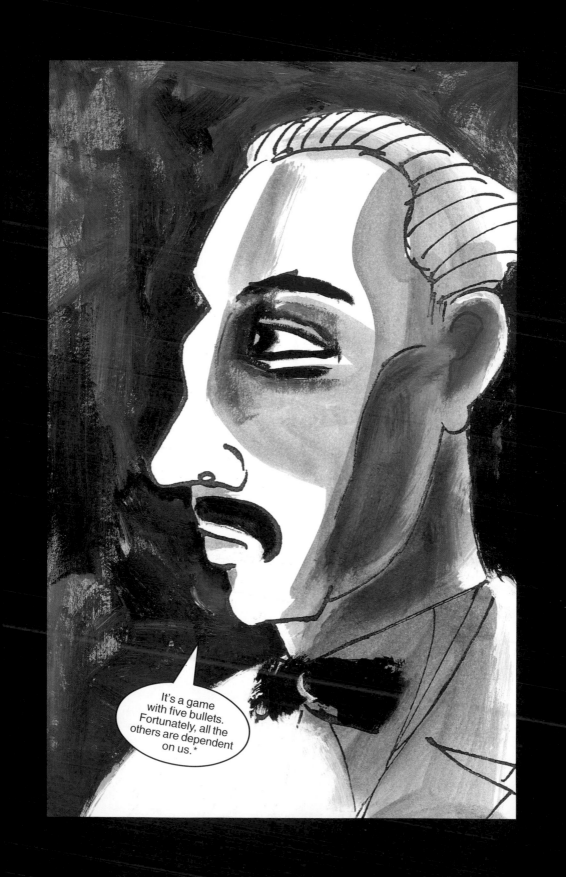

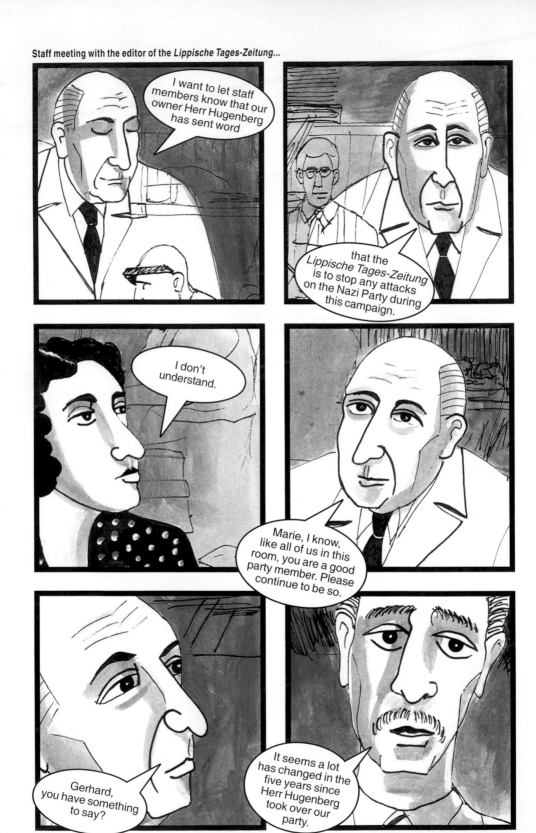

CHAPTER 8

Rummaging

*I believe that it is also false to want to
be fashionable. If one is fashionable for the
greatest part of one's career, one will produce
second-class work. Perhaps by chance one will
arrive at being a success but this means that
one is a follower and not an innovator.
An artist should lead, blaze trails.*

—ORSON WELLES (1915-1985) FILMMAKER

Oslo, Norway...

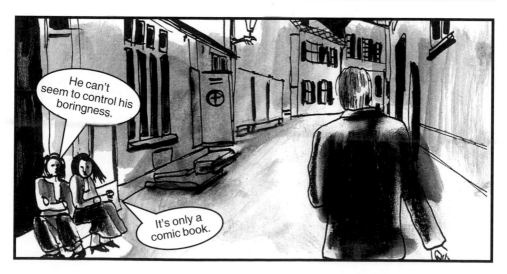

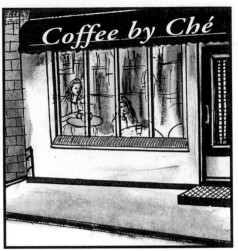
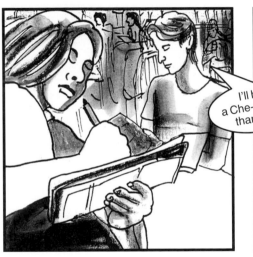
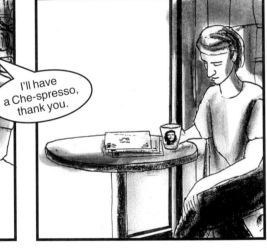

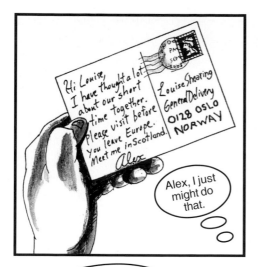

Hi Louise,
I have thought a lot
about our short
time together.
Please visit before
you leave Europe.
Meet me in Scotland.
Alex

Louise Shearing
General Delivery
0128 OSLO
NORWAY

Alex, I just might do that.

"I met him during my first semester at university. He was very serious. We'd go to art galleries together. He liked their quiet. Like a church but not a church."

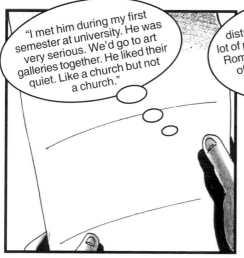

"He was very distrustful and it took a lot of patience to know him. Romance was something of a struggle for him. But the passion was there."

"At one gallery, we saw your sculpture of French anarchist Louise Michel. The inscription of her words resonated with him:

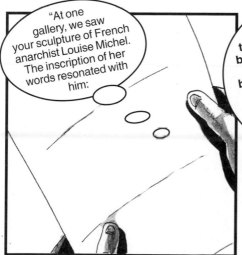

'Since it seems that every heart that beats for freedom has no right to anything but a little slug of lead, I demand my share. If you let me live, I shall never cease to cry for vengeance.'"

185

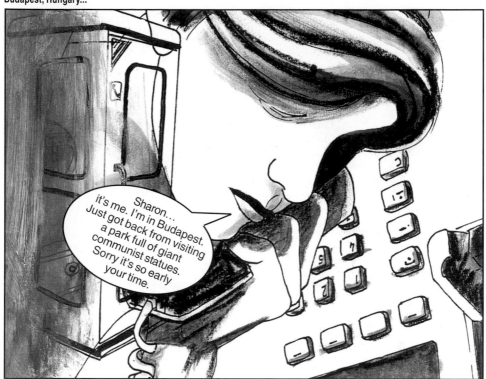

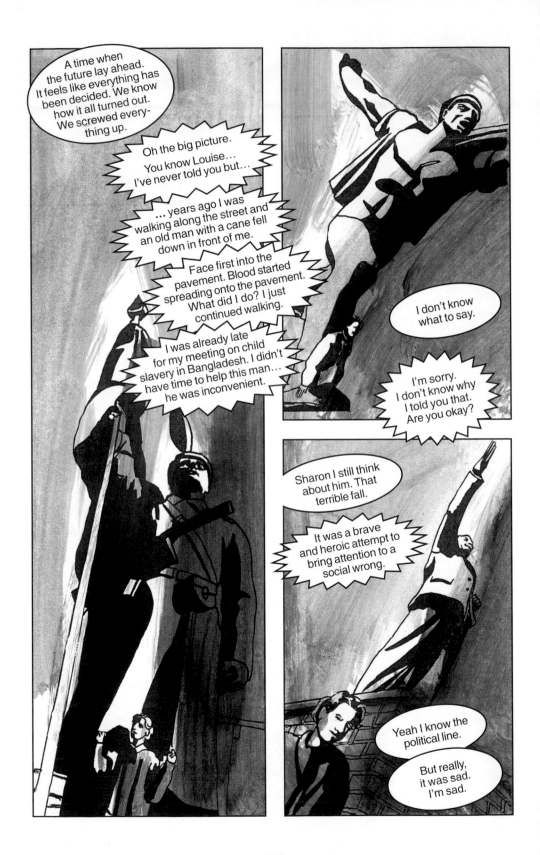

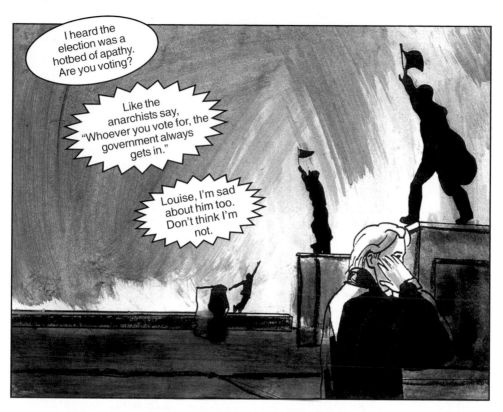

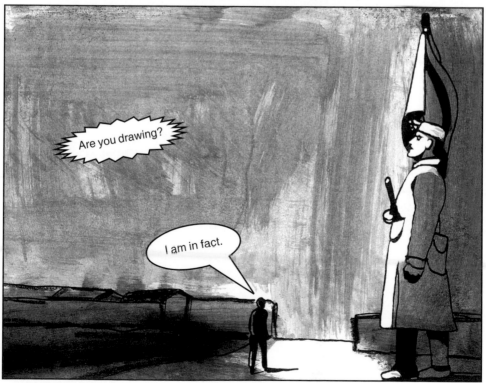

189

CHAPTER 9

Election Noir

By the skillful and sustained use of propaganda,
one can make a people see even heaven as hell
or an extremely wretched life as paradise.

—ADOLF HITLER (1889-1945) NAZI PARTY LEADER

Only silence is shame.

—BARTOLOMEO VANZETTI (1888-1927),
AMERICAN ANARCHIST, EXECUTED IN MASSACHUSETTS

Hitler in his Lippe hotel with his mistress **Eva Braun** at his side, talks on the phone to **Hermann Goering**...

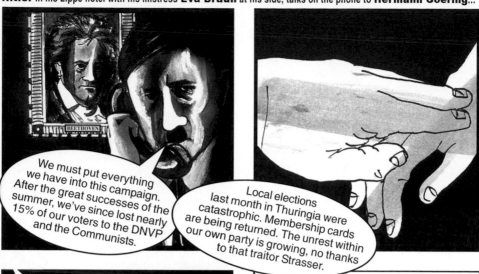

We must put everything we have into this campaign. After the great successes of the summer, we've since lost nearly 15% of our voters to the DNVP and the Communists.

Local elections last month in Thuringia were catastrophic. Membership cards are being returned. The unrest within our own party is growing, no thanks to that traitor Strasser.

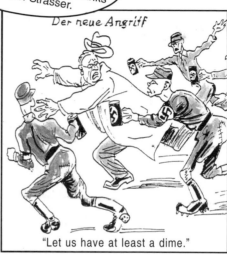

Hermann, the road to power is now or never. This election is pivotal to tipping the scales in our favour. In the Oldenburg election last year, we brought down a chancellor; this time we make one.

But tho Party is running out of money. The *Berlin Tageblatt* shows us begging pedestrians on the street.

Der neue Angriff

"Let us have at least a dime."

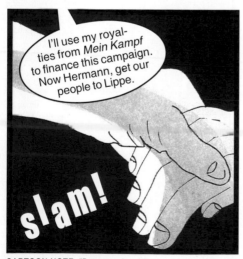

I'll use my royal-ties from *Mein Kampf* to finance this campaign. Now Hermann, get our people to Lippe.

slam!

I know it's not your birthday Adolf, but we could listen to *Ode to Joy*, or maybe Wagner.

CARTOON NOTE: "Der neue Angriff" translates as "The New Attack," which mocks the Nazi party's financial difficulties that led to sidewalk solicitation of coins by storm-troopers.

On platforms across Germany, storm-troopers board trains bound for Lippe...

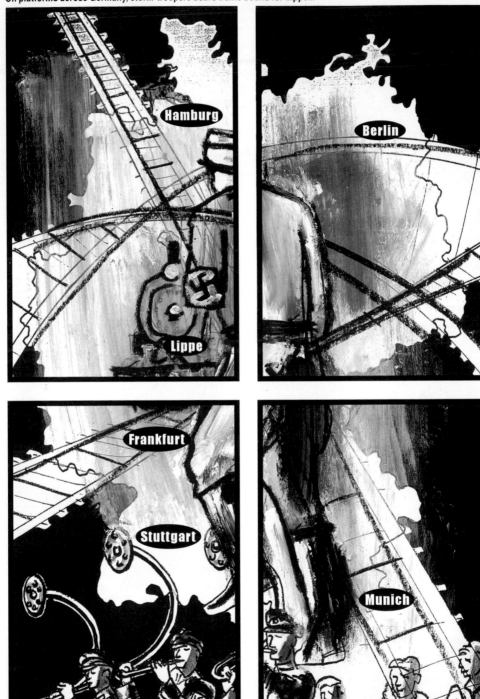

The instrument played above is a bronze horn called The Lur. The Nazis tried unsuccesfully to popularize it as a national symbol.

Travelling through snowy rural roads, **HITLER** tirelessly campaigns across Lippe. Every rally features a marching band of storm-troopers entertaining the crowd and forming an honour guard as Hitler arrives.

HITLER in Augustdorf...

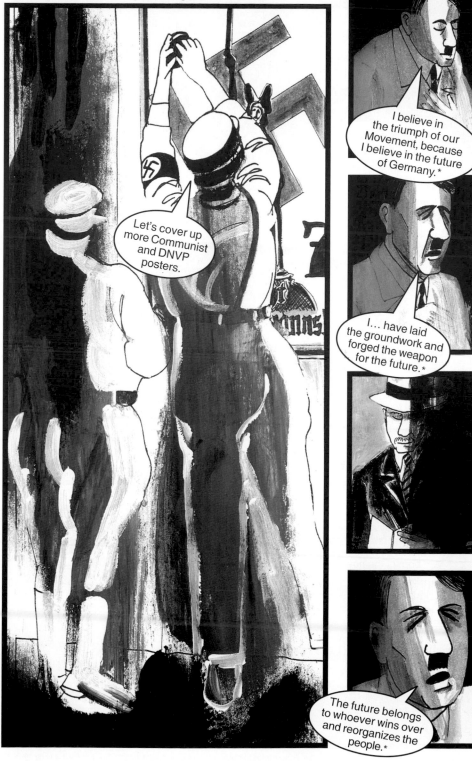

HITLER in Leopoldshöhe...

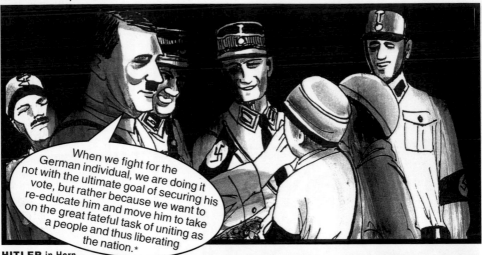

When we fight for the German individual, we are doing it not with the ultimate goal of securing his vote, but rather because we want to re-educate him and move him to take on the great fateful task of uniting as a people and thus liberating the nation.*

HITLER in Horn...

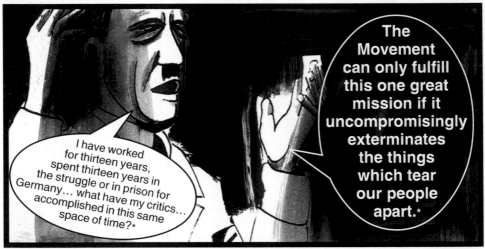

I have worked for thirteen years, spent thirteen years in the struggle or in prison for Germany... what have my critics... accomplished in this same space of time?*

The Movement can only fulfill this one great mission if it uncompromisingly exterminates the things which tear our people apart.*

HITLER in Oerlinghausen...

We are fighting constantly and everywhere, at every corner, every hour of the day! A Reich‡ is coming, born of the power of the Movement...*

‡ Reich refers to the country of Germany. The Nazi Party wanted to create a Third Reich, considering the first two Reich's to be the Holy Roman Empire (5th-6th century) and the German Empire (1871-1918).

HITLER in Hohenhausen...

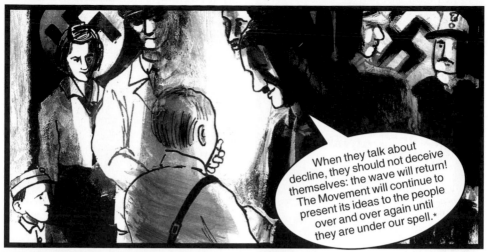

When they talk about decline, they should not deceive themselves: the wave will return! The Movement will continue to present its ideas to the people over and over again until they are under our spell.*

HITLER at Schwalenberg Castle...

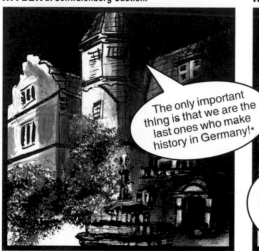

The only important thing is that we are the last ones who make history in Germany!*

HITLER in Calldorf...

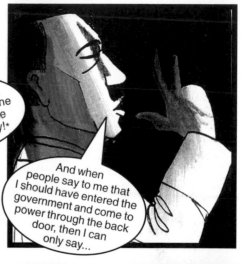

And when people say to me that I should have entered the government and come to power through the back door, then I can only say...

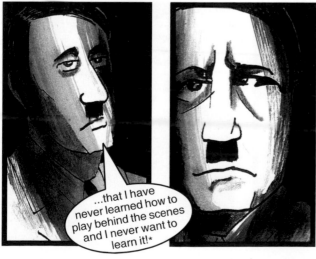

...that I have never learned how to play behind the scenes and I never want to learn it!*

195

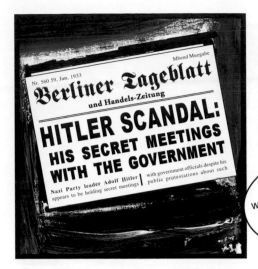

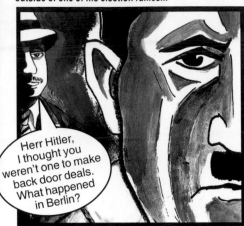

Herr Hitler, I thought you weren't one to make back door deals. What happened in Berlin?

My visit to Berlin...

...had been planned for more than two weeks to make use of my one-day break in the Lippe election campaign.*

Aside from the talks with... Goering and other leading party comrades...

I was at the opera, once more enjoying a marvelous performance of Verdi's *La traviata*.*

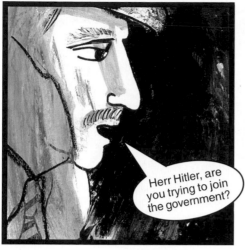

Herr Hitler, are you trying to join the government?

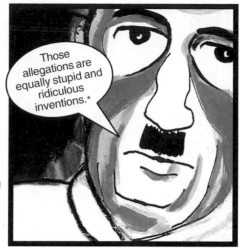

Those allegations are equally stupid and ridiculous inventions.*

I have so often explained my basic attitudes in regards to the formation of the government in depth that the Berlin rags seem to be the only ones with memories short enough to have forgotten them.*

Are you worried about being yesterday's man, that the government can ignore you now after your party's vote declined in November?

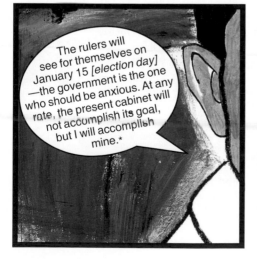

The rulers will see for themselves on January 15 [election day]—the government is the one who should be anxious. At any rate, the present cabinet will not accomplish its goal, but I will accomplish mine.*

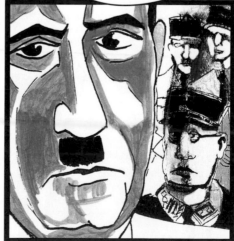

197

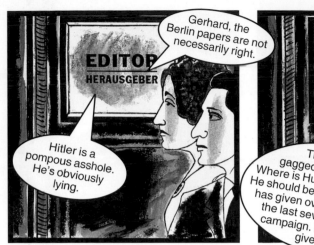

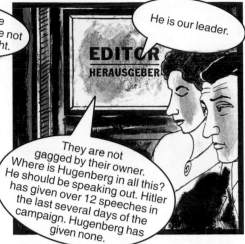

RUDOLPH, **MARIE** and the editor of the *Lippische Tages-Zeitung*...

HITLER campaigning in Lemgo...

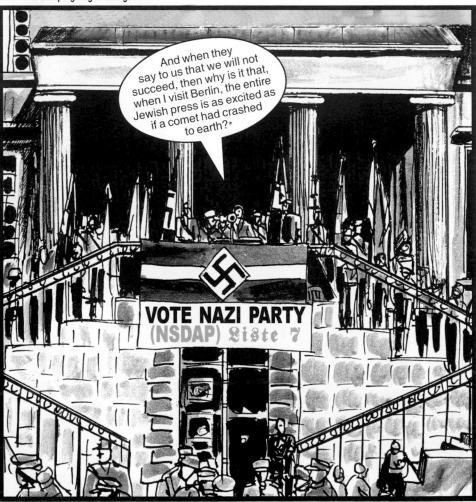

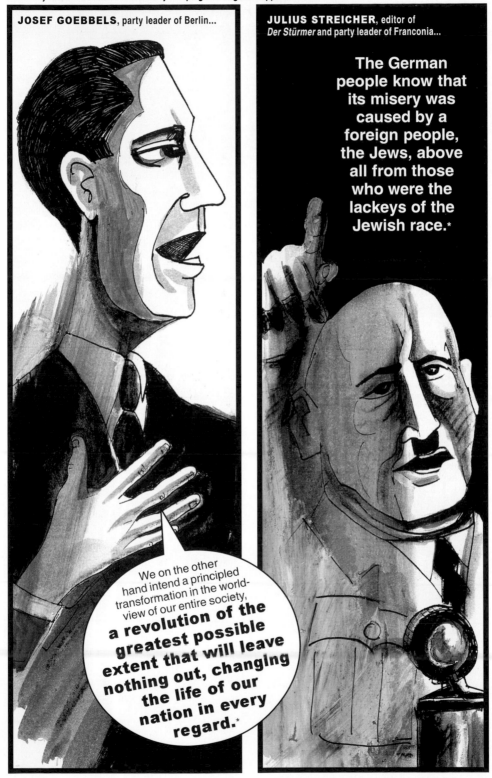

Slowly, with exhausting effort, we must re-establish the right to work. **We want** to give German people work again so they can earn their own bread.

We want to sow once more and show that a person can live from his own efforts, not depending on some kind of support, that no one starves because someone has stolen from him the right to work.

The whole nation must demand that.*

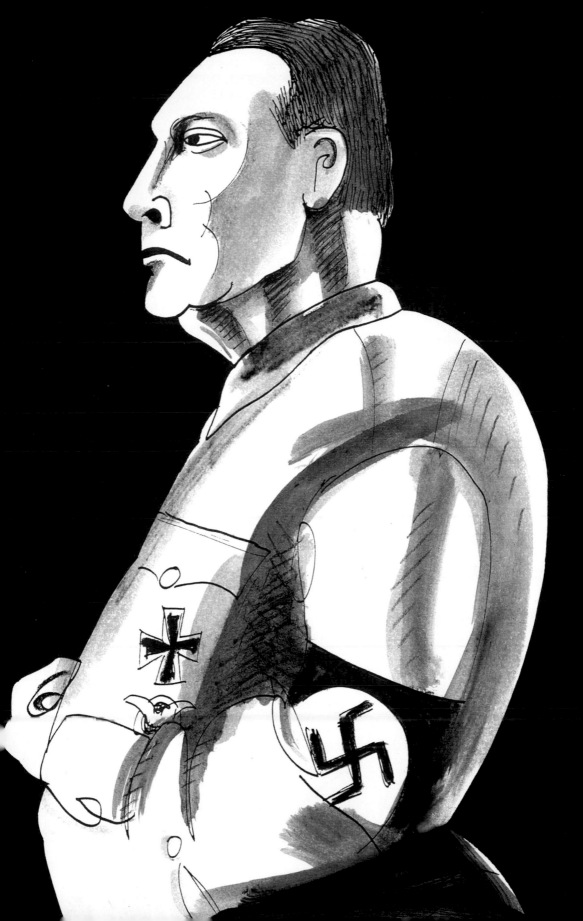

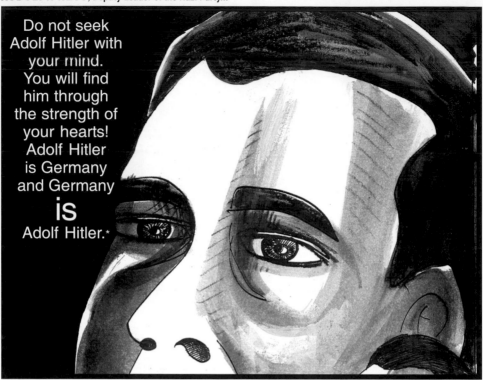

Do not seek Adolf Hitler with your mind. You will find him through the strength of your hearts! Adolf Hitler is Germany and Germany **is** Adolf Hitler.*

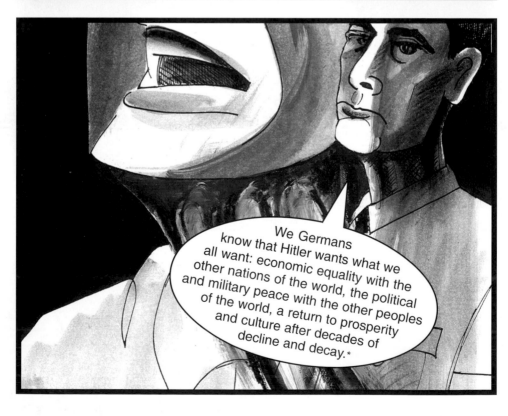

We Germans know that Hitler wants what we all want: economic equality with the other nations of the world, the political and military peace with the other peoples of the world, a return to prosperity and culture after decades of decline and decay.*

Nazi posters from top right: *Against Hunger and Despair. Vote Hitler; Hitler Our Last Hope; List 7 for a Free Hermannsland; Enough! Vote Hitler.* **Covered up DNVP poster reads:** *Leave the old flags. German-National Uprising.*

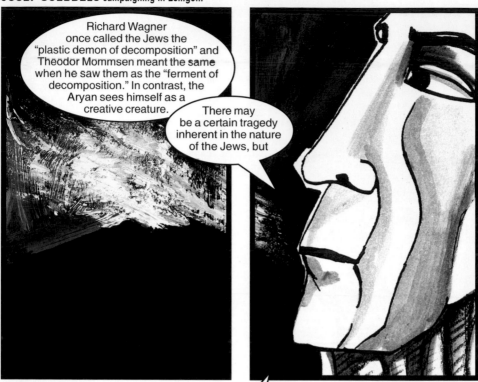

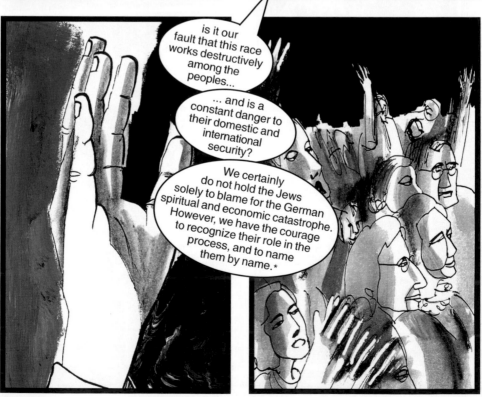

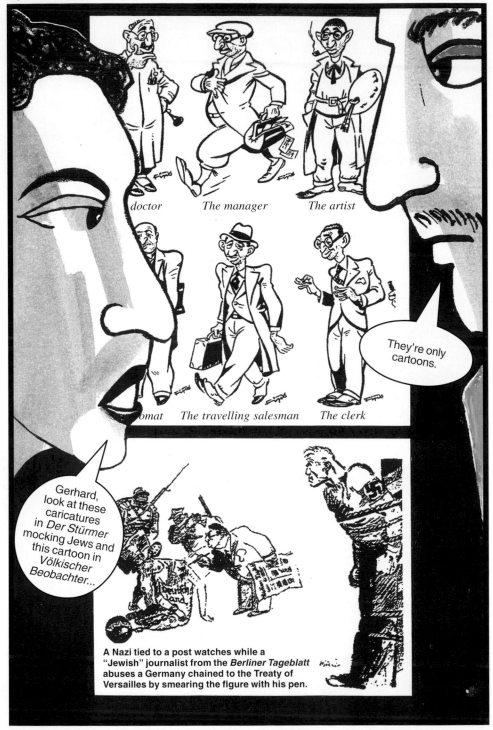

doctor The manager The artist

...omat The travelling salesman The clerk

They're only cartoons.

Gerhard, look at these caricatures in *Der Stürmer* mocking Jews and this cartoon in *Völkischer Beobachter*...

A Nazi tied to a post watches while a "Jewish" journalist from the *Berliner Tageblatt* abuses a Germany chained to the Treaty of Versailles by smearing the figure with his pen.

The above caricatures appeared in the anti-Semitic, anti-Catholic, anti-capitalist, anti-Communist *Der Stürmer*, an unofficial Nazi newspaper whose circulation reached nearly half a million by 1938. Its front cover motto was "The Jews are our misfortune!" Most of the Nazi leadership (including Hitler) supported *Der Stürmer*. The publication was even distributed among Germans living in Canada and the U.S. The cartoon at the bottom of the page is by Mjölnir (see appendix).

Those Damned Nazis

by Joseph Goebbels

Why Are We Nationalists?
We are nationalists because we see the nation as the only way to
bring all the forces of the nation together to preserve and improve
our existence and the conditions under which we live.

Why Are We Socialists?
We are socialists because we see in socialism, that is the union of
all citizens, the only chance to maintain our racial inheritance and
to regain our political freedom and renew our German state.

Why a Workers' Party?
Work is not mankind's curse, but his blessing. The idea that the
dirtier one's hands get, the more degrading the work, is a Jewish,
not a German, idea.

Why Do We Oppose the Jews?
The Jew is the cause and beneficiary of our slavery. He has ruined
our race, corrupted our morals, hollowed out our customs and broken
our strength. The Jew is uncreative. He produces nothing, he only
haggles with products. The Jew is the enemy and destroyer of the
purity of blood, the conscious destroyer of our race. But the Jew,
after all, is also a human being. Certainly, none of us doubts that.
We only doubt that he is a decent human being.

Revolutionary Demands.
The return of German honour. More pay for German workers!
First provide housing and food for the people, then pay reparations!
Provide work for those willing to work! Give the farmers land!
A solution to the Jewish question! We call for the systematic
elimination of foreign racial elements from public life in every area.
Down with democratic parliamentarianism! Germans always will
have preference before foreigners and Jews. A strengthening of
German forces and German customs. We do not enter parliament
to use parliamentary methods. We know that the fate of peoples is
determined by personalities, never by parliamentary majorities.
Revolutions are spiritual acts. That is what we demand![‡]

‡ At least several hundred thousand copies of this Nazi pamphlet were printed in 1932.

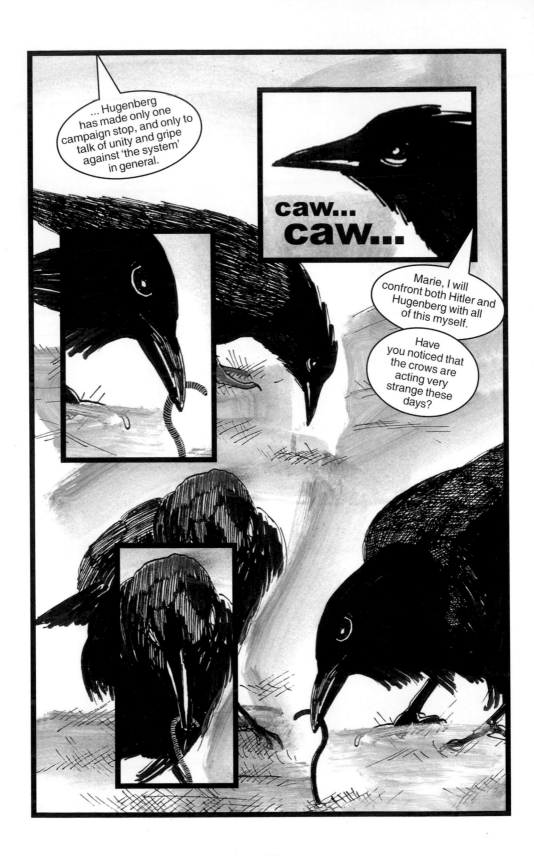

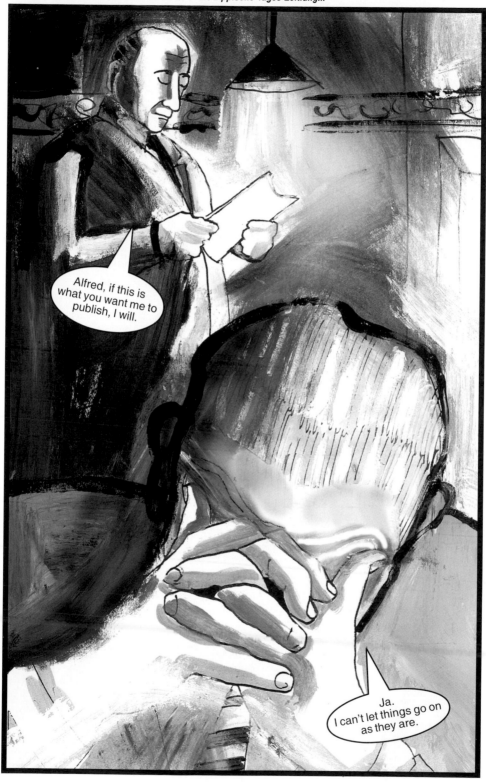

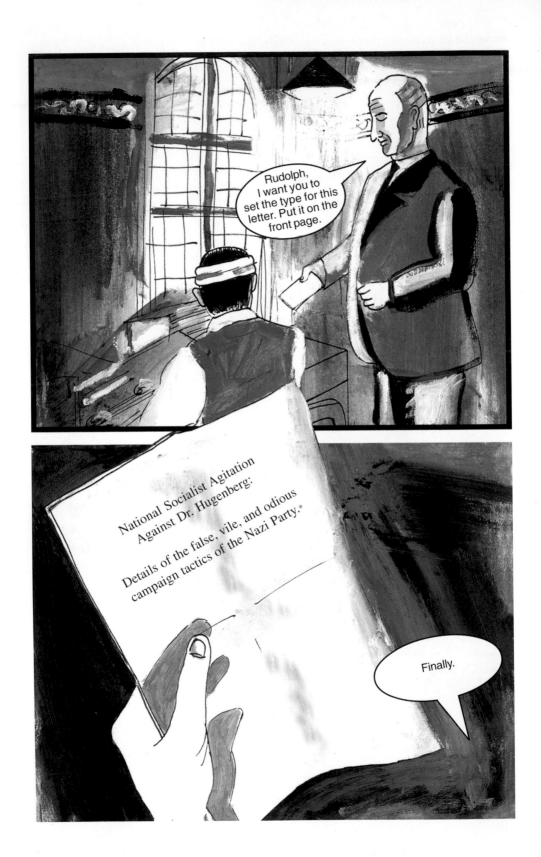

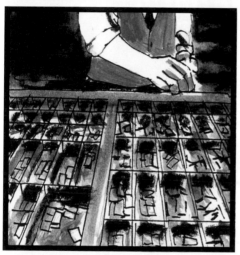
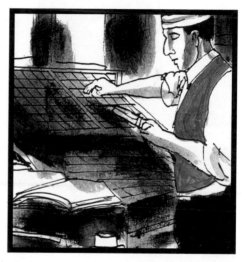

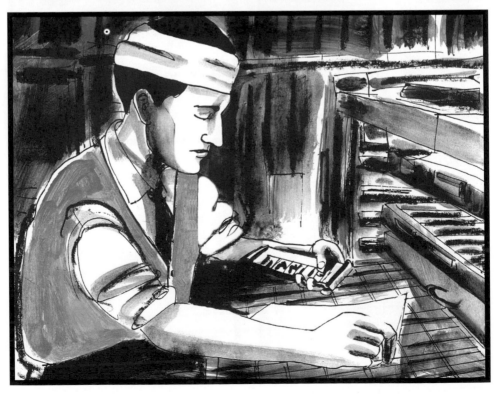

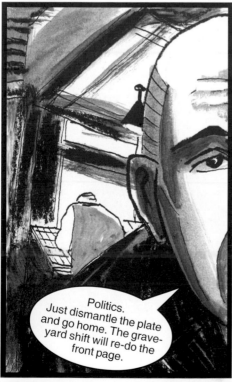

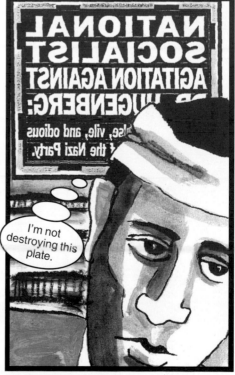

In lithography, printing plates are first prepared backwards in order to print correctly when the ink is applied to the plate and pressed onto paper.

After his shift, **RUDOLPH** heads into the night...

Following evening campaign rallies in Lippe, **HITLER** retires to his hotel room with **EVA BRAUN**...

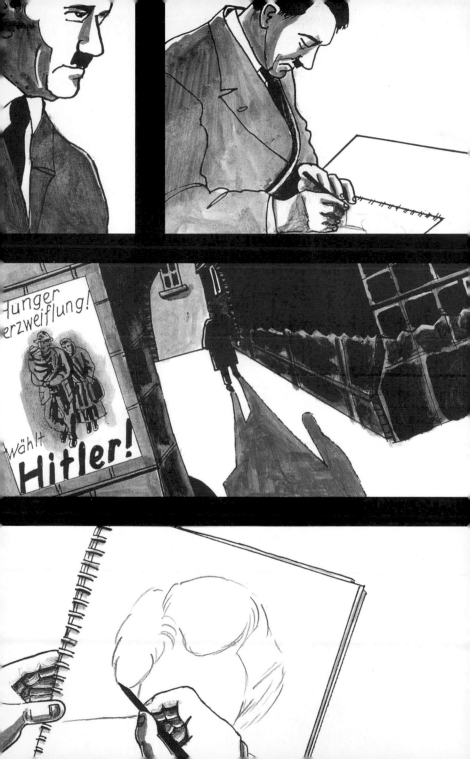

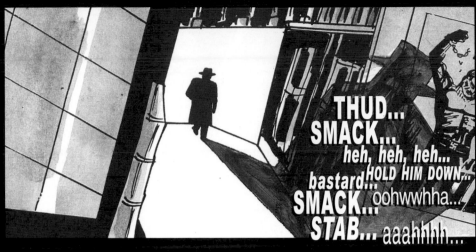

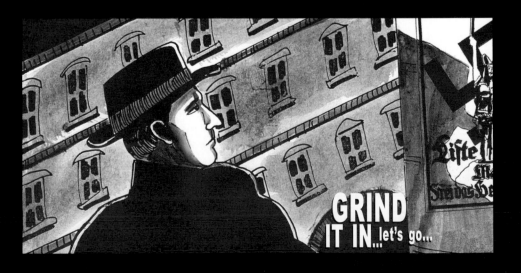

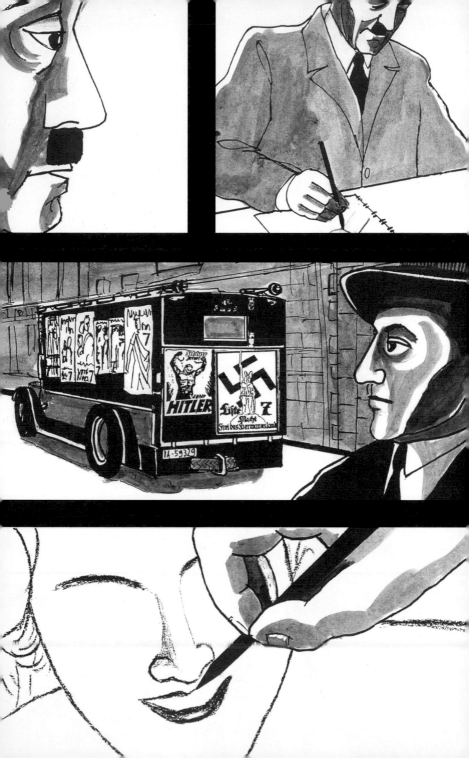

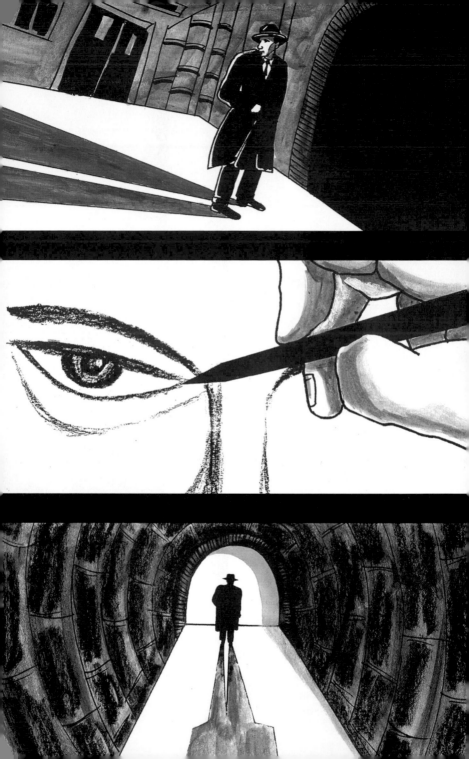

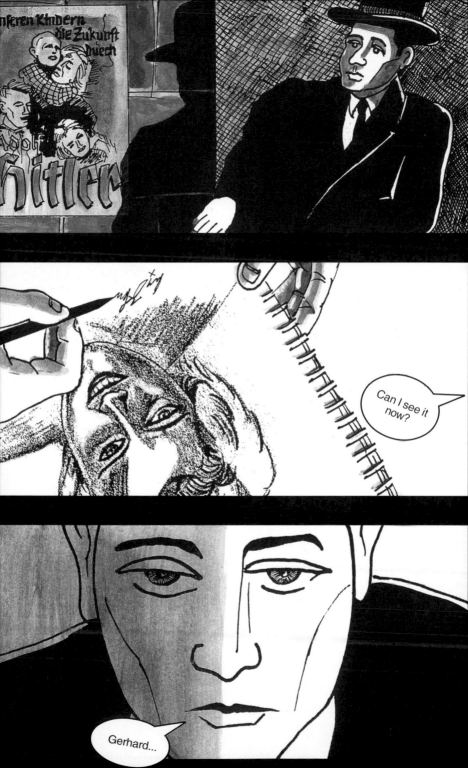

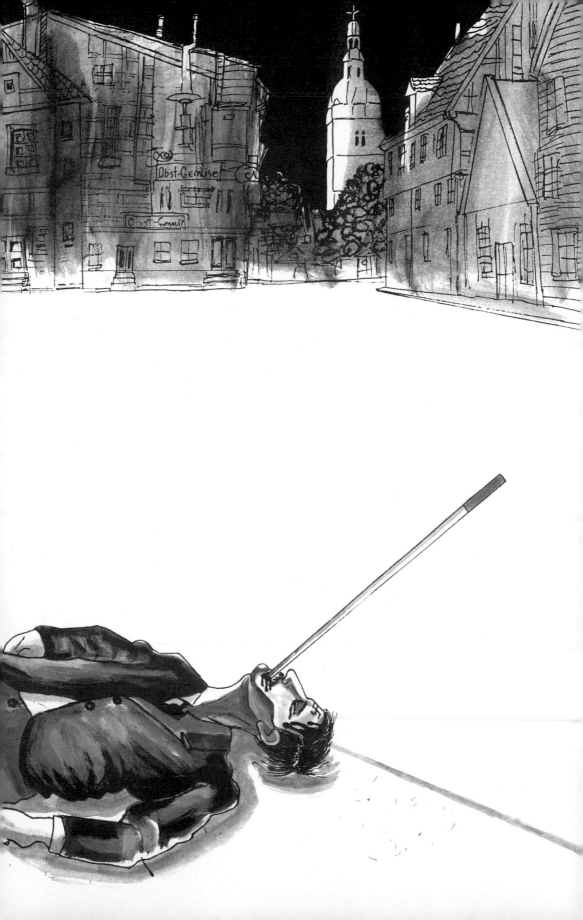

Nr. 1002 97, January 10, 1933　　　　　　Syndikats (Scherl)

Lippische Tages-Zeitung

Zeitung des freien Zustandes von Lippe. 1933

COMMUNISTS

MURDER REPORTER VICIOUS POOL CUE ATTACK

RUDOLPH and **MARIE...**

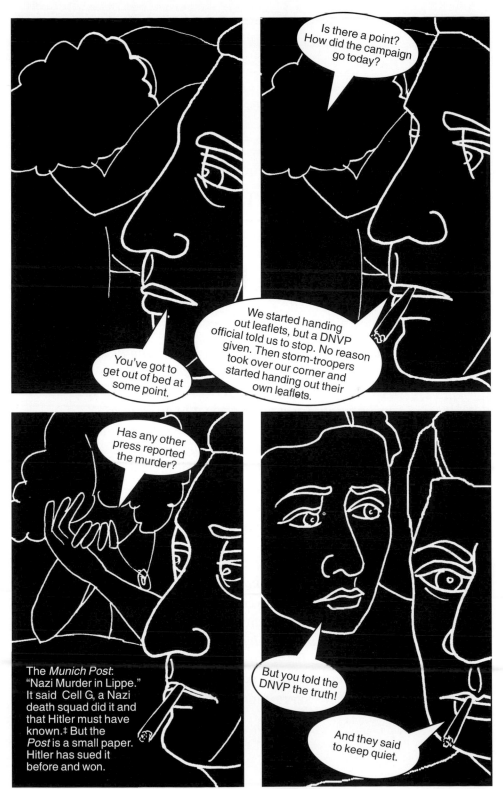

‡ "Nothing happens in the Movement without my knowledge, without my approval."—Adolf Hitler

CHAPTER 10

Voting & the Abyss

All my life I have wanted to be a great painter in oils. I am tired of politics, and as soon as I have carried out my program for Germany I shall take up my painting. I feel that I have it in my soul to become one of the great artists of the age and that future historians will remember me, not for what I have done for Germany, but for my art.

—ADOLF HITLER, AS QUOTED BY SIR NEVILE HENDERSON, *TIME MAGAZINE*, SEPTEMBER 11, 1939

A group of watercolors and sketches by Adolf Hitler sold for $220,000 this week, which is pretty good for someone rejected by an art school and criticized for his inability to depict human figures.

—GARY ROTSTEIN, *PITTSBURGH POST-GAZETTE*, SEPTEMBER 28, 2006

ON ELECTION DAY for the Lippe state parliament, January 15, 1933, the Nazi Party gained over 5,000 more votes in Lippe than they had in the November national election, whereas this time the DNVP lost more than 4,000. This was the vote difference that the Nazi party was able to claim in propaganda as a great "victory."

Marie and I voted *against* the Nazis by voting for *our* party the DNVP. But the DNVP leadership undermined its own supporters by restricting our efforts in the campaign to fight the Nazis. Because we submitted to party discipline, our efforts to combat the Nazis were pathetic.

Though this was only a regional state election and Hitler would have to do a lot more backroom manoeuvring to clinch power, it was a step in his ascent. Because of our failure, we were instrumental in his struggle to take over Germany two weeks later.

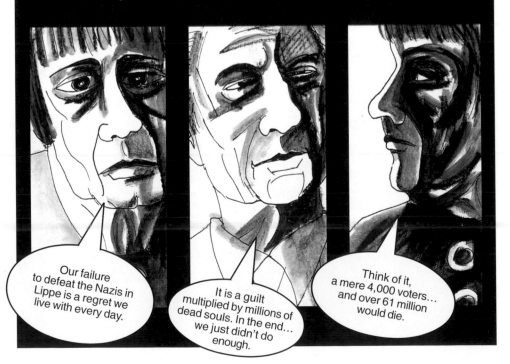

Our failure to defeat the Nazis in Lippe is a regret we live with every day.

It is a guilt multiplied by millions of dead souls. In the end... we just didn't do enough.

Think of it, a mere 4,000 voters... and over 61 million would die.

Syndikats (Scherl)

Lippische Tages-Zeitung

Nr. 1032 99, Jan 16, 1933

Zeitung des freien Zustandes von Lippe. 1933

FREE STATE OF LIPPE ELECTION RESULTS

Nazi Party: 39,064 (**39%**)
Social Democratic Party: 29,827 (**30%**)
Communist Party of Germany: 11,047 (**11%**)
German National People's Party (DNVP): 6,009 (**6%**)
Five other parties: 12,994 (**12.5%**)

98,941 valid votes cast

VÖLKISCHER⊕BEOBACHTER

NAZI WAVE RISING AGAIN*

Der Stürmer

NAZI LANDSLIDE!*

der Angriff
Tageszeitung der Deutschen Arbeitsfront

The avalanche of the people's upheaval has once more come into motion, and we shall see to it that it never again stops.*

Berliner ⊕ Tageblatt
und Handels-Zeitung

In truth, Hitler has brought home from his historic struggle in Lippe only a fly impaled on the tip of a sword.*

Der Sieg
(The Victory*)

He sallied forth to bag the German eagle and conquered thirty-nine percent of the Lippe sparrow.*

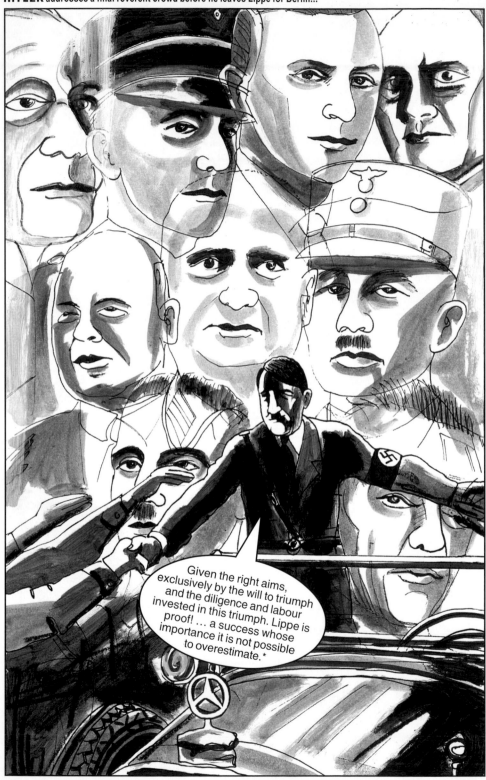

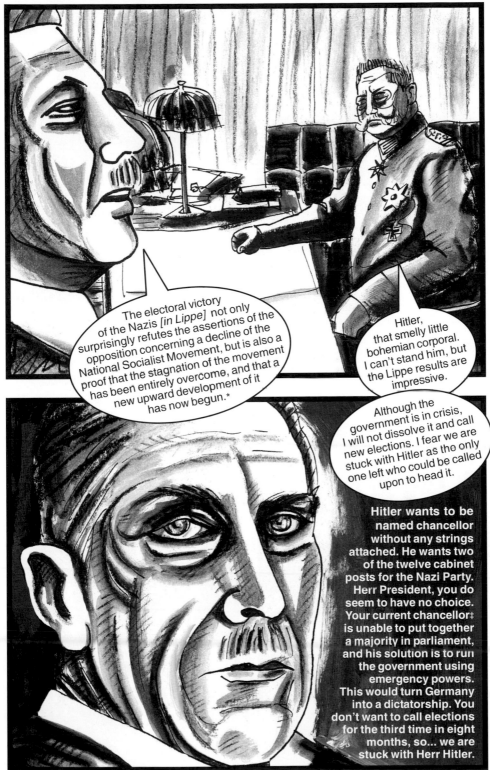

‡ General Kurt von Schleicher was the chancellor at this time.

I will...

... agree to...

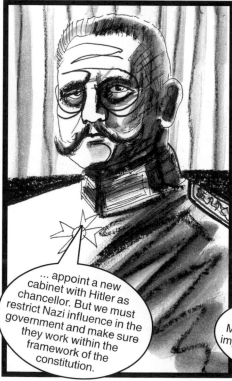

... appoint a new cabinet with Hitler as chancellor. But we must restrict Nazi influence in the government and make sure they work within the framework of the constitution.

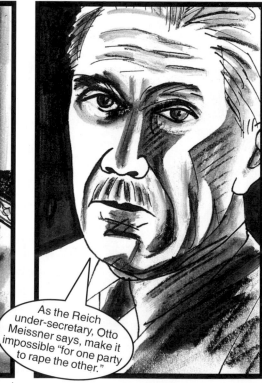

As the Reich under-secretary, Otto Meissner says, make it impossible "for one party to rape the other."

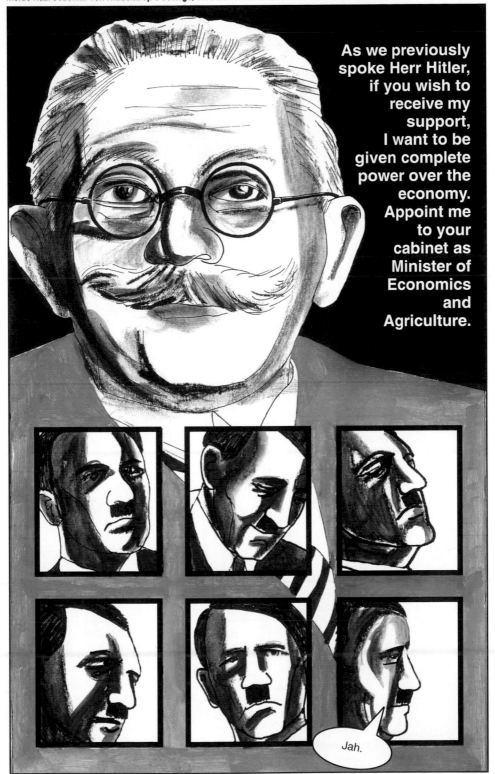

On January 30, 1933, 15 days after the Lippe election, President **HINDENBURG** appoints Adolf Hitler chancellor...

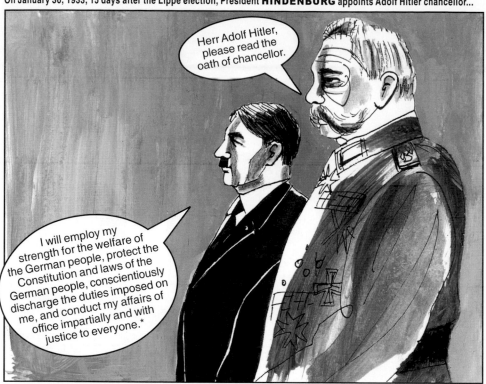

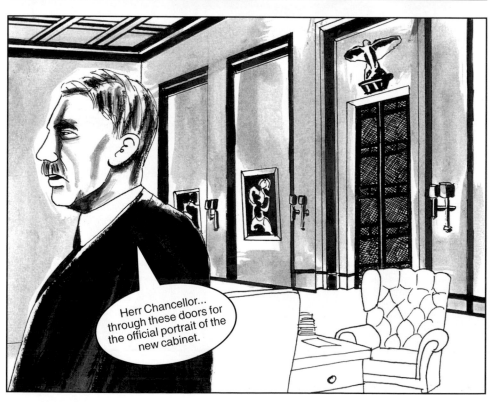

The coalition cabinet assembles for photographs...

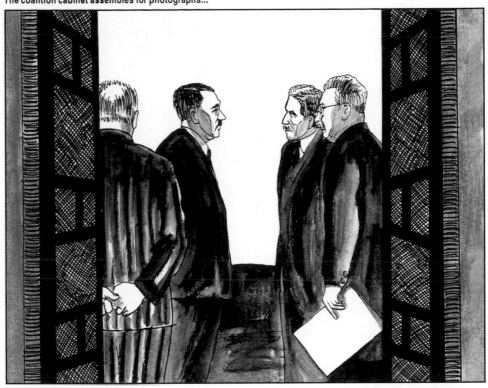

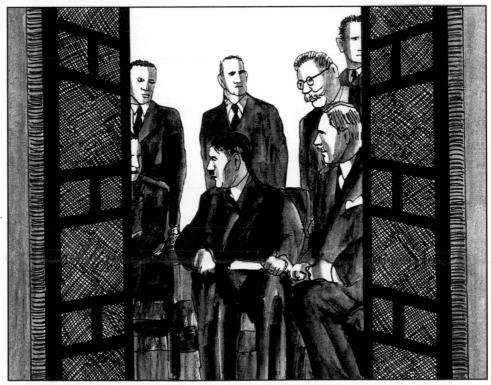

Hitler's initial twelve-member cabinet was comprised of three Nazis, and nine other members (including two DNVP and Von Pappen).

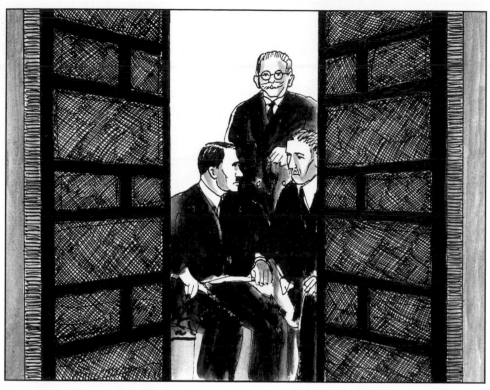

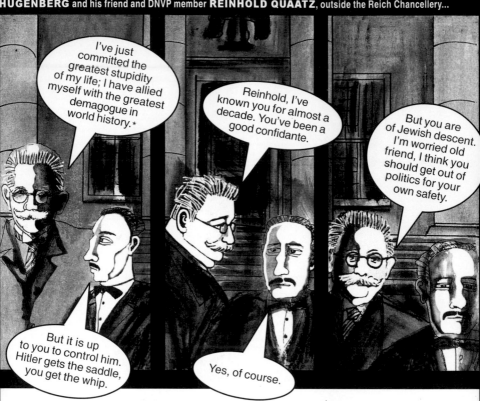

I've just committed the greatest stupidity of my life; I have allied myself with the greatest demagogue in world history.*

Reinhold, I've known you for almost a decade. You've been a good confidante.

But you are of Jewish descent. I'm worried old friend, I think you should get out of politics for your own safety.

But it is up to you to control him. Hitler gets the saddle, you get the whip.

Yes, of course.

Fahrschule Hugenberg

(Hugenberg's Driving School)

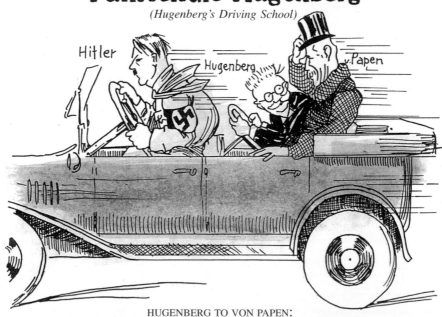

HUGENBERG TO VON PAPEN:
"That newcomer up there in front can imagine all he wants that he's steering, but we'll set the economic course!"*

Cartoon from *Vorwärts* ("Forward"), the daily newspaper of the Social Democratic Party.
On Feb. 3, 1933, Hermann Goering had the paper banned.

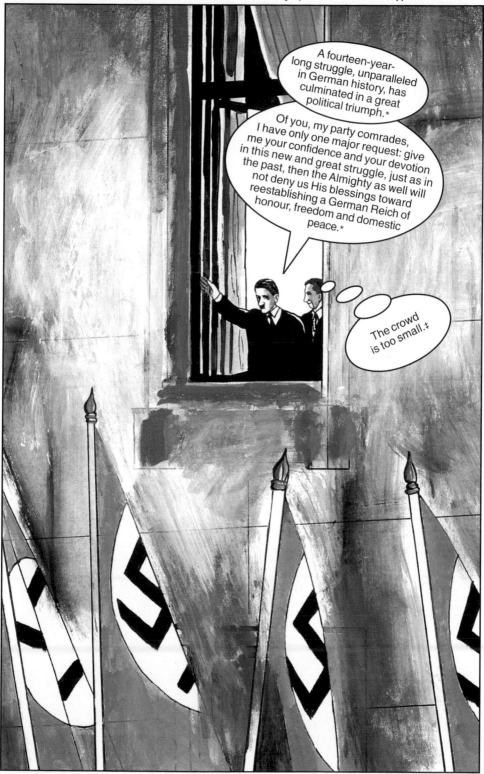

‡ Josef Goebbels would re-stage the torchlight parade a few nights later for movie cameras.

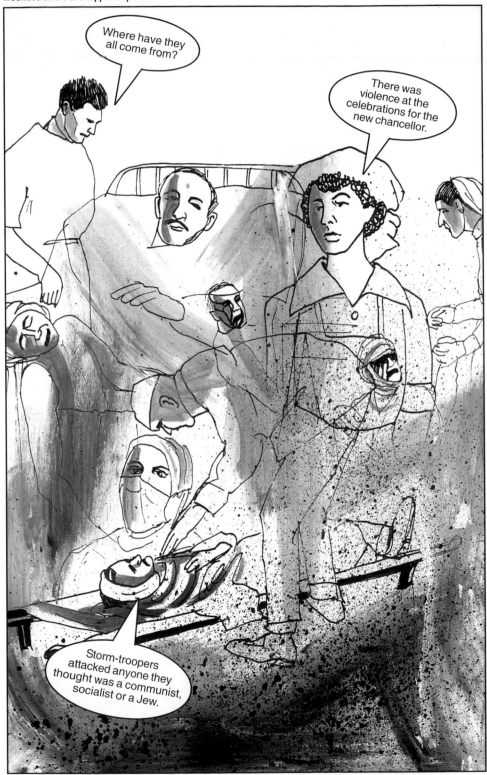

The Berliner Borenzeitung

YOUR CONSERVATIVE DAILY

PARADES CELEBRATING
HITLER
HELD ACROSS
GERMANY

VOLKISCHER ⊕ BEOBACHTER

DNVP
REICHSTAG
FLOOR LEADER
FOUND DEAD

Der Stürmer

HUGENBERG
RESIGNS
MINISTRIES

VOLKISCHER ⊕ BEOBACHTER

DNVP
DISSOLVED

Der Stürmer

ALL POLITICAL
PARTIES
BANNED

VOLKISCHER ⊕ BEOBACHTER

GREGOR
STRASSER
DEAD

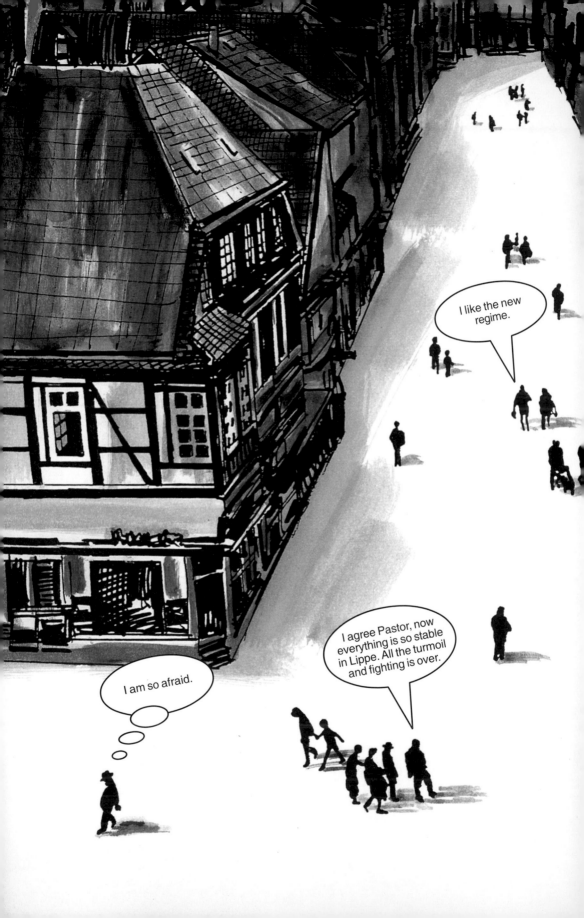

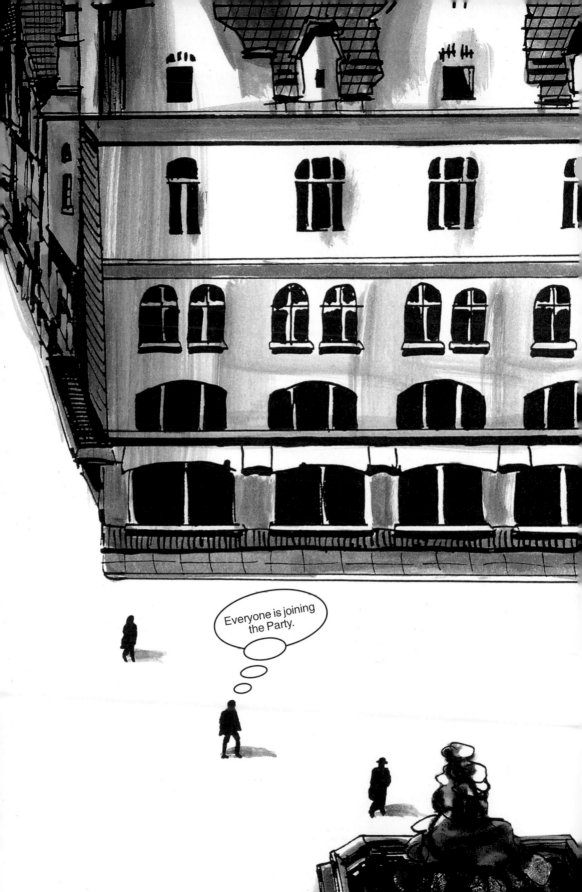

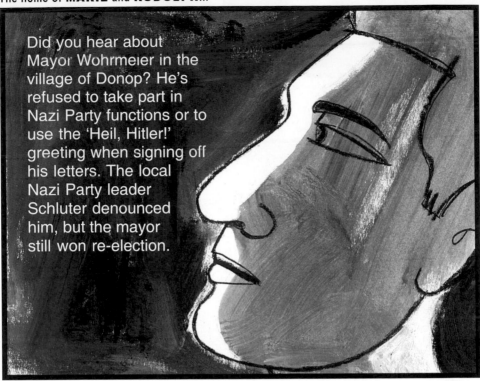

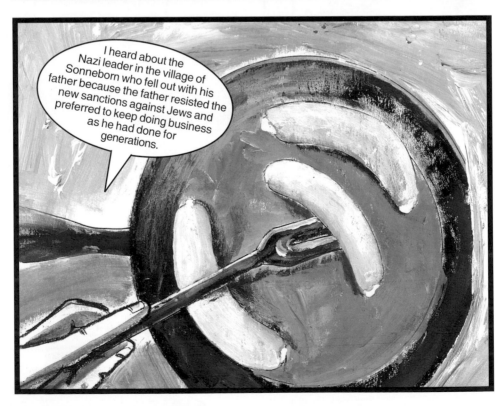

Marie, what should we do?

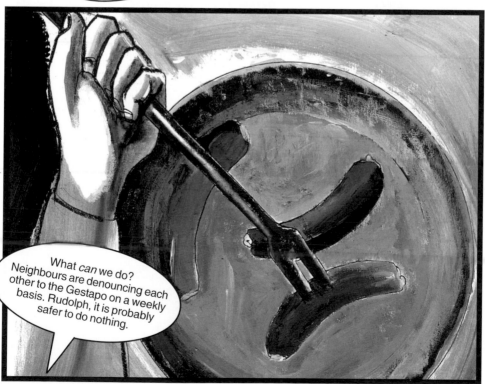

What *can* we do? Neighbours are denouncing each other to the Gestapo on a weekly basis. Rudolph, it is probably safer to do nothing.

CHAPTER 11

The Gift

*As long as Nazi Violence was unleashed only, or mainly,
against the Jews, the rest of the world looked on passively
and even treaties and agreements were made with the
patently criminal government of the Third Reich....
The doors of Palestine were closed to Jewish immigrants,
and no country could be found that would admit those forsaken
people. They were left to perish like their brothers and sisters
in the occupied countries. We shall never forget the heroic
efforts of the small countries, of the Scandinavian, the Dutch,
the Swiss nations, and of individuals in the occupied part of
Europe who did all in their power to protect Jewish lives.*

—ALBERT EINSTEIN (1879-1955) SCIENTIST

The café...

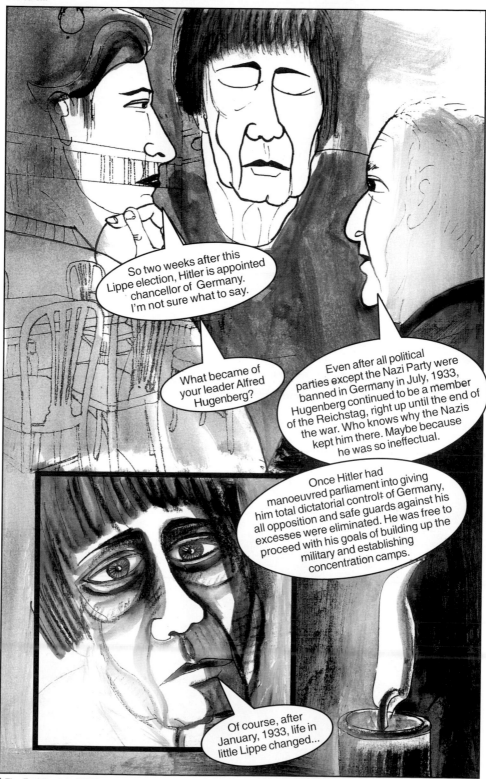

‡ The *Enabling Act of 1933* granted Hitler's cabinet the authority to enact laws without the participation of parliament for four years.

Using the threat of communism as justification, the new government promoted anti-Jewish hatred and supression of political opinion. If you believed in the lies, you believed in the repression.

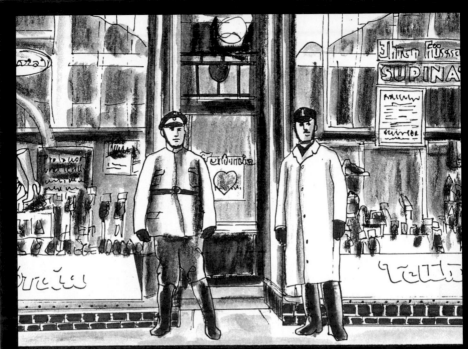

Storm-troopers blocked doorways to enforce boycotts of Jewish shops in Lippe...

Lippe children joined the Hitler Youth...

A neighbour of ours, Jurgen Stroop, became the SS Major General in charge of surpressing the uprising of Jews in the Warsaw Ghetto. He was convicted of war crimes and executed in Poland in 1952.

At the same time, Hitler stabilized Germany with popular public works projects that gave the unemployed jobs.

Every January, over the next 12 years, the Lippe election would be commemorated by the Nazi Party. Hitler even attended the celebrations in 1934 and 1936.

It would be reported much later that Hitler used the example of the Lippe election as proof that he could win the Second World War by sheer willpower.

The Nazi Party also erected a plaque in honour of the Lippe election.

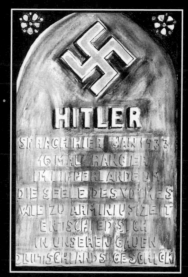

The inscription read:

Hitler spoke here January 1933
16 times he fought in the Lippe region
for the hearts and souls of the people.
Just like in the time of Hermann‡, Germany's
destiny was decided in our region.*

After the war, most of the townspeople denied they had ever denounced anyone to the Gestapo.

As well, Lippe Nazi officials claimed they had been ignorant of the extermination of the Jews.

‡ Also known by his Latin name Arminius, leader of a coalition of Germanic tribes fighting the Romans in AD 9.

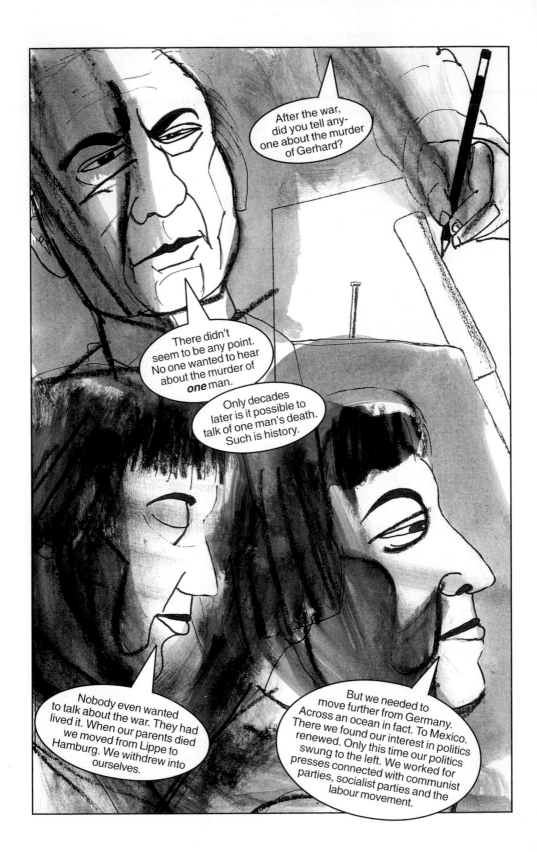

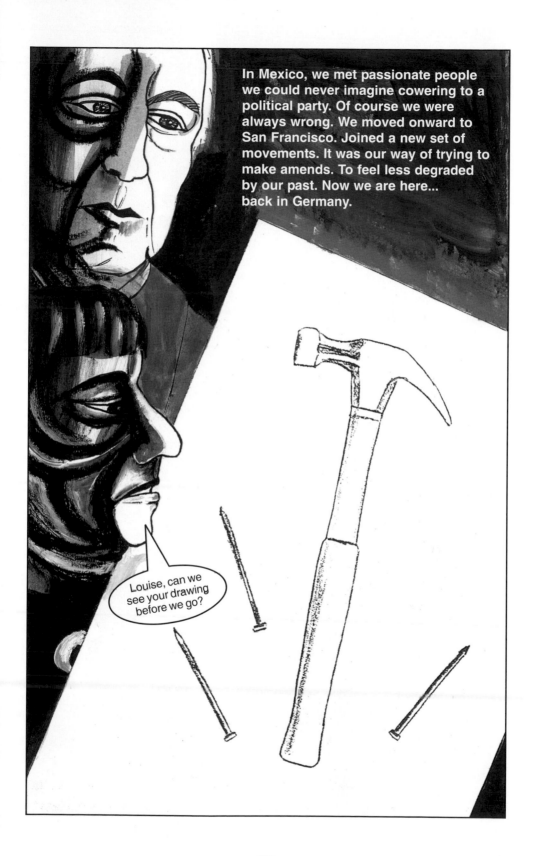

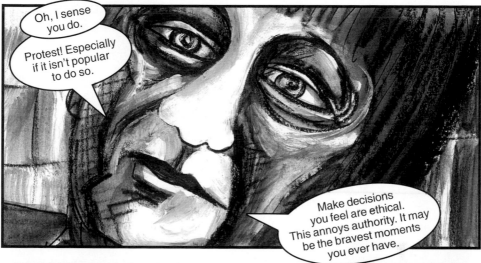

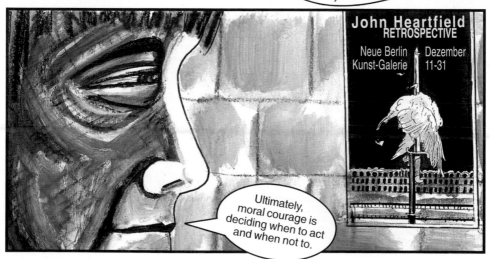

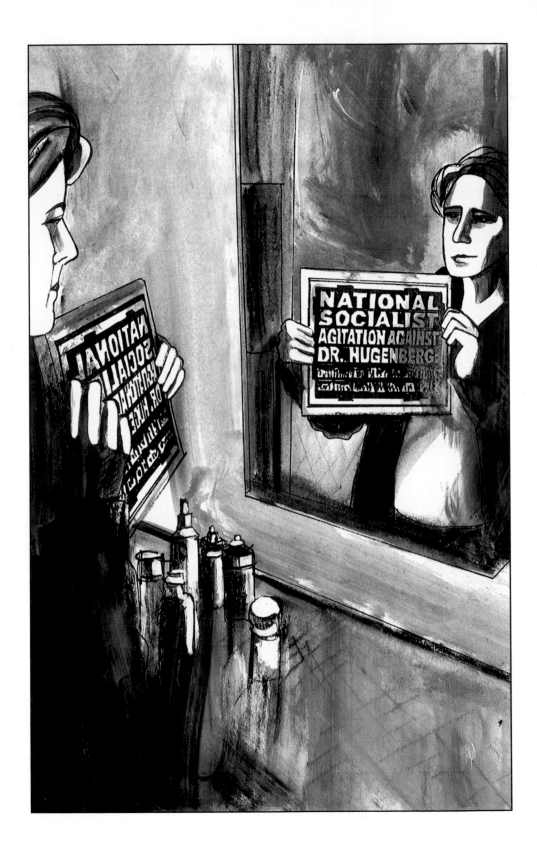

NATIONAL SOCIALIST AGITATION AGAINST DR. HUGENBERG:

Details of the false, vile, and odious campaign tactics of the Nazi Party.

Berlin...

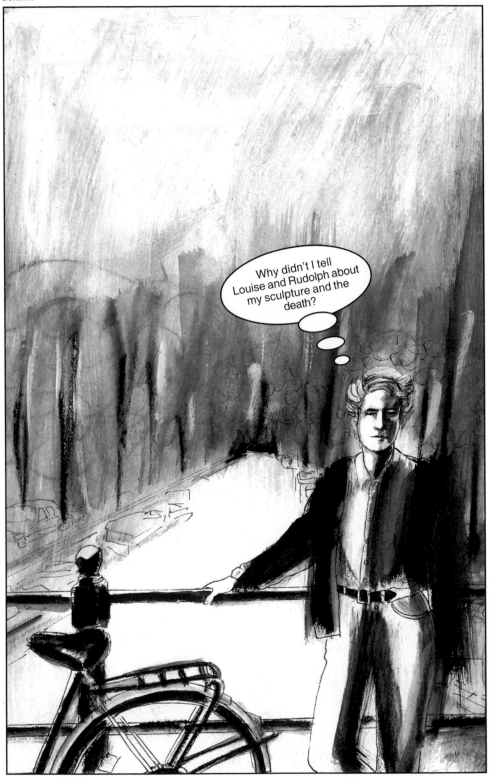

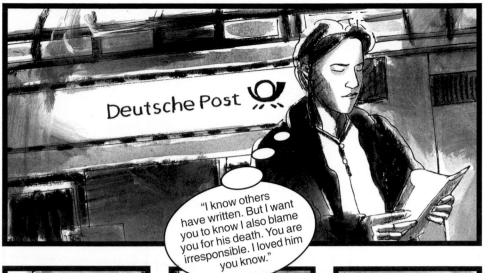

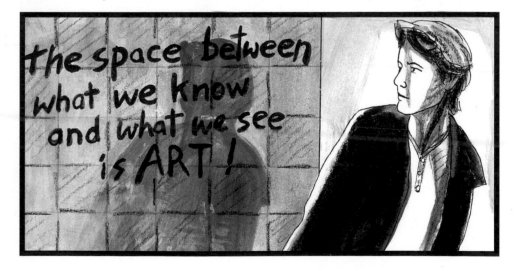

CHAPTER 12

The Old Man,
the Cambodian &
the Artist

*A hundred times a day one can
hear rousing music on the radio,
choirs encouraging one to buy
Coca Cola, and one cries desperately
for l'art pour l'art.*

—BERTOLD BRECHT (1898-1956) PLAYWRIGHT

Berlin Ostbahnhof...

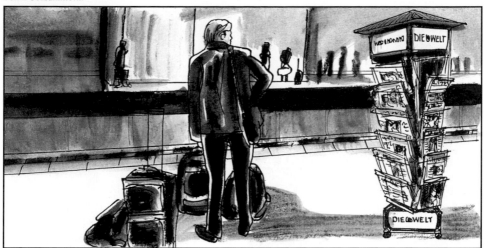

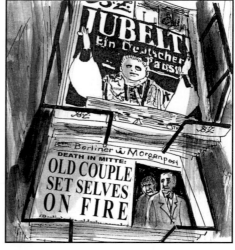

Oh Marie and
Rudolph...

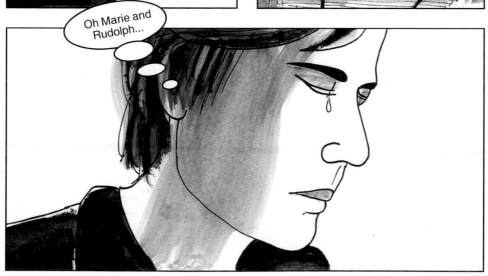

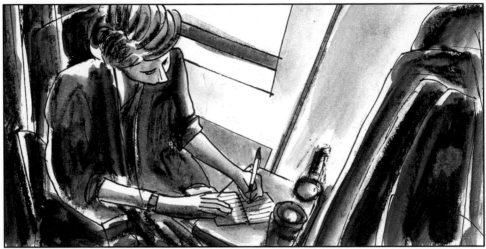

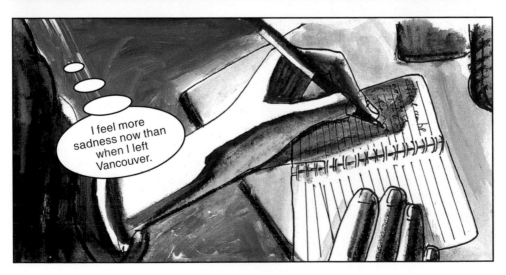

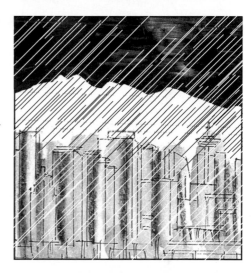

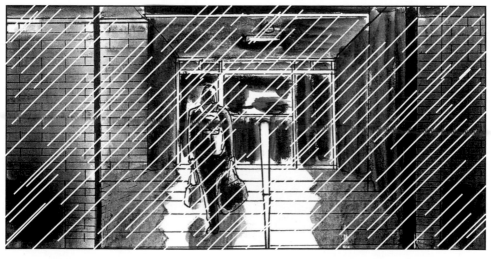

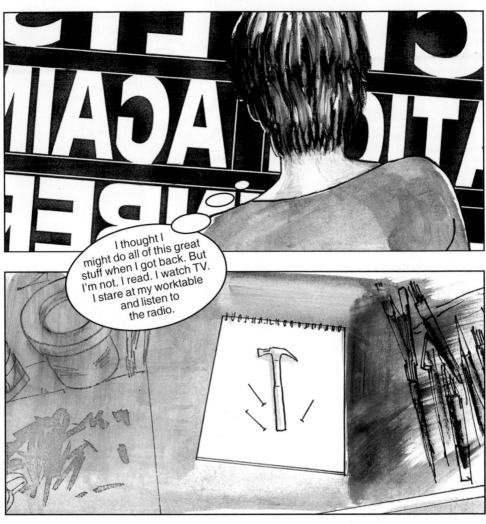

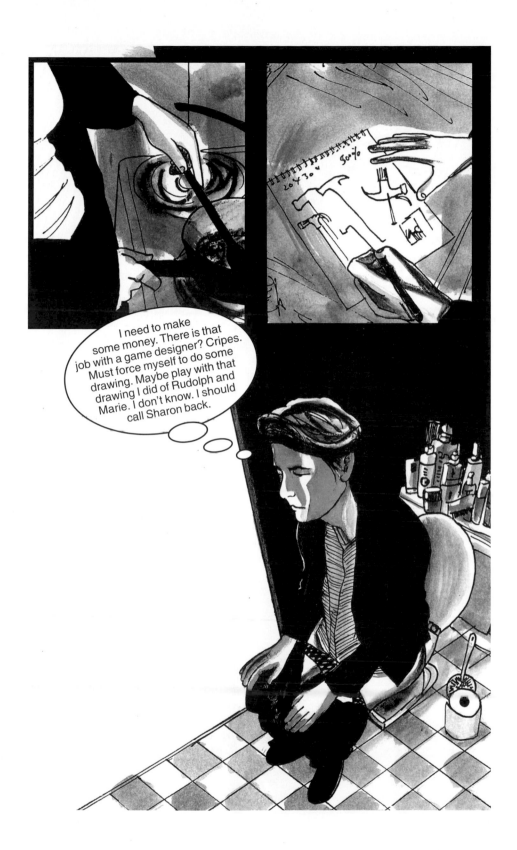

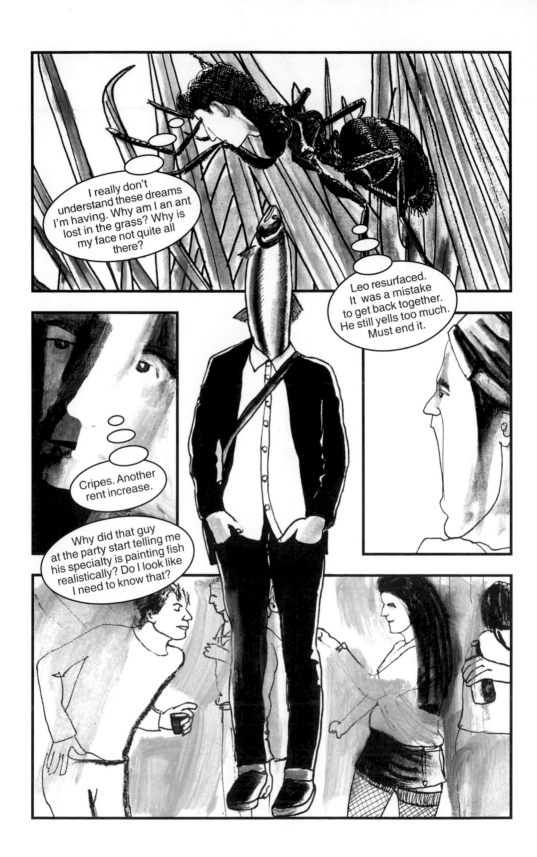

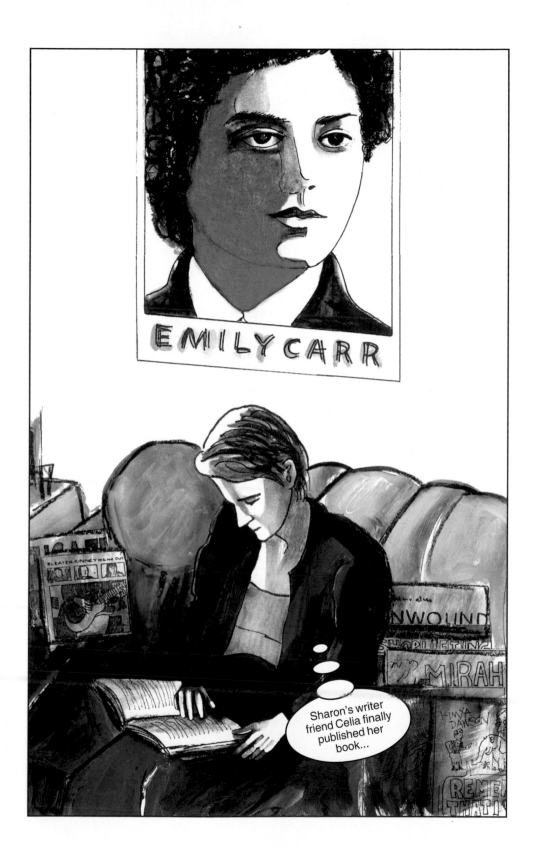

In another room at the big building of many studios, a man, quietly yet authoritatively, tells a boy around eleven years old, "They're just different forms of art, Duncan. They're just different forms of art." I have the impression that the boy has expressed discomfort or confusion, or perhaps dislike. Why the man defends the art with this platitude is obvious: he wants to avoid a scene. If the boy said, "This is a bunch of crap," he would have been correct. And quite possibly the father-guy, if he had any sense of anything, and balls, could have better met the boy's observation with, "True, but seeing that doesn't require that you say it out loud. You might hurt the artist's feelings and draw attention to yourself, revealing that you are astute and aware and that will cause you problems throughout your life. So pipe down for now and perhaps keep thinking about it and later you can write a story about it, or a review, on your blog."

Having learned through exposure to everything—through technology—that we are entitled, we seek our bounty. We have deduced that what we are entitled to is a smooth-running production instead of this messy business of living that unfolds itself slightly differently each day, presenting us with the same annoying variables. If we are smart, we prepare to assess and document the nuances of our findings, not as part of uncodifying the great non-meaning of life, but to dredge and display all the idiosyncratic components of being. Is there a why? Not really.

94

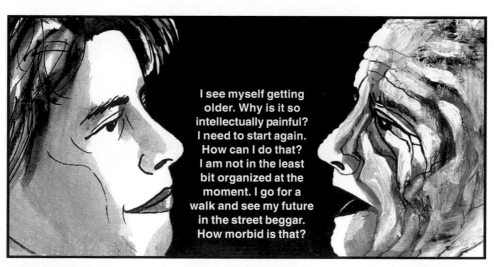

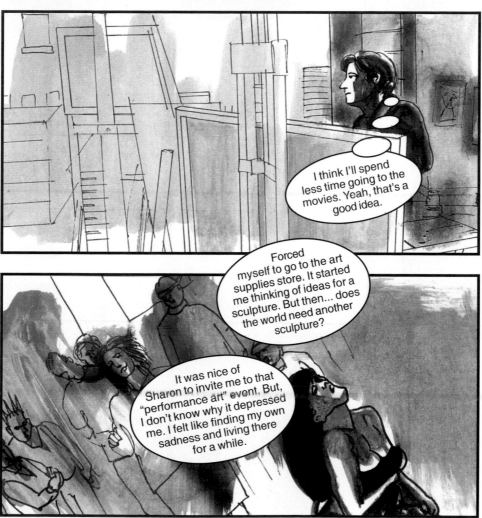

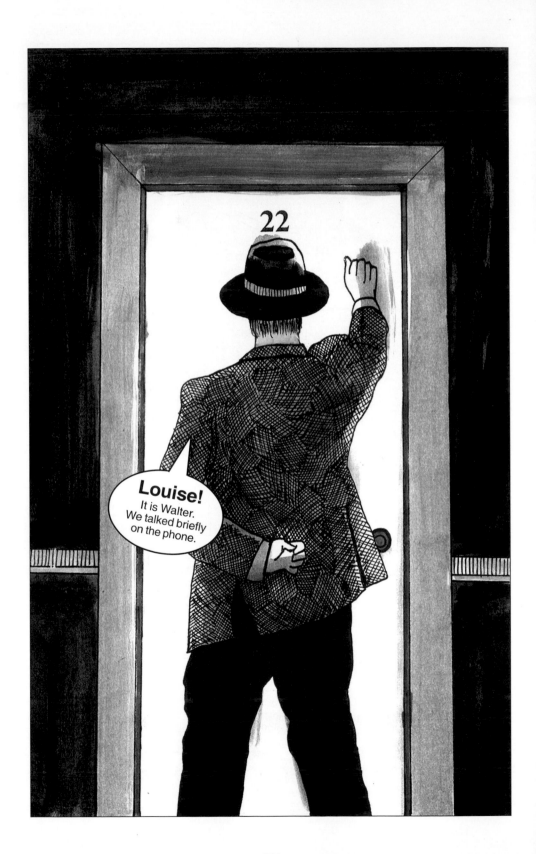

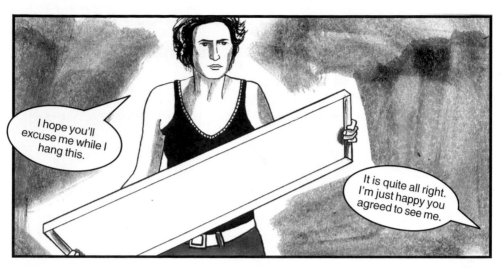

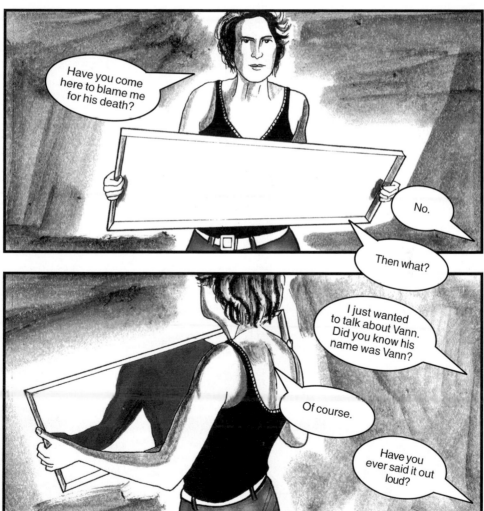

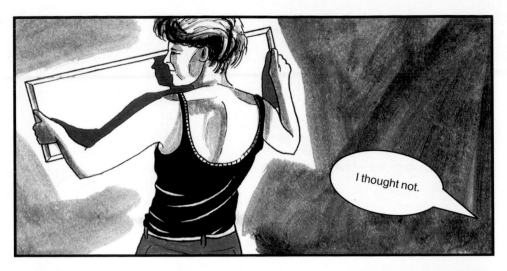

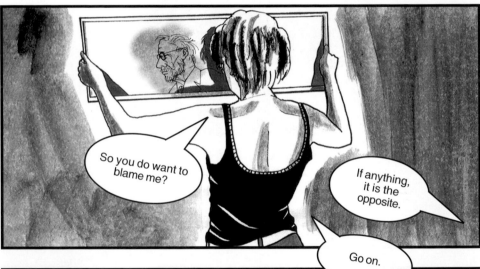

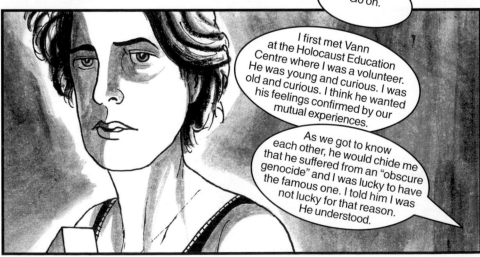

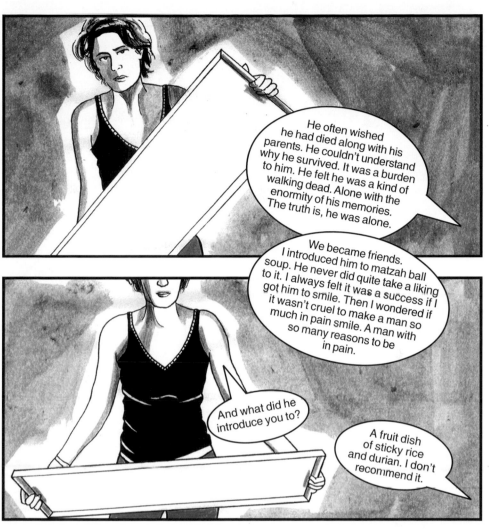

He often wished he had died along with his parents. He couldn't understand why he survived. It was a burden to him. He felt he was a kind of walking dead. Alone with the enormity of his memories. The truth is, he was alone.

We became friends. I introduced him to matzah ball soup. He never did quite take a liking to it. I always felt it was a success if I got him to smile. Then I wondered if it wasn't cruel to make a man so much in pain smile. A man with so many reasons to be in pain.

And what did he introduce you to?

A fruit dish of sticky rice and durian. I don't recommend it.

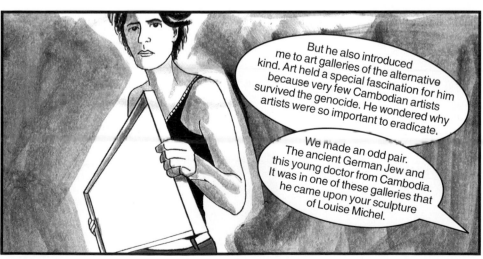

But he also introduced me to art galleries of the alternative kind. Art held a special fascination for him because very few Cambodian artists survived the genocide. He wondered why artists were so important to eradicate.

We made an odd pair. The ancient German Jew and this young doctor from Cambodia. It was in one of these galleries that he came upon your sculpture of Louise Michel.

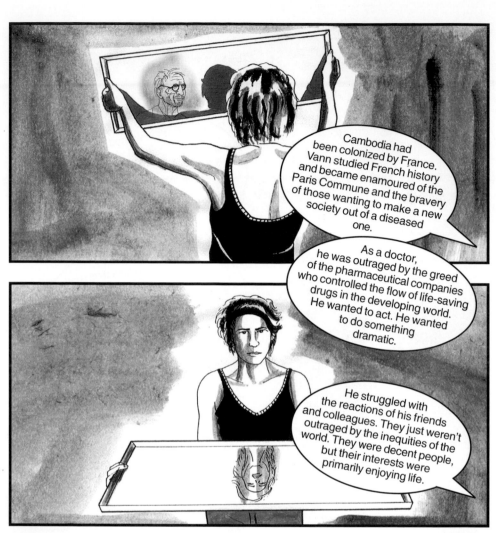

Cambodia had been colonized by France. Vann studied French history and became enamoured of the Paris Commune and the bravery of those wanting to make a new society out of a diseased one.

As a doctor, he was outraged by the greed of the pharmaceutical companies who controlled the flow of life-saving drugs in the developing world. He wanted to act. He wanted to do something dramatic.

He struggled with the reactions of his friends and colleagues. They just weren't outraged by the inequities of the world. They were decent people, but their interests were primarily enjoying life.

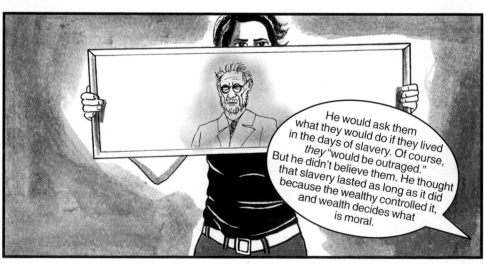

He would ask them what they would do if they lived in the days of slavery. Of course, *they* "would be outraged." But he didn't believe them. He thought that slavery lasted as long as it did because the wealthy controlled it, and wealth decides what is moral.

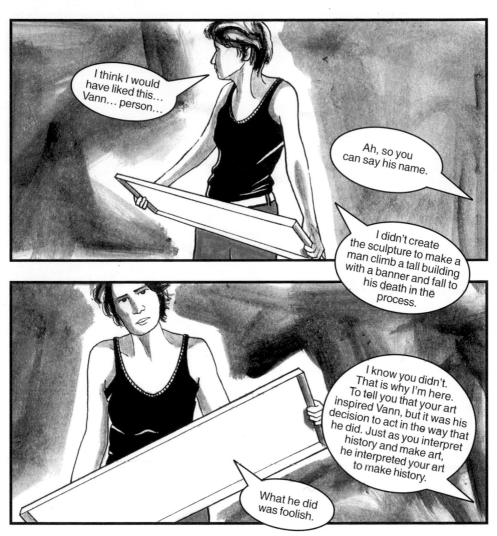

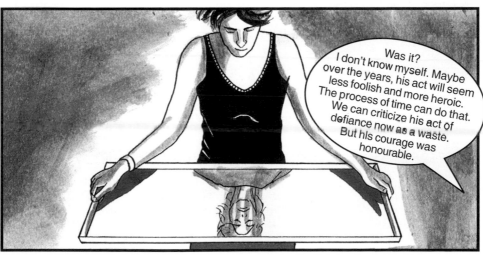

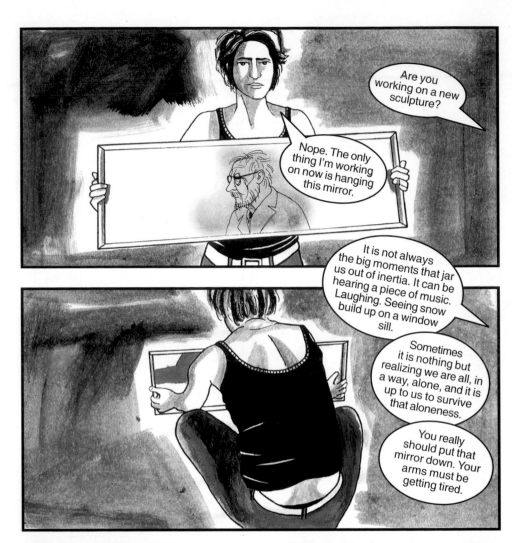

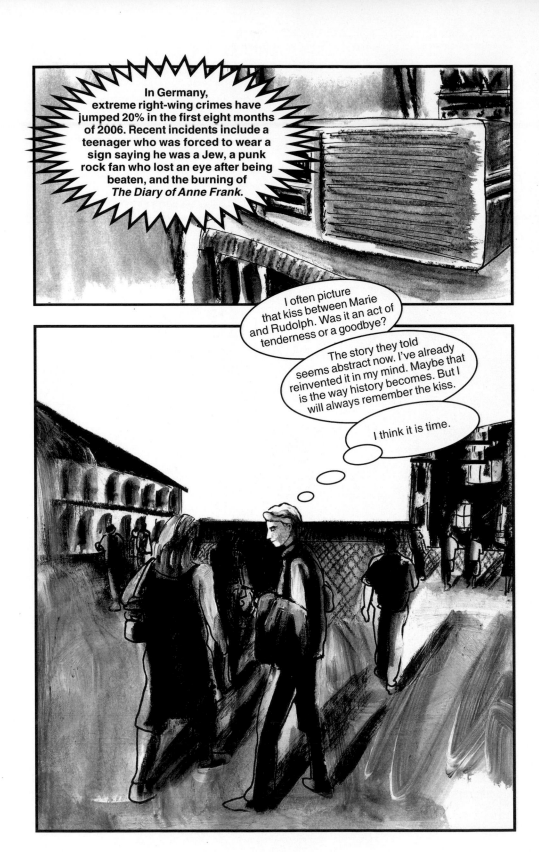

CHAPTER 13

The Sculpture

Spread the word, write it, sing it, shout it out, whisper it,
type it, paint it, draw it, film it, dance it, jiggle it, shake it up
and down, say it, hang it, poster it, stencil it, serve it hot or cold,
try it out, don't be afraid, experiment, practice, agitate, organize,
resist, create, speak, act, do something intelligent, somewhere,
something new and exciting that will bring us one step
closer to where we all want to go: a healthy planet,
without exploiters and exploited, here and now.

—NORMAN NAWROCKI, ANARCHIST POET, MONTREAL, 2007

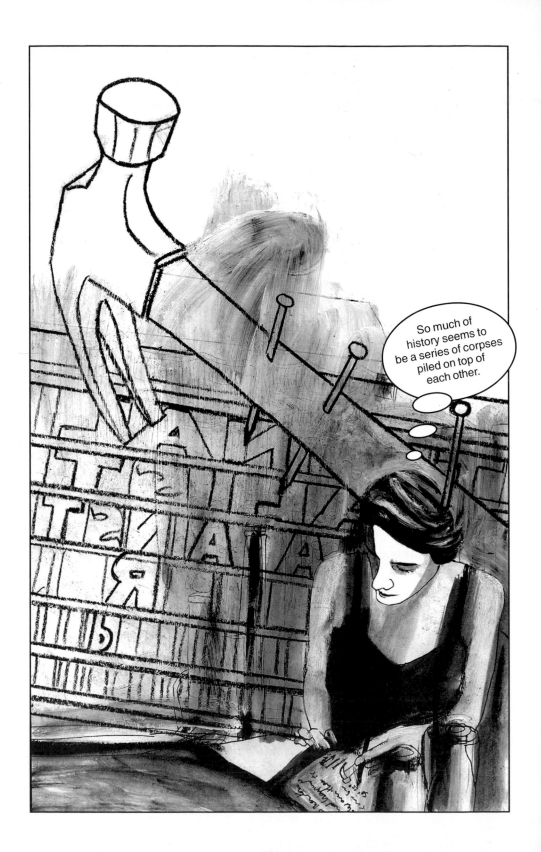

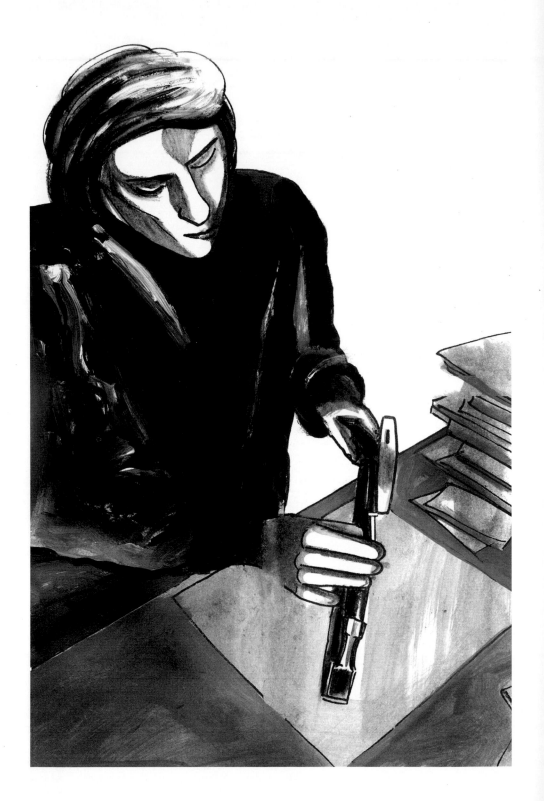

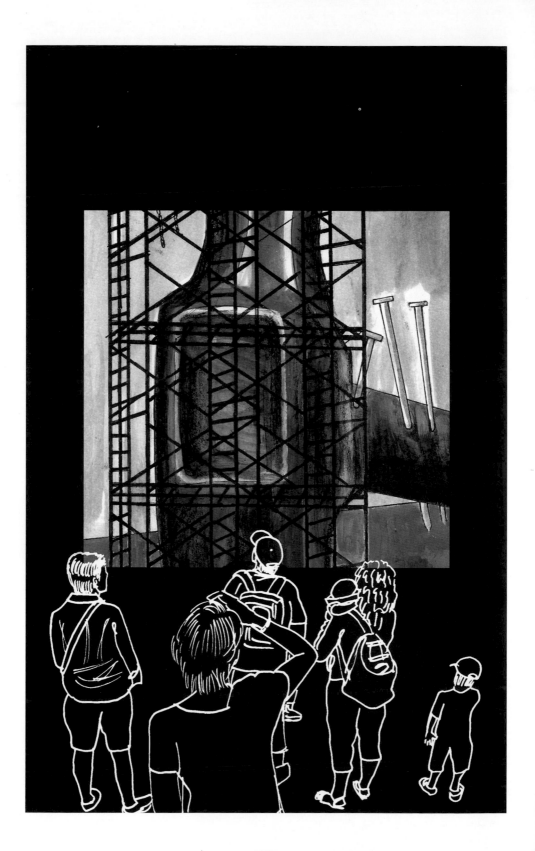

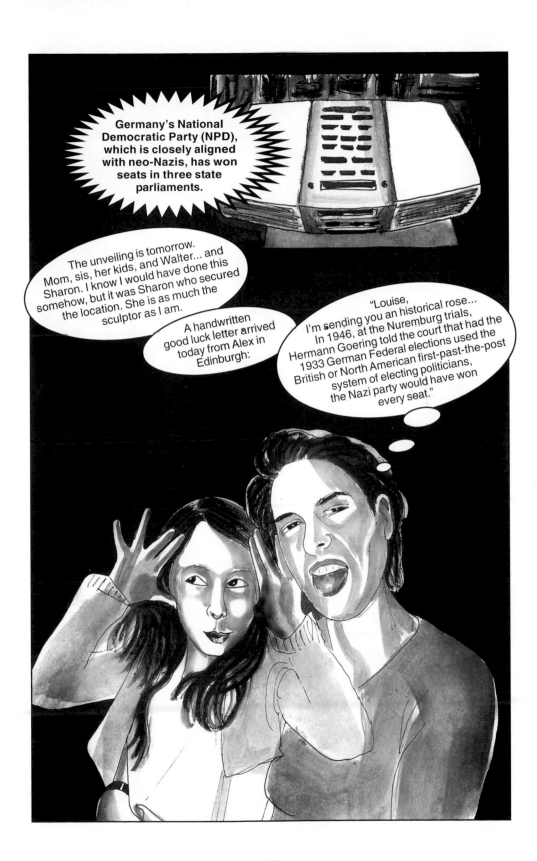

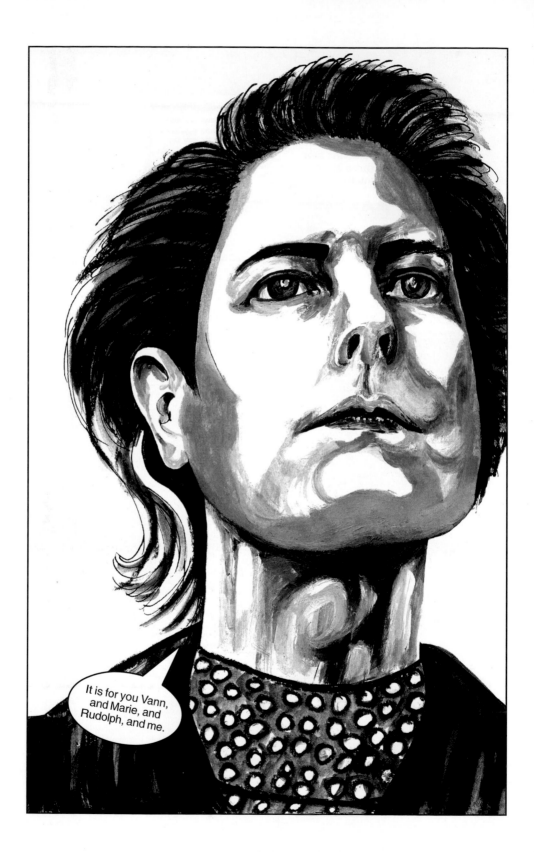

UPRISING OF THE DAMNED

LOUISE SHEARING

BRONZE

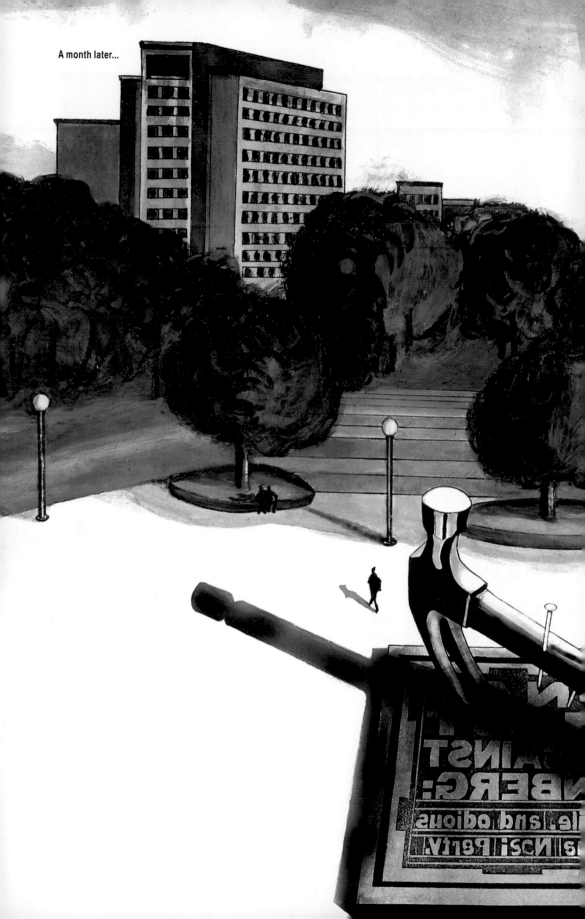

A month later...

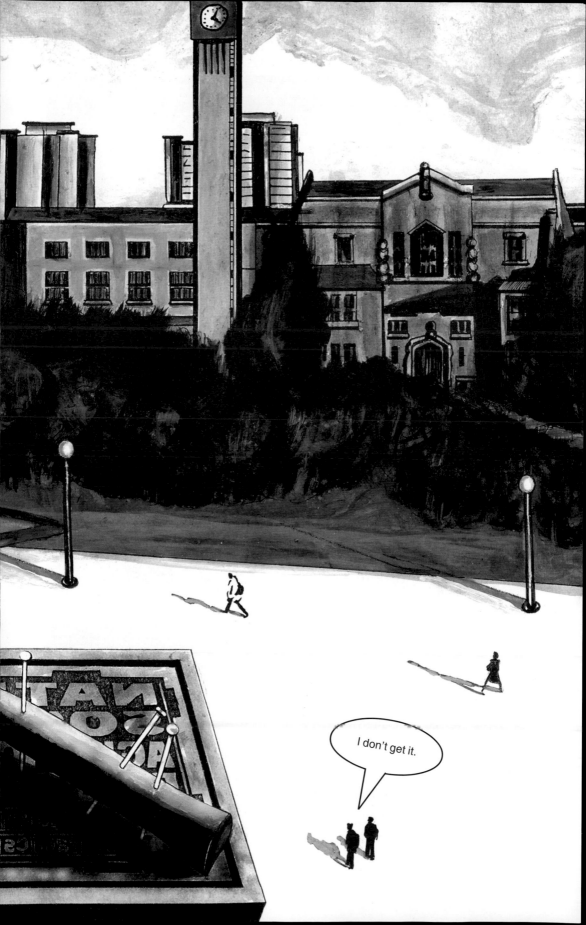

FINI

CHRONOLOGY

What Happened?

*We who lived in concentration camps
can remember the men who walked through
the huts comforting others, giving away
their last piece of bread. They may have
been few in number, but they offer
sufficient proof that everything can be
taken from a man but one thing: the last
of the human freedoms—to choose one's
attitude in any given set of circumstances,
to choose one's own way.*

—VIKTOR FRANKL (1905-1997),
AUSTRIAN PSYCHIATRIST, HOLOCAUST SURVIVOR

January 30, 1933: Adolf Hitler becomes chancellor of Germany.

February 27, 1933: Germany's parliament building, the Reichstag, is destroyed by arson. The fire is blamed on a communist.

March 5, 1933: The Nazi Party only gets 44% of the vote in the federal election despite widespread intimidation and arrests of members of other parties.

March 20, 1933: Dachau becomes the first Nazi concentration camp (previously, the British had used "concentration camps" to imprison Boers in 1900-02).

Nazi book burning, 1933

March 23, 1933: The Enabling Act is passed by Germany's federal parliament. The act gives Hitler complete authority to pass laws without either parliamentary consent or control. This effectively turns Germany into a dictatorship. The Social Democratic Party (SPD) is the only party to vote against the act. The Communist Party (KPD) were not allowed to vote because Hitler had annulled their parliamentary seats.

April 1, 1933: Most Jewish teachers fired in Germany.

April 25, 1933: German sports clubs expel Jews.

April 1933: Nazis organize a boycott of Jewish businesses, physicians and attorneys. Storm-troopers attack anyone who ignores the boycott.

May 1933: The Nazi Party takes control of German trade unions.

May 1933: Book burning begins on campuses across Germany. Students enthusiastically burn almost 25,000 "un-German" books, including writers such as Bertolt Brecht, Ernest Hemingway and Helen Keller. This was part of a plan to synchronize culture by bringing the arts in line with Nazi ideology. Jews and those politically or artistically suspect were purged from cultural organizations.

"The Protestant Church must, for the sake of its calling, here and thankfully greet the great intent coming out of the National Socialist movement."
—Heinrich Rendtorff, Lutheran Bishop of Mecklenburg, Germany, 1931

July 14, 1933: All parties, except the Nazi Party, are forced to dissolve. The government bans the formation of any new parties.

August 1933: Jews in Nuremberg are forbidden to use public baths.

August 1933: From exile in Prague, the Social Democratic Party (SPD) publishes a list of 65 German concentration camps.

August 2, 1934: President Hindenburg dies. Hitler merges the offices of chancellor and president and assumes the new position. All military and civil servants ordered to swear a personal loyalty oath to Hitler.

March 1935: Germany begins rearmament and troop buildup in violation of the Treaty of Versailles.

March 31, 1935: Jewish musicians banned from performing.

September 15, 1935: *The Nuremberg Laws on Citizenship and Race* are introduced whereby a Jew cannot be a citizen of the Reich, vote or hold public office.

March 7, 1936: The German army occupies the Rhineland in violation of the Treaty of Versailles.

August 1-16, 1936: Adolf Hitler officially opens the Summer Olympics in Berlin.

November 1, 1936: Hitler and Italy's fascist dictator Benito Mussolini form a military alliance.

April 15, 1937: Jewish students in Germany are not allowed to graduate.

April 26, 1937: Bombs dropped from German and Italian planes destroy three quarters of the Basque town of Guernica in Spain.

March 12, 1938: Hitler's armies invade Austria, annexing it as part of the German Reich.

September 29, 1938: British Prime Minister Neville Chamberlain signs the Munich Agreement with Hitler. The settlement was considered an act of appeasement that gave Germany the Sudetenland in Czechoslovakia in return for Hitler's promise not to invade any other countries.

November 9-10, 1938: Nazi leader Joseph Goebbels organizes Kristallnacht (The night of broken glass), a pogrom where 1,000 synagogues and 7,000 Jewish businesses, cemeteries, hospitals, schools, and homes were attacked and looted while the police and fire brigades stood by and did nothing.

November 12, 1938: Jews banned from attending movies and concerts in Germany.

December 3, 1938: Jews banned from German swimming pools.

March 15, 1939: Germany invades all of Czechoslovakia.

May 13, 1939: Germany lets a ship set sail from Hamburg carrying nearly 1,000 Jewish refugees. In what became known as "the voyage of the damned," passengers are refused asylum in Cuba, U.S.A., and Canada before returning to Europe.

August 23, 1939: Russia's Joseph Stalin and Adolf Hitler sign the Nazi-Soviet Pact, an agreement whereby both countries promise to remain neutral if either become involved in a war.

September 1, 1939: Germany invades Poland. This is considered by many to be the start of the Second World War.

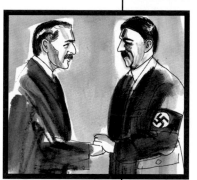

British Prime Minister Chamberlain and Hitler during the Munich Agreement, 1938

"It was no business of ours to interfere in Germany's internal affairs either [regarding] Jews or [regarding] anything else, dictators are very popular these days and we might want one in England before long."
—The Prince of Wales, 1933

September 3, 1939: Britain and France declare war on Germany.

September 10, 1939: Canada enters war against Germany (40,000 Canadians would die and 50,000 were wounded).

September 1939: German army in Poland commits mass rape on both Polish and Jewish women and girls.

April 8, 1940: Germany invades Norway and Denmark.

May 10, 1940: Germany invades France, Holland, and Belgium.

Kristallnacht, the morning after, 1938

May 15, 1940: Holland surrenders to Germany.

May 28, 1940: Belgium surrenders to Germany.

June 22, 1940: France signs an armistice with Germany. A pro-Nazi puppet regime is established to govern France.

July 10, 1940: Battle of Britain begins.

August 23, 1940: German Luftwaffe carry out night bombing raids, known as *The Blitz*, on London.

September 27, 1940: Japan joins 'axis' with Germany and Italy.

November 1940: Hungary and Romania join the axis.

February 14, 1941: German 'Afrika Korps' land in North Africa.

April 6, 1941: Germany invades Yugoslavia and Greece.

April 17, 1941: Yugoslavia surrenders to Germany.

"I am certain that the Nazis will clean things up and put Germany on the way to being a real power in Europe again..."
—Lord Reith,
a founder of the British Broadcasting Company (BBC), 1933

May 10, 1941: Deputy Führer Rudolf Hess parachutes into Scotland reportedly to broker a peace deal between Germany and Britain. Britain imprisons Hess for the entire war.

June 22, 1941: Germany invades the Soviet Union.

August 2, 1941: Jews banned from using German public libraries.

August 20, 1941: German forces begin 900-day seige of the Russian city of Leningrad (now called St. Petersburg).

December 1, 1941: A decree orders Jews over six years of age within Germany and all occupied areas to wear a yellow Star of David badge with the word "Jude" ("Jew") on the left side of their chest.

December 7, 1941: Japanese airforce attacks U.S. naval base at Pearl Harbor, Hawaii. Japan declares war on the U.S. and Britain.

December 8, 1941: The U.S. enters the war against Germany (300,000 would die and 300,000 were wounded).

December 11, 1941: Germany and Italy declare war on the US.

December 1941: Nazis create the first extermination camp, Chelmno (in Poland). Deportation of Jews from across Europe to extermination camps begins.

February 24, 1942: Canadian government orders that Japanese Canadians be sent to internment camps, mostly in British Columbia.

January 20, 1942: In Wannsee in south western Berlin, a meeting of government and SS officials (The Wannsee Conference), takes place to muster support and cooperation for the Third Reich's plan for the "Final Solution of the Jewish Question." The plan calls for the extermination of the Jews of Europe. SS-Obersturmbannführer Adolf Eichmann acts as secretary and takes the minutes of the meeting.

January 13, 1942: German U-boat offensive along eastern U.S. coastline.

February 14, 1942: Jews are banned from bakeries and candy stores in Germany.

April 1942: Japanese Americans interned in US.

May 15, 1942: Jews not allowed to have pets in Germany.

June 1942: Gas chambers begin being used to kill Jews and other prisoners at Auschwitz.

June 1942: A group of Munich university students calling themselves The White Rose begins a leaflet campaign urging the public to actively oppose the Third Reich.

June 20, 1942: Jews not allowed to attend school in Germany.

July 22, 1942: Deportations from the Warsaw Ghetto in Poland to concentration camps begins.

July 22, 1942: Treblinka extermination camp in Poland opens.

October 9, 1942: Jews not allowed to buy books in Germany.

September 13, 1942: Germany attacks Stalingrad, Russia.

November 4, 1942: In a major victory, the Allies force the Axis to retreat at El Alamein in Egypt.

January 18, 1943: The Warsaw Ghetto Uprising, led by Jewish insurgents, begins but is crushed months later by German troops commanded by Lippe-born Jürgen Stroop.

January 27, 1943: American air forces carry out their first bombing raid on Germany (Wilhelmshaven).

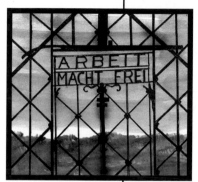

This sign, roughly translated as "Work shall set you free," was placed at the entrances of several concentration camps, including this one at Dachau.

"My sizing up of the man, as I sat and talked with him, was that he is really one who truly loves his fellow man."
–W. L. MacKenzie King, Prime Minister of Canada, after a visit with Hitler, 1937

February 2, 1943: German army surrenders at Stalingrad.

February 22, 1943: Three members of The White Rose (including Sophie Scholl) are convicted and beheaded.

March 2, 1943: German army starts withdrawal from Africa.

March 16-20, 1943: German U-boats sink twenty-seven merchant ships in the Atlantic Ocean.

Josef Goebbels'
charred body, 1945

May 13, 1943: German and Italian troops surrender in North Africa.

July 27-28, 1943: Hamburg, Germany encased in a firestorm caused by Allied bombing.

August 2, 1943: Uprising by hundreds of inmates at the Treblinka extermination camp in Poland is crushed, but not until prisoners are able to destroy the crematoria.

September 8, 1943: Italy surrenders.

November 18, 1943: British carry out air raids on Berlin.

June 6, 1944: Allied forces invade (D-Day) Europe via France.

July 20, 1944: Hitler injured in an assassination attempt carried out by Colonel Claus von Stauffenberg in East Prussia.

"Yes, Heil Hitler.
I, too, say that
because he is truly
a great man."
—David Lloyd George,
British Prime Minister,
1936

August 1, 1944: Warsaw Uprising begins when the Polish Home Army attempts to end the German occupation of Poland.

August 4, 1944: Gestapo arrest Anne Frank's family in Holland.

August 18, 1944: German Communist Party (KPD) leader Ernst Thalmann is executed at Buchenwald concentration camp. He had been in prison since 1933.

September 25, 1944: Hitler orders all remaining males between sixteen and sixty in Germany to sign up for army service.

"His rapid rise in the
world worried me. I
must honestly confess
that I would have
preferred it if he had
followed his original
ambition and become
an architect."
—Paula Hitler,
Adolf's sister

December 16-27, 1944: Battle of the Bulge in the Ardennes.

January 26, 1945: Soviet troops liberate Auschwitz.

February 13-14, 1945: Allied bombing raids destroy Dresden, Germany in a firestorm.

April 1, 1945: German forces trapped by U.S. troops in the Ruhr.

April 12, 1945: U.S. Army liberates Buchenwald concentration camp. British Army liberates Bergen-Belson concentration camp.

April 16, 1945: Soviet troops begin final assault on Berlin.

April 28, 1945: Mussolini hanged by Italian partisans.

April 30, 1945: U.S. Army liberates Dachau concentration camp.

April 30, 1945: Adolf Hitler and Eva Braun commit suicide in Berlin. In preparation for their suicide by cyanide, Hitler first had the capsules tested on his dog Blondi.‡

May 1, 1945: Josef Goebbels and his wife Magda commit suicide in Berlin after poisoning their six children.

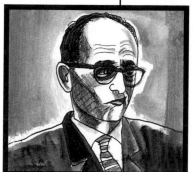

Adolf Eichmann
on trial, 1962

May 5, 1945: U.S. Army liberates Mauthausen concentration camp.

May 7, 1945: Germany unconditionally surrenders.

August 6, 1945: US Airforce drops atomic bomb on Hiroshima, Japan, killing 140,000 people.

August 9, 1945: US Airforce drops atomic bomb on Nagasaki, Japan, killing 80,000 people.

August 14, 1945: Japan surrenders, effectively ending the Second World War. But officially, The Treaty of Peace with Japan was not signed until 1951. Almost sixty-two million people, or 3% of the world's population, died in the war, though estimates vary greatly—about twenty-four million soldiers and thirty-eight million civilians. An estimated six million Jews were killed.

"…in the name of the bishops of all the dioceses in Germany, to convey to you on your birthday the warmest felicitations."
— *Cardinal Bertram, Breslau, Poland, congratulating Hitler on his fifty-first birthday, 1940*

October 1, 1946: The International Military War Tribunal at Nuremberg sentences twenty-four leaders of the Third Reich for crimes against humanity (twelve receive the death penalty). Rudolf Hess is given a life sentence. Ex-chancellor Franz Von Papen is acquitted but the court does note he did commit "political immoralities."

October 15, 1946: Hermann Goering commits suicide.

October 16, 1946: Nuremberg defendants are executed.

March 12, 1951: DNVP leader Alfred Hugenberg dies, age 85.

June 1, 1962: SS-Obersturmbannführer Adolf Eichmann is executed in Israel. His final words are "Long live Germany. Long live Austria... I had to obey the rules of war and my flag."

October 1, 1966: Architect and Minister of War, Albert Speer released from prison after serving a twenty-year sentence for war crimes. He goes on to become a bestselling author and dies in 1981.

May 2, 1969: Ex-chancellor Franz Von Papen dies, age 89.

1970s: Aryan Nations, a US new-Nazi group is founded.

1984: US neo-Nazi group, The Order, murders Alan Berg.

‡ Blondi (1934-1945) even has a Wikipedia entry.

1984: Canadian teacher Jim Keegstra convicted of inciting hatred for teaching that Jews "created the Holocaust to gain sympathy."

1987: Former Deputy Führer Rudolf Hess, 93, kills himself after 46 years in prison. Nine thousand neo-Nazis gather at his grave in 2004.

2001: Eli Rosenbaum, director of the U.S. Justice Department's Office of Special Investigations states: "The real winners of the Cold War were Nazi war criminals, many of whom were able to escape justice because the East and West became so rapidly focused after the war on challenging each other."

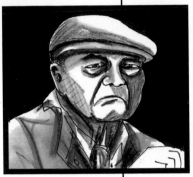

War criminal Michael Seifert dies in prison in 2010.

2002: Writer Antony Beevor reports that by the end of the Second World War, Russia's Red Army soldiers raped around 2,000,000 German women and girls.

2005: *Mein Kampf* becomes a bestseller in Turkey.

2006: British historian David Irving pleads guilty to denying the Holocaust in Austria.

2006: Iranian president Ahmadinejad denys the Holocaust.

2007: A German court convicts Ernst Zündel of "incitement for Holocaust denial." He is sentenced to 10 years.

2007: Robert J. Lilly estimates that 14,000 women in England, France and Germany were raped by U.S. soldiers in the Second World War.

2007: The Austrian government offers a reward for the arrest of Aribert Heim, 93, who was known as "Dr. Death" for his practices of injecting prisoners with gasoline, salt, and poison at Mauthausen. After the war, Heim married, joined a hockey team, and became a gynecologist.

2008: *Deutsche Welle* reports that only one in three Germans under twenty understand the meaning of the word "Holocaust."

2008: Michael Seifert, 83, an SS guard known as the "Beast of Bolanzo" is extradited to Italy from Vancouver, Canada. He had been convicted *in absentia* in Italy for torturing and killing prisoners.

2010: Neo-Nazi group Bosanski Pokret Nacionalnog Ponosa (Bosnian Movement of National Pride) is founded in Bosnia and Herzegovina.

2010: Nazi death squad member Heinrich Boere, 88, is sentenced to life imprisonment in Germany for murders in 1944.

2010: Neo-Nazis, Tsagaan Khas (White Swastika) forms in Mongolia.

2010: Bollywood announces plans to make a sympathetic portrayal of Hitler's love for India in a film titled *Dear Friend Hitler*.

2010: A U.S. Justice Department report reveals the CIA knowingly granted Nazi war criminals a safe haven after the Second World War.

"Politically, neo-Nazi groups are not a big force. But worryingly they reflect widely held views across society."
—Alexander Verkhovsky, *Moscow's Sova Centre, which monitors hate crime in Russia. Their statistics show 310 people were victims of racist and neo-Nazi crimes (including 37 murders) in the first six months of 2007.*

APPENDIX

Animators, Cartoonists, & Designers in the Third Reich

The animated film industry in Germany was still in its infancy (despite the beautiful hand-cut silhouette films by Lotte Reiniger‡) when Hitler became chancellor in 1933. He was an enthusiastic supporter of film animation and, along with Propaganda Minister Goebbels, the Third Reich put its resources into developing this art form.

Adolf Hitler

In his diary, Goebbels wrote: "I have given twelve Mickey-Mouse-movies as a present for the Führer at Christmas! He is pleased about it. He is absolutely happy about this treasure."

Hitler wanted the Third Reich to produce animation as good as Walt Disney's *Snow White and the Seven Dwarfs*. The techniques of the Disney Studios were already being studied by 1931, with German animators drawing cartoon figures with four instead of five fingers.

Production of animated films did not slow down even during the war, with many being produced for propaganda purposes. Animator Hans Held produced *Der Störenfried* (*The Troublemaker*) in 1940. The story involved the animals of the forest banding together to drive the troublemaker—a fox—away (hedgehogs wore Wehrmacht helmets on their heads).

A Berlin-Dahlem-based animation company was founded in 1941 by the propaganda ministry. One of its quality productions, *Armer Hansi*, was a 17-minute film that took two years to make and was notable for its use of electronic music by Oskar Sala, who later became famous for his score for Alfred Hitchcock's *The Birds*.

Gerhard Fieber, who worked in an animation studio based in the town of Dachau (near Munich), said after the war, "This was a bad time. During the working hours you were busy with trickfilm figures, at the same time you could see prisoners on the street who were harnessed in front of wagons as a replacement for horses. Nevertheless, you had to draw funny figures—it was horrible."

In 1948, Fieber founded EOS Film, which became the biggest animation studio in Germany and produced the first full-length animated film of the post-war era called *Tobias Knopp*.

A significant female animator during the Third Reich was Anna-Luise Subatzus. During the war she worked in the town of Dachau. After the war, she returned to her home town of Detmold, Lippe to work as a translator for the British military government. In 1949, she began animation on *Tobias Knopp*. It would be the only film she ever received a credit on. Anna-Luise Subatzus died in Breman, in 1994.

* * *

Hans Schweitzer was an anti-Semitic Berlin-born graphic designer and cartoonist who went under the pen name *Mjölnir* (meaning *God's Hammer* in German

‡ Lotte Reiniger (1899-1981), is credited with making the first animated feature film.

mythology). In 1924 he worked for the DNVP (German National People's Party) but later changed his political affiliation to the Nazi Party. Schweitzer became the best-known propagandist of the Nazi Party because of the quality and strength of his designs, posters, caricatures and paintings. He was reported to be Hitler's favourite artist.

Schweitzer was a close friend of Joseph Goebbels and they often spent summer holidays together. Goebbels hired Schweitzer to create art for the daily newspaper *Der Angriff* (*The Attack*). Another friend, SS leader Heinrich Himmler, became

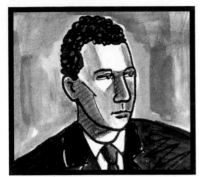
Hans Schweitzer

godfather of Mjölnir's son Helge in 1936. Himmler later made the cartoonist an honorary colonel in the SS. In 1936, Goebbels gave Mjölnir a post in the Propaganda Ministry with the title of Reich Deputy for Artistic Design. Mjölnir's job was to translate Nazi ideology (including the demonizing of Jews) into "artistic form" for uniforms, stamps, flags, monuments, posters and even the civic decorations during the Olympic games.

Particularly known for his violent depictions of Jews, Schweitzer declared in 1936, "The mainspring of political satire is hate."

In 1938 he was a member of the committee selecting artworks for that year's version of the Degenerate Art‡ exhibit (which included art by Otto Dix, Paul Klee, Marc Chagall, Raoul Hausmann, El Lissitzky, Piet Mondrian and Wassily Kandinsky).

During the Second World War, Schweitzer became the Nazi's leading poster designer and briefly fought as a soldier.

Schweitzer was arrested by the Americans near Schleswig-Holstein in 1947 (he claimed a modernist artist whose work he had previously attacked, tipped off authorities). During his denazification proceedings in 1948, Schweitzer stated that he regarded the Star of David that Jews were forced to wear as "a police measure against espionage" and that he himself "was not aware that during the war Jews disappeared from Berlin… I did not know that Jews were in concentration camps… I did not know that the SS took actions against Jews." Schweitzer also stated to the court, "I was aware that the party aimed at a legal solution of the Jewish question. I agreed with that. As a young artist I witnessed how German art was moving further and further away from the natural basis of true art. I thought it right that the excessive Jewish influence, which had risen far above the percentage of Jews in the total German population, should be reduced by legal measures to a sensible level." He further testified that "I believed that I should fight against the damaging influence of Jewry."

The court found Schweitzer only guilty of being a member of the SS and he was fined 500 marks ($1,341.00 U.S. in 2009 dollars). The judges, in a controversial decision, noted that as a graphic artist, Schweitzer belonged to the field of political

‡ Nazi term to describe "modern art" as un-German, Jewish, and communist.

propaganda and thus in no way were his activities criminal.

In 1955, Schweitzer's conviction was completely expunged after several appeals. He would go on to change his name to Herbert Sickinger and have a successful career as a graphic artist working for the weekly magazine *Deutsche Wochen-Zeitung* and teaching painting in Westphalia to German and American students.

Upon Schweitzer's death in 1981, at age 79, the radical right-wing press would honour him with fawning obituaries.

* * *

German cartoonist **Erich Schilling**, born in 1885, was originally a critic of the Nazi Party, but later became a devoted supporter of the Third Reich. In 1945, Schilling committed suicide in Bavaria.

* * *

Born in Norway in 1873, **Olaf Gulbransson** was best known for his caricatures that appeared in the satirical magazine *Simplicissimus*. After the Nazis took power in 1933, the editors of *Simplicissimus* claimed that Gulbransson actively worked with the Nazis for the remainder of the Third Reich. In 1941, the Nazis made him an honorary member of the Society of Berlin Artists. In 1943, Gulbransson became emeritus professor at the Academy of Fine Arts, Munich and was also awarded the Goethe-Medal for Art and Science. He died in Tegernsee, Germany in 1958, at the age of 85.

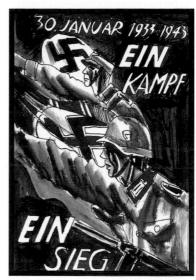

This 10th anniversary poster by Hans Schweitzer links the Nazi's struggle in the Second World War with Hitler's appointment as chancellor in 1933. The text reads: 30 January 1933-1943. One Battle! One Victory!

* * *

Otto von Kursell, born in 1884, was a painter, graphic artist and caricaturist who joined the Nazi party in 1922. During the Third Reich, he was a member of the Reichstag and director of the National School of Fine Arts in Berlin. His caricatures were vehemently anti-Semitic and were often published in *Auf Gut Deutsch* (In Plain German). He died in 1967, age 83.

* * *

Belgian cartoonist **Hergé** (1907-1983), creator of *Tintin*, worked for a Nazi newspaper during the Second World War. According to newspaper reports, he never regretted this work, other than to say he might have done things differently if had he known about the death camps.

* * *

In 2005, **Nikolai Borg**, 86, a graphic designer, claimed that he was commissioned by the Nazis to design the VW logo for Volkswagen, the German car manufacturer. Borg said that Adolf Hitler met with VW boss Ferdinand Porsche in 1939 to discuss the idea of a "people's car," which led to Borg being asked to design the VW logo by Fritz Todt, the Nazi transport minister in charge of building motorways.

Philipp Rupprecht was a cartoonist who drew under the pen name of "Fips." In 1925, he started out drawing for the social democratic party-linked newspaper *The Fränkische Tagespost*. When sent to produce a caricature of Nazi Julius Streicher at a court appearance, he instead did a mocking cartoon of Streicher's opponent in court. This led Streicher to hire Rupprecht to draw for *Der Stürmer*, where he would go on to create thousands of anti-Semitic cartoons. Rupprecht worked on *Der Stürmer* until the very last issue was published on February 22, 1945.

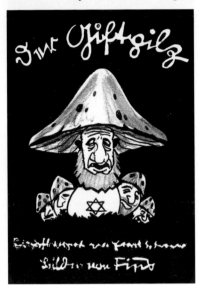

Ruprecht also illustrated two anti-Semitic children's books: *Don't Trust a Fox in a Green Pasture or a Jew Upon His Oath* (1936) and *The Poisonous Mushroom* (1938).

Over a 20-year span, Rupprecht's cartoons were considered essential by the Nazi Party in shaping German working-class opinion against Jews and building acceptance for a "final solution" to the Jewish question.

After the war, Rupprecht was put on trial and sentenced to six years hard labour for his cartooning. After his release from prison he worked in Munich and Starnberg as a painter and decorator.

Rupprecht died in 1975, aged 74.

Front cover of Rupprecht's anti-Semitic children's book *The Poisonous Mushroom* ("Just as it is often hard to tell a toadstool from an edible mushroom, so too it is often very hard to recognize the Jew as a swindler and criminal..."). Today, neo-Nazis can be found selling original copies of the book for thousands of dollars.

Author's notes

The Listener is based on my research into the historical record of the Lippe state election of January 15, 1933. It is by no means a definitive history of the election. I have taken many liberties with the story, but I've tried to remain true to the basic historical details. The characters of Marie and Rudolph and their interactions are a work of fiction. The journalist Gerhard and his murder are fictitious but there were indeed murders committed in Lippe by the Nazis.

Text on page 272 written by Jean Smith. Thanks to Christian Koenig, M.Sc., of the German Translation Service in Vancouver, for the translation of the plaque commemorating Hitler's Lippe campaign on page 253. The lyrics quoted on page 14 are from the song *Bread and Roses*, based on a poem by James Oppenheim.

Louise Michel (1830-1905), the subject of the fictional sculpture referred to in the story, was a feminist and anarchist who played a major role in the insurrection known as The Paris Commune, a ruling body of anarchists and socialists who seized power in order to benefit the working class of Paris (March to May, 1871).

This book would not have been possible without the valuable editorial support of Jean Smith and Wendy Atkinson who did the tough work of reading the dreaded early versions of the manuscript. Many thanks to John Samson, Rick Wood and the editorial collective at Arbeiter Ring Publishers for their work and enthusiasm for this book. Many thanks to Sarah Michaelson for copy editing the manuscript.

Most of the words credited to Adolf Hitler in this book were taken from actual speeches or interviews given by him during the Lippe election of 1933.

To find out if the citizens of Detmold (once the capital of Lippe) still remembered that fateful election 78 years ago, I wrote to the city's chief archivist Dr. Andreas Ruppert and received this reply: "Historians and archivists in Lippe are absolutely aware of the situation of 15th of Jan. in 1933. There are articles and even a book on this event, and many articles on the time of the Weimar Republic and National-Socialism deal with those elections, too."

In 1945, on the day before Adolf Hitler committed suicide in Berlin, he dictated his will. One of the items in the brief 320-word document stated that, "My paintings, in the collections which I have bought in the course of years, have never been collected for private purposes, but only for the extension of a gallery in my home town of Linz on Donau. It is my most sincere wish that this bequest may be duly executed." Incredible as it may seem, after all the invasions, pogroms, misery and millions of deaths, Adolf Hitler's last wish was to open an art gallery.

In the long run, I do think that film—my films included—
could have some sort of political impact eventually because
they might be able to change our basic perspectives,
our basic understanding of things, and changes of this sort,
of course, in the long range will have definite effects.

—WERNER HERZOG, FILMMAKER

Selected Bibliography

Adam, Peter. *Art of the Third Reich*. New York: Harry N. Abrams, 1995.

Broszat, Martin. *Hitler and the Collapse of Weimar Germany*. New York: Berg, 1987.

Domarus, Max. *Hitler: Speeches and Proclamations 1932-1945-The Chronicle of a Dictatorship*.
 Wauconda, IL: Bolchazy-Carducci, 1992.

Evans, Richard J. *The Coming of The Third Reich*. New York: Penguin, 2004.

Evans, Richard J. *The Third Reich in Power, 1933-1939*. New York: Penguin, 2005.

Herzstein, Robert. *The Nazis*. Alexandria, VA: Time-Life Books, 1980.

Hinz, Berthold. *Art in the Third Reich*. New York: Pantheon Books, 1979.

Jones, Larry Eugene. "'The Greatest Stupidity of My Life': Alfred Hugenberg and the Formation of the Hitler Cabinet, January 1933." *Journal of Contemporary History* 27, no. 1 (1992).

Leopold, John. *Alfred Hugenberg: The Radical Nationalist Campaign Against the Weimar Republic*. New Haven: Yale University Press, 1977.

Marquardt, Virginia Hagelstein. *Art and Journals on the Political Front, 1910-1940*. Gainesville: University Press of Florida, 1997.

Meissner, Hans-Otto. *Magda Goebbels: The First Lady of the Third Reich*. Translated by Mary Keeble. New York: Dial Press, 1980.

Paret, Peter. *An Artist Against the Third Reich: Ernst Barlach, 1933-1938* Cambridge: Cambridge University Press, 2003.

Paret, Peter. *German Encounters with Modernism, 1840-1945*. New York: Cambridge University Press, 2001.

Paret, Peter. "God's Hammer." *Proceedings of the American Philosophical Society*. 136, no. 2 (1992).

Petropoulos, Jonathan. *The Faustian Bargain: The Art World in Nazi Germany*. Oxford: Oxford University Press, 2000.

Pringle, Heather. *The Master Plan: Himmler's Scholars and the Holocaust*. New York: Viking, 2006.

Rosenbaum, Ron. *Explaining Hitler: The Search for the Origins of His Evil*. New York: Harper Perennial, 1999.

Shirer, William L. *The Rise and Fall of the Third Reich: A History of Nazi Germany*. New York: Simon & Schuster, 1959.

Spotts, Frederic. *Hitler and the Power of Aesthetics*. Woodstock, NY: Overlook Press, 2003.

Time-Life Books, ed., *Storming To Power*. Alexandria, VA: Time-Life Books, 1989.

Toland, John. *Adolf Hitler*. Garden City, NY: Doubleday, 1976.

Trevor-Roper , Hugh. *Hitler's Table Talk, 1941-1944: His Private Conversations*. Translated by Norman Cameron and R.H. Stevens. London: Phoenix Press, 2000.

Turner, Jr., Henry Ashby. *Hitler's Thirty Days to Power: January 1933*. Reading, MA: Addison-Wesley, 1996.

Wagner, Caroline. *Die NSDAP auf dem Dorf: Eine Sozialgeschichte der NS-Machtergreifung in Lippe*. Munster: Aschendorff, 1998.

Links

The Black Dot Museum of Political Art:
blackdotmuseum.wordpress.com

How Art & Music Can Change the World:
howartandmusiccanchangetheworld.blogspot.com

Mecca Normal on Facebook:
www.facebook.com/pages/Mecca-Normal/49770142508

Mecca Normal on Myspace:
www.myspace.com/meccanormal

David Lester *Inspired Agitators* posters:
www.buyolympia.com

•

To set up a reading, performance, lecture, art exhibit,
by David Lester / Mecca Normal, contact davidlester735@hotmail.com